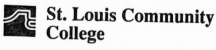

St. Louis Community College

Forest Park
Florissant Valley
Meramec

Instructional Resources
St. Louis, Missouri

American Science Fiction
and the Cold War

American Science Fiction and the Cold War

Literature and Film

David Seed

FITZROY DEARBORN PUBLISHERS
CHICAGO • LONDON

© David Seed, 1999

Published in the United Kingdom by
Edinburgh University Press
22 George Square, Edinburgh

Published in the United States of America by
Fitzroy Dearborn Publishers
919 North Michigan Avenue,
Chicago, Illinois 60611

Typeset in Monotype Apollo
by Koinonia, Bury, and
printed and bound in Great Britain by
Cambridge University Press

A CIP record for this book is available
from the British Library

A Cataloging-in-Publication record for this book
is available from the Library of Congress

ISBN 1-57958-195-1 Fitzroy Dearborn

Contents

Acknowledgements

Grateful thanks are given to the following for their help during this project: Poul Anderson, Paul Boyer, Ray Bradbury, Paul Brians, David Brin, John Clute, Chandler Davis, M. J. Engh, Jack Finney, H. Bruce Franklin, Charles Gannon, Russell Hoban, Dean Ing, David Karp, Judith Merril, Frederik Pohl, Jerry Pournelle, Kim Stanley Robinson, Mordecai Roshwald, Andy Sawyer, William J. Scheick, George Slusser, Albert E. Stone, Lorna Toolis, and Daniel L. Zins. I acknowledge the invaluable release from teaching to complete this book from an AHRB award and a fellowship from the Leverhulme Trust. Finally a special debt of gratitude to my wife Joanna for her unwavering encouragement and support at every stage of this project.

Introduction

The Cold War was a metaphor. As soon as the label was applied to material conditions it carried entailments for subsequent designations of the postwar scene. Generally dated from a 1947 speech by Bernard Baruch ('we are in the midst of a cold war') and then popularised by the journalist Walter Lippmann (see Goldman 1960: 60), the phrase had been used as early as October 1945 by George Orwell whose article 'You and the Atom Bomb' foresaw a situation of armed paralysis, of hostility that could never develop into overt combat with a superstate 'at once *unconquerable* and in a permanent state of "cold war" with its neighbours'. Orwell mistakenly assumed that the atomic bomb would stay too costly to mass-produce, but shrewdly found early signs of a *status quo* that could only be described paradoxically as a 'peace that is no peace' (Orwell 1970: 26). Once put into circulation the two terms in 'cold war' came to imply that 'two mutually exclusive political systems were frozen in ideological place' and that politics could only be conducted as conflicts where victory became the 'only means of resolution' (Hinds and Windt 1991: 219).

Examination of political speeches for covert messages has led one commentator to argue that the US perception of the Cold War was structured around key metaphors, like the analogy between the Soviet Union and 'dangerous predators' (Medhurst et al. 1990: 74). Such metaphors carried their own narrative with them – here primarily of attack – which postwar science fiction repeatedly actualised. The 1954 film *Them!*, for instance, picks up the double metaphor of ants-as-monsters and ants-as-people to dramatise the unpredictability of the Bomb and fears of Communist attack. Radiation from the White Sands testing ground has produced gigantic mutant ants who threaten centres of civilisation like Los Angeles. They are thus 'spawned' by the Bomb but also embody a

perception of Communist society. An expert in the film virtually draws the analogy for us when he explains: 'Ants are the only creatures on Earth other than man who make war. They campaign; they are chronic aggressors; and they make slave labourers of the captives they don't kill'. So when the military moves into action against the ants it is no surprise that a journalist asks 'has the Cold War gotten hot?' The question opens up one way of viewing the narrative as a battle between the USA and Communist aggressors encoded as a monster fantasy, and the film was no isolated instance. The novelist Poul Anderson figured the Communist millennium as 'humanity turned into an ant-hill' and Norman Spinrad concluded *The Iron Dream* (1972) with a description of an empire resembling the Soviet Union as the 'end-product of Communist ideology – an anthill of mindless slaves presided over by a ruthless hierarchy'.[1] These examples, taken from fictional and non-fictional sources, suggest that science fiction novels and films are not producing arbitrary fantasy but rather reworking key metaphors and narratives already circulating in the culture.

Hayden White has argued that historical and fictional discourses have common aspects in narratives that transmit 'messages about the nature of a shared reality'. At any given historical moment there exists an 'enormous number of kinds of narratives that every culture disposes for those of its members who might wish to draw upon them for the encodation and transmission of messages' (White 1987: 41). These narratives are formed through a process White labels the 'tropics of discourse', by which he means the metaphorical and related strategies employed by historian and novelist alike to fashion a 'comprehensible totality' from their materials (White 1978: 2, 125). White's argument is broader than that of Lakoff and Johnson (Lakoff and Johnson 1980) on metaphor, although both coincide in demonstrating that metaphor and other rhetorical devices play an integral part in how we structure our concepts. Being less tied to prescriptive conventions of representation than realism, science fiction can defamiliarise metaphors of the times by rendering them as concrete metonyms. Thus Bernard Wolfe depicts the arms race as a bizarre form of athletics in *Limbo* and Nick Boddie Williams transforms the Iron Curtain metaphor into an atomic curtain in his 1956 novel of that title, a curtain which now screens postholocaust America, not the Soviet bloc.[2] In these and similar cases the fiction uses narrative to interrogate the key metaphors within Cold War discourse.

White bridges the gap between factual material and fiction by arguing that both draw on a common pool of narratives and images

circulating in the culture. For example, in February 1957 James W. Deer addressed the controversy on civil defence in the pages of the *Bulletin of the Atomic Scientists* where he extrapolated a sequence of races from 1945 into the near future of fission (A) bombs, fusion (H) bombs, ICBMs, and finally an 'international race for shelter'. Deer foresaw the construction of self-sufficient underground 'city-states' which would house most of the population. His account did not demonstrate planning so much as a confirmation that humanity was performing to a script:

> The play has begun, and we are the actors. The end is implicit from the nature of the beginning. Within the framework of fusion bombs, guided missiles, and shelters, there is nothing we can do but go ahead and play out our part in the preordained ritual. (Deer 1957: 67)

The following year James Blish's novel *A Case of Conscience* incorporated Deer's propositions. Here an arms race has indeed led to a shelter race and massive underground complexes. However, Blish makes explicit what is only a suggestion in Deer: that these complexes resemble tombs not refuges: 'the planet would be a mausoleum for the living from now until the Earth itself perished' (Blish 1963: 97). Secondly Deer's fatalism is explicitly protested, but by a figure from another planet who renounces the 'Shelter state' declaring his right to be a 'citizen of no country but that bounded by the limits of [his] own mind' (Blish 1963: 168). Blish applies Deer's perception of ritual through a party (performance) where the guests travel around on trains (i.e. according to preordained 'tracks'). And lastly, Blish exploits the traditional topography of the unconscious to demonstrate a collective neurotic unrest simmering 'underneath the apparent conformity'. Blish's novel supplies an unusually direct instance of non-fictional debate feeding into fictional imagery but such connections will recur throughout this period. The one overriding issue was that of nuclear war which raises particular difficulties of realisation as a subject.

(ii) Derrida and the Nuclear Subject

In the summer of 1984 the journal *Diacritics* brought out a special number designed to found a new school of post-structuralist analysis called 'Nuclear Criticism', which was to examine 'all the forms of nuclear discourse'. A start was made on this programme

with discussions of the contradictions within deterrence and the relation between the nuclear and the tradition of the sublime (Fergusson 1984), but the centrepiece of the issue was an essay by Derrida ('No Apocalypse, Not Now (Full Speed Ahead, Seven Missiles, Seven Missives')) in which he bombards the reader with a number of propositions, the most important of which for present purposes are three dealing with the nuclear referent, specialism and literary representation.[3] Derrida argues that nuclear war would be an event without precedent bringing the 'total and remainderless destruction of the archive'; and then he puts forward his central point: 'the terrifying reality of the nuclear conflict can only be the signified referent, never the real referent (present or past) of a discourse or a text' (Derrida 1984: 23). Nuclear war thus takes on a 'fabulous textuality' since it only exists 'through what is said of it' and, since they cannot be known in advance, the views of 'experts' become merely opinion. Derrida carefully retains the real as the starting point for his formulation, but runs the risk of substituting one kind of specialism for another. Ken Ruthven has accordingly insisted that it is crucial to 'preserve the nuclear referent and to resist efforts to textualise it out of existence' (Ruthven 1993: 174). More elaborately J. Fisher Solomon has argued for including the process of becoming within referentiality, proposing an 'objective reality of empirical potentiality' (Solomon 1990: 63) to counter Derrida's stark opposition between science and belief.

If Derrida is redefining rather than denying the nuclear referent, one effect of his argument is to raise the status of literature.[4] For if nuclear war can only be approached speculatively, then literature – and particularly science fiction – can occupy a space equal to sociological, strategic and other modes of speculation. Paradoxically, even as he is opening up a literary subject, Derrida turns his back on nuclear fiction in a gesture of conservatism by citing Modernists like Mallarmé, Kafka and Joyce as being more relevant to the nuclear age. He thereby ignores the massive corpus of fiction listed in Paul Brians's pioneering and indispensable *Nuclear Holocausts* (1987), for if nuclear war is as important as Derrida recognises, then this fiction should be attended to and the literary canon re-examined (cf. Zins 1990). In fact this very fiction confirms Derrida's thesis on the unusually elusive nature of the nuclear subject by showing again and again a collective suppression of the dreaded event which is often signalled pronominally quite simply as 'it'. The recurrence of secret underground locations suggests a representation through images of the suppressed. James Agee's 1946 sketch 'Dedication Day' (Agee 1972), for example, describes a

surface celebration of technological triumph while beneath the surface workers, including survivors from Hiroshima and Nagasaki, labour over the 'Eternal Fuse'. This topographical separation has been read as spatialising the same ambivalence of American attitudes to the Bomb (Boyer 1994: 244) which informs Nick Boddie Williams's *The Day They H-Bombed Los Angeles* (1961). Here the 'they' of the title proves to be the USA itself and the true enemy other Americans who are being transformed into predatory animals. The agent of this change is a giant, expansive protein molecule created by the Pacific H-bomb tests and washed on to American shores as plasma. The narrative therefore has a circularity in so far as H-bombs are being used to eradicate the mutants caused by the bomb in the first place and not, as one character assumes, by 'them damned dirty Commies'. The bomb's value as a weapon is counter-balanced by the threat of its effects getting out of control.

Granted that nuclear war poses a special problem of expression, Derrida's insistence on foregrounding the 'strategic manoeuvers' of discourse to 'assimilate that assimilable wholly other' (Derrida 1984: 28) rightly directs us to pay attention to the narrative and stylistic procedures followed in attempts at describing such an event. Peter Schwenger's *Letter Bomb* (1992) follows this lead in skilfully demonstrating the twists, turns, and deferrals of nuclear texts which, for example, follow a circular time-sequence: 'Predicting a future, we ... find ourselves turned back to the past, which is our present, and our present task to interpret' (Schwenger 1992: 10). Derrida's warning of the elusiveness of the nuclear subject can already be seen in H. G. Wells's *The World Set Free* (1914), a precursor narrative which both alarmed physicist Leo Szilard with its depiction of nuclear war and also suggested to him the possibility of a chain reaction he was to apply in the planning of the first atomic bomb (Lanouette 1992: 107, 134). Wells's account of nuclear attack is problematised at its centre: 'It is a remarkable thing', the narrator reports, 'that no complete contemporary account of the explosion of the atomic bombs survives. There are of course innumerable allusions and partial records, and it is from these that subsequent ages must piece together the image of these devastations' (Wells 1988: 137). The result is a patchwork of specu-lation and rumour because Wells shrewdly notes that survivors' trauma would lead them to suppress memories of their experience.

Wells sets a pattern which will recur throughout the Cold War where representational difficulty regularly makes the nuclear subject metafictional. We can see this process at work in Roger Zelazny's *Damnation Alley* (1969) where a major textual disruption

temporarily suspends the narrative of a journey across post-holocaust America made by an alienated lone biker as he takes medical supplies from California to Boston. The landscape he traverses confronts him with increasingly fabulous monsters (mutations, giant bats), but before he reaches his destination Zelazny suspends the narrative to describe a 'setting without plot or characters', inviting the reader to 'frame' it with a chosen title. Through a single sentence extending for more than two pages Zelazny evokes a nuclear apocalypse written across Nature where the transformation of elements expresses itself through alternative propositions ('perhaps it takes fire from the hot spots where the cobalt bombs fell and, of course, perhaps not also') which ultimately elude coherence: 'it just doesn't seem that any name will fit'.[5] As language slips off a stable referent it seems that the subject escapes.

(iii) Nuclear Ultimacy

Derrida installs his discourse of ultimacy ('absolute', 'irreversible', 'total', etc.) through the premise of the 'uniqueness of an ultimate event' whose very uniqueness collapses the distinction between belief and science. It makes no sense to Derrida for anyone to claim any special expertise on nuclear war because no precedent exists which would underpin such expertise. What about Hiroshima and Nagasaki? one might object. Not so, Derrida replies: 'The explosion of American bombs in 1945 ended a "classical", conventional war; it did not set off a nuclear war' (Derrida 1984: 23). In this amazingly categorical statement Derrida ignores the continuing debate over how to 'narrativise' these two events (to speed Japanese surrender or to warn the Soviets of America's new technology?). These events are used throughout the postwar period to measure the possible destruction of a nuclear war. The latter's grim iconography (clothes patterns imprinted on bodies, eyes turned to jelly, the shadows of atomised victims imprinted on walls, etc.) all derives from 1945, particularly from John Hersey's reportage narrative *Hiroshima* (1946).[6]

The 1984 issue of *Diacritics* devotes considerable space to Jonathan Schell's *The Fate of the Earth* (1982) which attempts to describe a full-scale holocaust and attacks the Reagan administration's nuclear brinkmanship. There are, however, important differences between Schell and Derrida which emerge if we backtrack to a key contribution to the nuclear debate, Herman Kahn's *Thinking about the Unthinkable* (1962), which set out to attack the pessimism of

Nevil Shute's *On the Beach*. His declared target was fear: 'Either they ["many people"] are afraid of where the thinking will lead them or they are afraid of thinking at all' (Kahn 1962: 27). Kahn confronted this situation with a determination to introduce an analytical rigour which would have been congenial to Derrida. In practice this resulted in an abstracted emphasis on technology and international politics, so Kahn's claim of strategic expertise then would be part of the 'science' which Derrida rejects as spurious. In contrast, both Kahn and Schell view nuclear war as a variety of scenarios, not a single instance (Kahn discusses 'war surviving' situations); and Schell further describes nuclear war as a process not a discrete event. Admittedly taking the worstcase scenario, Schell argues from a premise of ecological and social holism that the Earth and human society form a single system whose delicate balance will be unpredictably disrupted by a nuclear war, constructing an argument from scientific reports and speculation which exemplifies before the fact Derrida's blurring of science and belief. But if nuclear war is the unknown limit case, then the proposition itself that it is a total unique event becomes a matter of belief, a conviction of probability.

Derrida's insistence on ultimacy forms part of his view of nuclear war as an ending, but here again Cold War narratives problematise the concept and make it into part of their subject. Thus an early film of the making of the atomic bomb was entitled *The Beginning or the End* (1947) while a later pulp movie about radiation producing gigantic grasshoppers was called *The Beginning of the End* (1957). The eschatology of science fiction narratives of the period (contextualised in W. Warren Wagar's *Terminal Visions*, 1982) revolves around the possibility of survival of course, but also around the story of that survival. The narrator of Stuart Cloete's 'The Blast' (1947), for instance, begins his account of nuclear attack after his assumption has passed that he is the sole survivor. The attack 'was what might be called the last real event in history. I seem to be in the interesting position of having survived history, of being history itself' (Conklin 1954: 12). The temporary impression of being history collapses together his self-perceptions as subject and object. Only the discovery of other survivors gives him an impetus to narrate and in the process changes his subject. When he is taken up by a band of American Indians he reflects that he has completed his 'story of the end of the white man's world'.[7] Cloete's awareness of what sort of narratives might articulate the nuclear aftermath is echoed much later by Bernard Malamud's Robinsonnade *God's Grace* (1982). This time the sole survivor is one Calvin Cohn, his

name combining ironic suggestions of predestination and priestly election, who attempts to reenact stories from Western culture on an island where his sole companions are apes. The latter perform – literally 'ape' – the role of humans in recapitulating the story of Abraham and Isaac, even simulating human speech. The apes' final loss of speech seems to indicate the end of civilisation (Schwenger 1992: 80), but here again the ending is not final. Though the novel closes with Cohn's impending death, a chronological beyond has been opened up, albeit tentatively, by the line 'maybe tomorrow the world to come?' and in the non-specific other presence implicit within the third-person narrator.

It seems then that nuclear narratives refuse ultimate endings. As the novelist Algis Budrys states, 'even its [science fiction's] most dedicatedly ingenious tales of apparently unremitting cataclysm must, by the nature of the prose, include a narrative presence of some sort – an actual character, or at least the author's voice' (Budrys 1986: 45). Richard Klein does not express this issue as a question of voice but rather locates a 'ghostly survival' in the 'position from which one anticipatorily contemplates the end, utter nuclear devastation, from a standpoint beyond the end, from a posthumous, apocalyptic perspective of future mourning' (Klein 1990: 77). Such narratives might play with contradiction like the 1955 film *The Day the World Ended* which opens with the 'Total Destruction' day of nuclear war, proceeds to reduce the term 'total', and concludes with a shot entitled 'The Beginning' as a man and woman straighten their rucksacks and march into the post-holocaust future.

(iv) Science Fiction as Social Criticism

The unique urgencies of the Cold War, and particularly fear of nuclear war, affected writers' perceptions of the changed status of science fiction. Asimov dated the shift precisely: 'The dropping of the atomic bomb in 1945 made science fiction respectable'. Similarly James Gunn: 'from that moment on thoughtful men and women recognised that we were living in a science fiction world'. Indeed by the mid-1960s news reports of rockets and nuclear weapons had become so routine that for James Blish they challenged the novelist's imagination.[8] Certainly science fiction was so quick to engage with nuclear war that by 1952 H. L. Gold, the editor of *Galaxy*, was complaining about how many stories 'still nag away at atomic, hydrogen and bacteriological war, the post-atomic world, reversion to barbarism, mutant children ... world dictatorships, problems of

survival wearily turned over to women, war, more war, and still more war' (Gold 1952: 2). Despite the stifling effects of the McCarthy years many novelists took justifiable pride in the way 'science fiction became the vehicle for social criticism' (Davenport 1964: 102). So declared Robert Bloch in a lecture series on this very topic delivered at the University of Chicago in 1957.[9] This study will contend throughout that science fiction novelists made constant interventions in the debates that were raging throughout the Cold War on such matters as civil defence, foreign policy and internal security. Above all these issues loomed the threat of nuclear war which gave an added urgency to this fictional representation. Here, paradoxically, the latter's power is deployed towards a realisation which will 'put off the day' (Dowling 1987: 86). These narratives perform a role of negative prophecy where dreaded outcomes are envisaged and therefore hopefully deferred, in such a way that the reader is induced to ponder on present signs of disaster.

How to decipher such signs can be a complex problem. Murray Leinster's *Operation Terror* (1962) appears to be using the time-honoured narrative of alien invasion when reports start leaking out of a 'paralysis beam' from a landed UFO, operated either by monsters or by men.[10] If men, it must be a 'cold war device'; and if it is not the Americans, there is only one other conceivable country responsible. But there is a third possibility, only discovered at the end: the United States knew the Soviets were finalising such a weapon and manufactured the UFO story so that the Americans would be seen as protectors. 'This was an attempt to fight the last war on earth in disguise' (Leinster 1968: 147). The 'theatre of war' revolves around not combat but the circulation of information. The wartime restrictions on any material relating to the Bomb which had led to the arrest of the writer Clive Cartmell in 1944 (see Berger 1984) had if anything become even tighter as the postwar security state took shape. Kris Neville's 'Cold War' (1949) defines the *status quo* through an absolute imperative of secrecy. When a journalist stumbles across a story about the neuroses of Space Station commanders he is gunned down by the secret service because the issue was 'too big to protect by normal, democratic procedures' (Campbell 1952: 411). In a lighter vein William Tenn parodies institutional secrecy in 'Project Hush' when an army team land on the Moon and discover a dome built – not by aliens – but by the 'goddam United States Navy' (Tenn 1956: 219). Secrecy often legitimates the reification of characters so that they become indistinguishable from the information they carry. So C. M. Kornbluth's teenage physics genius in 'Gomez' (1954) is classified as a 'weapon'

by Atomic Energy Commission Intelligence.[11] The restrictions on information explain the intended appeal of the stories in William Sambrot's *Island of Fear* (1963) which purport to be secret reports from different government agencies, giving the reader an illusion of insider knowledge on the space race and nuclear research laboratories.

Postwar science fiction demonstrates again and again the ways in which secrecy becomes institutionalised in mechanisms of control. Two of the most powerful treatments of this issue, Wilson Tucker's *Wild Talent* (1954) and Algis Budrys's *Who?* (1958) dramatise the failure of the state to contain its subject. In the first, a telepath Paul Breen is brought in by the American secret service to detect espionage routes. Finally shot because uncontrollable, Breen's treatment by the authorities is a 'mixture of exploitation and anxiety [which] mirrors reactions to the A-bomb itself' (Shippey 1979: 106). *Who?* pursues the logic of security processes to their ultimate impasse. Lucas Martino, an American scientist working on a top-secret project, is taken to an East German clinic after a near-fatal accident at his plant near the border. The novel opens with Western agents awaiting his return. To their amazement Martino has been rebuilt so extensively that he resembles a robot with an all-metal head. From then onwards his identity becomes an open enigma. Every hypothesis can be reversed: a recurring nightmare might show memories of what 'they' did to him, or anticipate his fear of the Americans. In other words, Martino might be a 'plant'. The tropes of physical investigation ('dig deeper', 'pull this thing apart', etc.) lead nowhere. As in Curt Siodmak's science fiction thrillers, like *Hauser's Memory* (1968) where the RNA of a defecting scientist is used to access his memory, the human subject and information become identified, while the latter remains elusive. In Budrys's novel we are told: 'The war was in all the world's filing cabinets. The weapon was information' (Budrys 1964: 6).

The narratives just considered do not fit the label of science fiction as 'futuristic' in any straightforward way and most of the works discussed in this study will turn out to be set in comparatively near futures with some internal examination of what changes brought about the new state of affairs. These futures, in Fredric Jameson's words, 'serve the ... function of transforming our own present into the determinate past of something yet to come' (Jameson 1982: 152). Whether the narratives estrange the reader from the present by the introduction of 'novums' or whether they use a chronologically more distant method of 'future retrospect', the focus here will fall primarily on how American science fiction

deals with the overlapping issues of nuclear war, the rise of totalitarianism and fears of invasion.[12] The result will demonstrate the fine responsiveness of fiction and film to a whole range of social, technological and political changes taking place during the Cold War.

(v) Cold War Criticism

Although the special number of *Diacritics* hardly triggered a new critical school it did help to develop 'nuclear criticism', in the lower case, to adopt a distinction by Ken Ruthven whose own *Nuclear Criticism* (1993) remains an excellent introduction to the subject. The earliest monograph in this area was David Dowling's *Fictions of Nuclear Disaster* (1987) which gives priority to the apocalyptic paradigm and opens a discussion of how writers 'attempt to locate the experience of nuclear disaster by surrounding the inexpressible with verbal strategies' (Dowling 1987: 13–14). Special issues on nuclear war were produced by the *Northwest Review* (1984) and *Science-Fiction Studies* (July 1986), the latter edited by H. Bruce Franklin whose *War Stars* (1988) remains an invaluable history of the superweapon in the American imagination. Martha A. Bartter's *The Way to Ground Zero* (also 1988) provides a useful thematic survey of treatments of the atomic bomb in American fiction. 1988 finally saw the foundation of the journal *Nuclear Texts and Contexts* which continues to provide a crucial forum for critical debate. Thomas Hill Schaub's *American Fiction in the Cold War* (1991) proposes a paradigm shift from thirties radicalism to a postwar 'liberal narrative' of disillusionment where writers shy away from partisan politics. Schaub limits his discussion to realist fiction, but his study reflects a general critical revision of writers like Flannery O'Connor and Sylvia Plath. Even literary criticism itself has been historicised by Tobin Siebers who accuses critical schools of shadowing the policies of different US administrations and who argues that the Cold War has 'introduced a model of the self-conscious critic whose greatest desire is to deny his or her own agency in the world' (Siebers 1993: 34).

In addition to booklength studies two further collections have been published on nuclear literature. The Winter 1990 special number of *Papers on Language and Literature* focuses more tightly on literature than the comparable issue of *Diacritics* but adopts a critical pluralism since, in the words of the editor William J. Scheick, nuclear criticism is a 'polymorphous ethical mode of

critical enquiry' based on the imperative to preserve life. Scheick and other critics figure also in Nancy Anisfield's 1991 collection on nuclear war literature, *The Nightmare Considered*. Arne Axelsson's *Restrained Response* (1990) surveys post-1945 American war fiction but uses a constraining realist model, whereas Patrick Mannix (*The Rhetoric of Antinuclear Fiction*, 1992) applies the Aristotelian modes of rhetorical appeal – ethical, rational, and emotional – to produce an account valuable for identifying spokespersons and the nature of debate in the fiction. Of the two more recent studies, Albert E. Stone's *Literary Aftershocks* (1994) discusses clusters of works including children's fiction and poetry to demonstrate 'literature's power as social instrument of information and indoctrination' (Stone 1994: xvi), whereas continuing the line of post-structural analysis Alan Nadel's *Containment Culture* (1995) cross-relates an impressive range of cultural texts from *Playboy* to diplomatic dispatches. Subjecting these works to sophisticated scrutiny, Nadel focuses his study on the trope of containment which is shown to conceal a duality of perspectives towards the bomb and related issues.

To conclude this brief survey, two works deserve special mention for the breadth of their scholarship which makes them essential reading for Cold War culture. Paul Boyer's *By the Bomb's Early Light* (1985, 1994) gives an astonishingly thorough 'thick description' of American responses to the Bomb within the first postwar decade and has been consulted at every stage of this study. And Spencer R. Weart's *Nuclear Fear* (1988) documents the whole postwar period, examining its topic through 'images', a notion broad enough for Weart to negotiate between motif and discourse. Like Paul Brians, Weart demonstrates that fear of doomsday, superweapons, etc. predates 1945 and that the Cold War was reinforcing already existing imagery.

This study will attempt a balance between close textual analysis and the historicism proposed by Hayden White and others. It will examine primarily US science fiction from 1945 up to the 1980s in a series of chapters which focus on individual authors or themes and which follows an approximate chronology up to the period of the Star Wars controversy. Each chapter will raise issues – the role of the home, operative metaphors, and so on – which are not unique to that material but which could be applied to the fiction discussed in other chapters. Space limitations have inevitably restricted coverage of topics like Vietnam, as well as the number of films covered.[13]

Notes

1. Anderson 1972: 89; Spinrad 1974: 252. In *Thermonuclear War* Anderson described the aim of Communism similarly: 'man is to be turned into a kind of ant' (Anderson 1963a: 111). Cf. Biskind 1983: 123, 132.

2. Cf. the author's note: 'It was written at the time we were debating the setting up of a fixed line far out from our shores (the Taft plan, the Hoover idea)' (Williams 1956: I).

3. For a point-by-point discussion of Derrida see Ruthven 1993: 71–8.

4. Christopher Norris glosses Derrida as follows: he recognises 'that nuclear "reality" is entirely made up of those speech-acts, inventions and projected scenarios which constitute our present knowledge of the future (unthinkable) event' (Norris 1995: 241–2); and continues that literature preserves its value by being performative (ibid.: 246). Jean Baudrillard's related diagnosis of the 'hyperreality' of nuclear culture is discussed in Messmer 1988b: 399–402.

5. Zelazny 1973: 145. For critical commentary on Zelazny see Morrissey 1986: 182–91.

6. For discussion of Hersey see Nadel 1995: 53–67 and Ruthven 1993: 35–40.

7. Conklin 1954: 64. Cloete anchors his narrative to the 1946 Bikini tests: 'it was, if one had been clever enough to see it, the beginning of the end' (ibid.: 26).

8. Asimov 1970: 93; Gunn 1975: 174; Blish 1965: 184.

9. The other speakers were Alfred Bester, Robert Heinlein and C. M. Kornbluth.

10. Leinster published one of the earliest accounts of a nuclear attack on America (*The Murder of the USA*, 1946), the reprisal for which establishes a Pax Americana. Leinster's 1945 story 'First Contact' about an encounter with an alien spacecraft achieved the rare privilege of being critiqued in Soviet science fiction. Ivan Yefremov described it as exemplifying a 'war ideology' in 'The Heart of the Serpent' (1961).

11. It was exactly this use of youth which John Hersey's *The Child Buyer* (1960) protested. The panicky search for potential scientists in the wake of the 1957 Sputnik launch 'as if children were to be somehow instruments of our power' led Hersey to construct a narrative as a hearing into this conspiracy against the nation's youth (Hersey interview. Columbia, MO: American Audio Prose Library).

12. The 'novum' is a term denoting a deviation from the reader's implied notion of reality applied in Suvin 1979.

13. For discussion of Vietnam see Franklin 1998; 165–86; for film criticism see Biskind 1983, Sayre 1982 and Shaheen 1978.

I

Postwar Jeremiads: Philip Wylie and Leo Szilard

The blame for Armageddon lies on man (Philip Wylie 1942)

(I)

All the narratives examined in this volume are warnings, envisaging a future whose imaginative representations, it is hoped, will prevent it from materialising. This chapter will examine primarily the works of the best-selling author Philip Wylie (1902–71) viewed as an example of the jeremiad genre which by the modern period had become inverted into an 'anti-jeremiad', which deploys a 'doomsday vision' through the 'denunciation of all ideals, sacred and secular, on the grounds that America is a lie' (Bercovitch 1978: 194, 191). Such a description fits Wylie's *oeuvre*. The son of a Presbyterian minister, Wylie rejected orthodox Christianity in favour of the role of spokesman for cherished national ideals which he felt were lapsing. He described his wartime indictment of the national character, *Generation of Vipers* (1942), as a 'miscellaneous Jeremiad', attacking American materialism, hypocrisy and – most importantly as a prediction of postwar developments – the creation of a dictatorship in the USA (Wylie 1942: 305). Wylie first achieved fame through two collaborations with Edwin Balmer, *When Worlds Collide* (1933) and *After Worlds Collide* (1934). The first of these describes the discovery of two planets hurtling towards Earth, the one set on a collision course, the other offering a chance of salvation in appearing habitable. The novel combines the story of Noah with apocalypse so that the old world is destroyed and a saving remnant is conveyed by spaceship (the 'Ark') to the new planet in a combination of spiritual will, national destiny and technological know-how. The sequel, however, brings this triumph into question when the pioneers discover that another rocket from Earth has landed with a band of Russians, Germans and Japanese determined

to set up a Soviet. The new planet now becomes the site for an ideological and territorial struggle between freedom and despotism, a clear anticipation of Cold War rivalries. As one character explains, 'they were sworn ... to set up their own government – to wipe out all who might oppose them. It is not even a government like that of Russia. It is ruthless, inhuman – a travesty of socialism, a sort of scientific fanaticism' (Wylie and Balmer 1970: 92).

From the end of the war up to the mid-fifties Wylie was involved with government nuclear policy in a whole range of areas. After serving with the Office of War Information he was invited to report on the Hiroshima bombing, a report which in the event was carried out by the journalist William L. Laurence. He served as special adviser to the Chairman of the Joint Committee for Atomic Energy and was given a Q (i.e. maximum) security clearance so that, again at government request, he could attend the Desert Rock A-bomb tests and brief publishers on the implications of the atomic age.[1] And finally he served as consultant to the Federal Civil Defence Authority whose perceived inertia led him to write the novel *Tomorrow!*. All of these roles were related to each other by the looming shadow of the Bomb, which Wylie was convinced had induced a national neurosis of suppressed fear. He revelled in the charge that he was an alarmist, claiming: 'I have done my best to create alarm about the Atom Bomb – a *certain kind* of alarm'.[2] Wylie fought consistently against a superficial optimism over the nuclear age and polemicised on behalf of supplying the public with information, however unwelcome. One of his more extreme proposals was to mount a series of public displays to acquaint the public with nuclear casualties from burns to decapitation. There is no evidence that this suggestion was acted on.

The Cold War then for Wylie was defined through one prevailing emotion. 'We live in a midnight imposed by fear – a time like all dark ages', he declared in his memoir *Opus 21* (Wylie 1949: 256). And four years later he stressed the unique capacity of science fiction to engage with that fear. In 'Science Fiction and Sanity in an Age of Crisis' Wylie railed against pulp science fiction for producing 'wild adventure, wanton genocide on alien planets, gigantic destruction and a piddling phantasmagoria of wanton nonsense' (Bretnor 1953: 234). It was only a few writers like Wells, Olaf Stapledon and Aldous Huxley who address the reader's mind. Science fiction should incorporate 'logical extrapolations from existing laws and scientific hypotheses' into tales 'with the hope of a subjective integration to match the integrated knowledge we have of the outer world' (Bretnor 1953: 239).

Throughout his postwar career Wylie attempted to realise this role by attacking two targets: national self-delusion and Communism. His unwavering hostility to Communism had an unusually personal basis. With his stepbrother he visited the Soviet Union in 1936, travelling as far as the Caucasus where they both rashly expressed their determination to report on the repression, poverty and suffering they had witnessed. During their return via Poland their railway carriage was left for hours in a siding. Wylie drank from a bottle of water and promptly fell seriously ill, possibly from cholera or plague. In the meantime Wylie's stepbrother was thrown to his death from a Warsaw hotel room, probably by Soviet agents. This information was made public by Wylie in *The Innocent Ambassadors* (1957), a narrative of a journey round the world framed as a report on the Soviet plan to dismember the world. 'What the cold war concerns', he declares, 'is *human belief*: primarily *your* belief!' (Wylie 1957: XIV). Wylie's conclusion to *The Innocent Ambassadors* resembles the 'application' which might close a sermon. Like Robert Heinlein (who read *The Innocent Ambassadors* before his own visit to the Soviet Union), Wylie calls on his readers to respond to a common danger by embarking on a mission to preserve freedom. Ironically, he takes John Foster Dulles to task for irrelevantly attacking Soviet atheism, although both writers applied a discourse of moral absolutes to contemporary politics. Wylie's jeremiads regularly promote a sense of crisis and envisage disasters as a means of testing American values and morale. Whatever narrative means he adopts, there is usually a single voice which expands, sometimes stridently, the author's convictions. Narrative and polemic often pull against each other, as they do in the works of the writer Wylie most admired at this time: Aldous Huxley.

In his 1946 tract *Science, Liberty and Peace* Huxley inveighs against nationalism as the root of all evil:

> To be a worshipper of one of the fifty-odd national Molochs is, necessarily and automatically, to be a crusader against the worshippers of all the other national Molochs. Nationalism leads to moral ruin because it denies universality, denies the existence of a single God, denies the value of a human being as a human being.

The 'natural reaction' of the nationalist to the atomic bomb is to 'make use of the new powers provided by science for the purpose of establishing world dominion for his particular gang' (Huxley 1947: 34, 37). Huxley embodied this bleak vision in *Ape and Essence* (1948) where the contemporary frame-narrative establishes nationalism as

a system of enforced orthodoxy specifically in Hollywood, condemning as 'un-American' any heterodox screenplays. The latter are burnt in scenes at once echoing the Inquisition and anticipating Ray Bradbury's *Fahrenheit 451*. The scenes also open up a space for Huxley's own novel as a criticism of contemporary culture. The inset script describes a post-holocaust America in the year 2108 contextualised by the narrator who describes modern history as a steady rise in nationalism and the abuse of science until fear has become the 'very basis and foundation of modern life'. The worship of false gods like science and nationalism has resulted in a literal cult of Moloch. Here Huxley anticipates later post-holocaust writers like Leigh Brackett and Edgar Pangborn in evoking a world of organised repression and ignorance where difference is suppressed as deviancy. Huxley refuses the grand narrative of evolution when nuclear war is ironically described by the narrator (clearly an author-surrogate) as the 'consummation of technological progress' (Huxley 1949: 37, 50).

Wylie had long admired Huxley's work and in 1949 he sent Huxley a copy of his *Opus 21* which contained assertions that *Ape and Essence* was no 'wild fantasy', but rather the 'logical extension of current events' (Wylie 1949: 198). His attacks on the over-valuation of science and the hypocrisy of established religion must have been totally congenial to Huxley who thanked Wylie for his gift and shrewdly recognised a problem the two writers had in common: 'You suffer, as I have always done, from the difficulty, the all but impossibility, of combining ideas with narrative'. Just as Huxley urbanely spotted the polemicist in Wylie, so the latter took *Ape and Essence* as evidence of the Cassandra-like role which by 1955 Philip K. Dick had decided was obligatory for the science fiction writer (Sutin 1995: 54): 'Huxley secretly views himself as more of a prophet than a potential savior'.[3] Ironically, this was exactly the role that Wylie was to play in his own novel on humanity's suicidal nuclear madness, *Triumph*.

(II)

Wylie used his fiction to engage with Cold War issues as early as 1946 when he published his story 'Blunder', set in the state of 'armed secrecy' following World War III (waged in 1966) which has left New England and Central Europe a lunar wilderness. Two scientists have discovered 'bismuth fission' and plan to explode a device in an abandoned mine to produce a new and indefinite

source of power. The realisation by other scientists that there is an error in the original calculations cannot be communicated in time to prevent the experiment and the resulting explosion (an 'omega ray') destroys the Earth. Taken literally, the potential moral stated by one of the scientists sounds absurd: 'If this goes wrong ... it's justice! It will teach the whole idiotic world that you cannot monopolise knowledge!' (Derleth 1948: 377). By the end of the story the 'whole idiotic world' has been reduced to red-hot ash and is incapable of learning anything, so that Wylie has to posit imaginary observers on Mars symbolically placed outside this final round of human lunacy. (For a comparable narrative of a ballistic missile triggering a massive underground fire see Anvil 1957.) *The Disappearance* (1951), by contrast, represents a more fantastic parable on the Cold War situation. On a certain day all women disappear, whereupon the Russians, assuming that the Disappearance has been engineered by the American imperialists, then activate plans for atomic attack using coastal mines and bombs smuggled into the country. The resulting war has a kind of diagnostic function within the novel to demonstrate the thesis that '*hatred* is man's principal characteristic; hostility and aggression are the chief manifestations of it in the objective realm' (Wylie 1972: 232).

Where *The Disappearance* attributes social and political ills to gender separation the 1955 novella *The Answer* draws on Christian mythology for its parable of the arms race, which drew appreciative comments from Eleanor Roosevelt and Bernard Baruch. A us nuclear test proves to have killed an angel who falls to Earth with a book bearing the message 'love one another'; then a parallel explosion takes place in Siberia with the same results. The Russian premier has a positively apocalyptic reaction: 'In the angel he saw immediately a possible finish to the dreams of Engels, Marx, the rest. He saw a potential end of communism and even of the human race' (Wylie 1956: 47). Each event then critiques the ideology of the opposing sides, ironically recalling the common Christian origins of American and Russian culture.[4] The parable suggests parallels between the two sides but the apparent evenness of comparison is undermined by the description of the Russian premier as a wily oriental despot with a 'Mongol face and eyes as dark as inexpressive and unfeeling as prunes'; and American officers as the embodiment of righteous strength ('anvil shoulders, marble hair, feldspar complexion', etc.) (Wylie 1956: 45, 10). The revelation of ideologically controlled hatred as a transformation of fear is a diagnosis directed only against the Russians, so *The Answer* proves in that sense to be a skewed fable. On the surface it recommends mutual respect and a

recognition of parallels between East and West; but the subtext uncritically polarises each regime along a series of oppositions between humanity and despotism, reason and repression.

This same imagery of illness and disease was used in Wylie's excursion into the thriller genre to describe Soviet sabotage. The possibility of the USA being attacked by smuggled atomic bombs had been raised in Dexter Masters's *One World Or None* (1946), and Chandler Davis's 1946 story 'The Nightmare' describes the related situation of a secret laboratory in New York for assembling bombs. The FBI agent-protagonist has a 'sudden vision': 'A pillar of multi-coloured smoke rising from the city, erasing the Bronx and Manhattan down to Central Park … A nightmare, a familiar and a very real nightmare, an accepted part of modern life, something you couldn't get away from' (Conklin 1948: 11). Exposure pre-empts the conspiracy whose national origin is never revealed. Wylie took up the same issue in his 1951 serial *The Smuggled Atom Bomb* which makes extensive use of the frisson of danger within the commonplace. A Florida physics graduate discovers an unusually heavy box in his lodger's room, which proves to contain uranium. Eventually it is revealed to be part of a Soviet conspiracy to destroy New York, which is forestalled by collaboration between the boy and the FBI. One agent describes espionage as a literal process of corruption where the conspirators 'reach the insides of patient, peaceful, law-abiding guys … rot out their hearts! And yet leave their outside just like always' (Wylie 1965: 92). The sapping of the body politic by the enemy within fails this time, unlike a story ('The Sacrifice') Wylie was planning in 1954 on the same theme where New York is destroyed but the Soviets 'forever disgraced'.[5] Wylie makes no bones about the identity of the only other nation with an atomic capability and so has no need to spell out who the saboteurs are. He continued to take Soviet sabotage so seriously that in 1961 he corresponded with Kennedy on the likelihood of American harbours being mined. Wylie's presumption was of a Communist expansionism which informs his two most famous novels of East–West combat, *Tomorrow!* (1954) and *Triumph* (1963), both of which describe pre-emptive strikes by the Soviets.

(III)

Tomorrow! was originally planned as a screenplay for a film (*The Bomb*) about a nuclear attack on American cities. His plan was enthusiastically received by General Vandenberg (Air Force Chief of

Staff), and supported by the Secretary for Defence and the chairman of the AEC (Atomic Energy Commission), Wylie explained his purpose as follows:

> The a-bomb is the great modern fear and will remain so for many years ... But it is more than a 'fear'; it is a fascination, a reality, a thing about which nearly all men and women and children constantly seek to learn more, even when what they learn constantly increases unconscious dread.[6]

Wylie's diagnosis of ambivalence brings more under control a contradiction which Alan Nadel has found in early conceptions of the nuclear age: that it represented 'both hope and horror' (Nadel 1995: 19). Certainly Wylie himself had experienced this uncertainty. In his article 'Deliverance or Doom' he tried to articulate a hope that nuclear power might aid the 'replanning of our world', but at the same time recognised that the 'military value of atomic fission' was 'enormous' and would not stay an American monopoly for long (Wylie 1945: 18).

In the event the film was jettisoned in favour of a novel which schematically separates out two attitudes to civil defence embodied in the twin midwestern cities of Green Prairie (preparedness) and River City (denial), loosely modelled on St. Paul and Minneapolis. Wylie explained that in the novel he had 'predicted that [the] USA, under atomic blitz, might panic and stampede simply because our people will not learn the lessons and the facts that their government, through FCDA [the Federal Civil Defence Authority] has tried for years to reach them'.[7] Reviewers took Wylie to task for the flatness of his characterisation but one of the main points of the novel is that these figures and the viewpoints they articulate should be familiar to the point of cliché. Characters are distinguished from each other primarily according to their capacity to accept and deal with the nuclear threat; indeed, Wylie reportedly wanted his novel to be the 'Uncle Tom's Cabin of the atomic age' (Frazier 1954: 128). Standing above all of them is a local newspaper editor whose extended editorial goes some way to justifying one reviewer's complaint that his was a 'tract in the form of a novel' (Hine 1954: 15). There is an absolute congruence between the editor's and the narrator's diagnoses of a collective denial of dread: 'It was a time when Americans once again refused to face certain realities that glared at them with ever-increasing balefulness' (Wylie 1954b: 49). The trouble with official surveys, he asserted in a 1954 article in the Bulletin of the Atomic Scientists was that statistics paid no attention

to the unconscious. In contrast Wylie's own conclusion was 'that the American people undoubtedly *would* panic under such bombing *in their present state of mind*,' (Wylie's emphasis, 1954a: 37–8).

Wylie's novel, therefore, aimed to confront this fear by debating, then describing, nuclear attack. Section headings supply an apocalyptic 'bomb-time' counting down to disaster: 'x-day minus 90' and so on. The attack comes on Christmas Day and *Tomorrow!* is one of the very few nuclear novels to describe an explosion. Wylie's desire to convey scale leads to a series of comparisons which show what the blast is not like:

> On the sidewalks, for a part of a second, on sidewalks boiling like forgotten tea, were dark stains that had been people, tens of thousands of people. The Light went over the whole great area, like a thing switched on, and people miles away, hundreds of people looking at it, lost their sight. The air, of a sudden, for a long way became hotter than boiling water, hotter than melted lead, hotter than steel coming white from electric furnaces ... (Wylie 1954b: 269)

The drama of Wylie's description risks blinding us to its problematical nature, for such an explosion cannot be witnessed like any other event. The focaliser at this point is the editor whose role of witness lasts only a nano-second before he is killed. Isaac Asimov addresses the same problem in his 1956 story 'Hell-Fire' (collected in *Earth is Room Enough*) where a super-slow-motion film of a nuclear explosion converts it into a spectacle with an unexpected revelation of a laughing demonic face in the fireball.[8] And, when describing a nuclear attack on New York, Jonathan Schell has to simultaneously hypothesise and deny the possibility of an observer two miles from ground zero in order to describe the sequence of flash, blast and fireball (Schell 1982: 48). Wylie implicitly (the imprint of human figures on the sidewalks) and Schell explicitly draws comparisons with Hiroshima, in the latter case to convey the monstrous scale of the imagined destruction. In fact Wylie admitted to a correspondent in 1952 that sense-perception was not the issue: 'at any reasonably safe distance, the bomb isn't what you *see* but what you *know*'.[9]

The contradictions within Wylie's description extend into the novel as a whole. In one of his articles on nuclear survival Wylie exhorts Americans to remember the spirit of Londoners when the V-2 rockets were following (Wylie 1951b: 42), but the analogy collapses before the scale of atomic bombs. And in *Tomorrow!* the obsolescence of Wylie's civil defence propagandising is demonstrated

firstly by the fact that H-bombs are already being used against America and secondly by the novel's denouement. When the Soviets demand surrender after bombarding the USA with nuclear and biological weapons, America responds by detonating a 'dirty' H-bomb (coated with cobalt) in the Baltic which wipes out whole countries this time, not only cities: 'In the ensuing dark, a Thing swelled above the western edge of Russia, alight, alive, of a size to bulge beyond the last particle of earth's air' (Wylie 1954b: 353). By this point Wylie has totally shifted the novel away from considerations of civil defence and survival on to apocalyptic ultimacy in America's confrontation with the enemy. The fact that Finland and the Baltic states are wiped out goes unnoticed before Wylie's preoccupation with the 'last war' which for the editor of the *Bulletin of the Atomic Scientists* seemed to pander to 'American smugness about being ultimately the inevitable victor'.[10]

In 1954 Wylie was approached by Martin Caidin, then a technical specialist with the New York State Civil Defence Commission, who was working on his first novel *The Long Night*. Like Wylie, Caidin had a specific civil defence thesis to substantiate, namely after nuclear attack to 'get the people back into their city' (Caidin 1956: 232). He explained that he 'concentrated upon the city as an entity' rather than on specific characters.[11] *The Long Night* (1956, originally entitled *This City Lived*) concentrates entirely on the collective experience of a city like New York during and immediately after nuclear attack. This episodic account combines individuals' experience of confusion with a scientifically precise description of the bomb blast and a demonstration of how an efficient civil defence system can swing into action. Caidin embraces apocalypse, however, in his novel's set piece: the firestorm which rages within hours of the explosion. Repeating the refrain 'there was no escape', he evokes a spectacle suggestive of hell and volcanic eruption:

> Shrieking insanely, they [the citizens] raced down streets over which the tar and asphalt ran in lava-like rivulets. Most of them covered no more than one or two hundred feet, before their shoes and feet burst into flames. Grasping their burning legs in maddened pain, they toppled and writhed in agony in the bubbling, flaming tar. (Caidin 1956: 124)

Caidin does not linger over his victims but gradually withdraws the narrative vantage point to the edge of the city so that he can conclude with a triumphant reestablishment of the municipal services. The long night has its dawn.

(IV)

The incipient anachronism of *Tomorrow!* was recognised by Wylie who saw the H-bomb as a weapon against which there was no defence and as a result withdrew from civil defence work. By 1960 he was attacking a persistent belief, 'as absolute as a religious faith', that, a nuclear war was winnable (Wylie 1960: 22). This same naive triumphalism is the target of Wylie's 1963 novel *Triumph* where one character ridicules those 'prophetic books and movies about total war in the atomic age' where 'Americans took dreadful punishment and then rose from the ground ... and defeated the Soviets and set the world free' (Wylie 1963: 96). *Triumph* then levels a polemic against the naive optimism of earlier nuclear fiction as well as reflecting Wylie's scepticism about civil defence which persisted right through to 1968 when he attacked Robert McNamara's 'thin shield' of nuclear weapons as ineffectual and expensive.

In *Triumph* Wylie radically alters his sense of an ending to undermine the very possibility of survival and in the process to repudiate his own earlier novel. The novel opens with what promises to be a weekend party at the home of millionaire Vance Farr. Beneath his house Farr has fitted out a nuclear shelter so elaborate as to be an absurd denial of any national civil defence system. After a nuclear strike, like Heinlein's *Farnham's Freehold* and Dan Ljoka's *Shelter,* chapters alternate between descriptions of the behaviour of Farr's group and non-narrative predictions of the external destruction:

> In a roughly circular area, miles across, underneath this thing, all buildings will have been vaporised. Farther out, for more miles the thrusting ram of steel-hard air will topple the mightiest structures and sweep all lesser edifices to earth, as if their brick and stone, girders and beams were tissue paper. (Wylie 1963: 40)

While the casualties mount ('millions', 'myriads', 'multitudes'), Farr and his guests are still down in their shelter experiencing such blasts through the mediation of recording equipment. The latter offers Wylie the means to link inside to outside. A surviving TV station in Central America transmits film of explosions taken for posterity ('the surviving world needs to know') by an aircrew which subsequently dies of radiation. As the survivors in the shelter gather before the screen, holocaust becomes media spectacle, the camera panning across lunar landscapes swept by radioactive clouds.

Both *Tomorrow!* and *Triumph* describe scenarios of nuclear attack where the USA reacts to first strikes from the Soviet Union, in the latter novel preceded by an invasion of Yugoslavia by 'volunteer' troops. The US defence system is attacked constantly by the narrator and later by Farr, speaking as Wylie's surrogate, for missing obvious inferences, failing to design a coherent plan, and above all for missing the ideological premise of Soviet Communism which was that their leaders 'had always been willing to pay *any* price whatever to conquer the world' (Wylie 1963: 46). Unlike the Americans, the Russians have a 'fiendishly planned' long-term strategy whereby state-selected members from all walks of life will be housed in massive underground bunkers. The few surviving US submarines bomb the underground bases but are themselves destroyed in the process. Wylie then points a sardonic epitaph: 'the doctrines of Marx, Engels, Lenin, Krushchev, Merov, and Grodsky were finally undone … at the cost of half a world and of the vast majority of people who once called themselves free and civilised' (Wylie 1963: 240).

The irony here is ambiguous since it could be directed solely against Communism but the novel equally attacks the US government's use of war games and routine 'doomsday' scenarios in its defence planning. East and West are both (unequally) indicted for their militarism and materialism. At the end of the novel, despite some similarities with Nevil Shute's *On the Beach* where no-one survives, Farr and his companions are rescued by helicopters from an Australian carrier and taken away from an America which will have 'no name'. Clearly there is no suggestion here of transformation, only of national erasure. Within Wylie's secular apocalypse the mushroom cloud here functions as a sign of destruction. The thunder, lightning and devastating fire similarly signify the spiralling of military technology out of human control, and the alignment of nations cannot be read as the godly confronting the ungodly because part of Wylie's purpose is to show his own nation's slippage into worshipping the false god of materialism. However potent the external threat is from Russia, Wylie ultimately writes America's status as a superpower into the novel as a negative quality since the failure of the USA to anticipate war results in worldwide destruction.

(V)

Wylie's hatred of the bomb was shared by the Hungarian-born physicist Leo Szilard who, however, approached the problem from a totally different perspective. Where Wylie feared the super-weapon, particularly in Soviet hands, Szilard saw its existence as a damning comment on humanity as a whole. Though a co-designer of the first atomic bomb after 1945, Szilard turned against its use and became a tireless campaigner for nuclear disarmament. Like Wylie, he opposed the imposition of security restrictions on scientific research and, mostly through the *Bulletin of the Atomic Scientists*, produced a series of stories all revolving around the subject of nuclear war, the most important of which were collected in *The Voice of the Dolphins* (1961). Like Dexter Masters, Judith Merril, and H. G. Wells before him, Szilard took an internationalist approach to world problems, declaring that a 'crusade for an organised world community' was needed (Szilard 1947: 34).

Where Wylie addresses the conscience of his nation as a secular prophet, Szilard adopts the role of scapegoat in 'My Trial as a War Criminal' (1947). After the Third World War (Russia attacks New Jersey with a biological weapon, America surrenders), the narrator and the whole American leadership are put on trial for their bombing of Japan. 'Russia' in this context is an idealised projection of Szilard's hopes in producing rational political planning and in declaring its allegiance to world government. Similarly 'The Diary of Dr. Davis' (1950) uses a Wellsian 'sleeper awakes' frame to describe the experiences of a scientist who has slept from 1948 to 1980 in his imagination, experiencing rational discussion of how to achieve peaceful coexistence. The voices of reason in the diary, however, go unheeded and two more world wars have to be endured before world government is established. The same sequence is followed in Wells's *The World Set Free* which opens its description of the 'last war' with the incredulous words:

Viewed from the standpoint of a sane and ambitious social order, it is difficult to understand and it would be tedious to follow the motives that plunged mankind into the war that fills the histories of the middle decades of the twentieth century. (Wells 1988: 56)

Szilard converts Wells's rational retrospect into his preferred fictional form of an autopsy on humanity itself. 'Report on "Grand Central Terminal"' (1948) uses the science fiction device of the extraterrestrial visit in order to dramatise the possible consequences

of the arms race. Visitors land in New York and other cities to find them deserted but undamaged, possibly expressing a fear expressed earlier by Szilard that America might be covered with radioactive dust (Szilard 1947: 7). One of the investigators Xram (Marx reversed) speculates that humanity destroyed itself in a massive war. The narrator remains sceptical:

> This sounded pretty unlikely indeed, since uranium is not in itself explosive and it takes quite elaborate processing to prepare it in a form in which it can be deteriorated. Since the earth-dwellers who built all these cities must have been rational beings, it is difficult to believe that they should have gone to all this trouble ... just in order to destroy themselves. (Szilard 1992: 144)

The narrator here personifies the rationality that humanity has lost, his puzzlement commenting satirically on mankind's demise. Again and again in Szilard rationality is displaced in time or across species. Dr. Davis's diary is juxtaposed to the course of history without affecting it; the quasi-anthropological visitors arrive too late to save humanity; and in 'The Mined Cities' (1961) Szilard returns to the 'sleeper awakes' device to give a perspective from 1980 where nuclear balance is ensured by devices placed with each superpower.

'The Voice of the Dolphins' (1960) grew out of Szilard's frustration with the East–West stalemate and gloom over the virtual inevitability of nuclear war, which led him to write to Krushchev and Kennedy. It is the fullest of Szilard's future histories and starts as an indictment of the Eisenhower administration's failure to solve the problem of the Bomb. The cause of peace is promoted when the Soviets and Americans establish a Biological Research Institute in Vienna. This develops into a 'think tank' from which the dolphins send proposals for disarmament and from which is bred a symbolic food of detente, an algae called 'amruss'. Szilard insisted that the book was not 'about the intelligence of the dolphin but about the stupidity of man' (Lanouette 1992: 415). The dolphins' utterances become institutionalised as the eponymous television programme named in opposition to the partisan Voice of America. Just at the point where disarmament has been agreed a virus kills off the dolphins, and so yet again the voice of reason is stilled. Szilard's biographer has written that 'most of Szilard's attempts to control the weapon he had helped create were too visionary. Too rational. Too clever. Too impatient' (Lanouette 1992: 357). His stories sardonically turn this impatience against themselves, problematising their own reception. 'Szilard' is thematised in 'The Voice of the Dolphins'

as a marginalised prophet who receives the minimal recognition of having a 'small crater' on the 'back side of the moon' named after him by Soviet scientists.

Notes

1. Wylie explained to J. Edgar Hoover that his purpose was 'to think more effectively about our own defences from onslaught and about ways of attacking Russia' (letter 5 May 1951, Wylie archive, Princeton University).

2. Draft of 'What Frightens Jon?' 5, Princeton. This essay was finally published in *The Redbook* for May 1952

3. Letter from Huxley to Wylie, 9 April 1949; letter from Wylie to Canfield (Huxley's publisher), 25 May 1948. Princeton.

4. The 1952 film *Red Planet Mars* similarly uses purported messages from Mars to trigger a religious revival which topples the Soviet regime and purifies the American administration.

5. Letter to fiction editor of *Collier's*, 18 March 1954; Princeton.

6. 'The Bomb', 801, Princeton. *Tomorrow!* became recommended reading for civil defence programmes and was enthusiastically reviewed by a FCDA administrator (Vol. 1, Peterson).

7. 'The ABC's of the H-Bomb' (1954: 1). Draft essay, Princeton.

8. The use of ultra-slow film established the image of the mushroom cloud: see Rosenthal 1991: 63–92.

9. 'Agenda for a Bull Session' (1952; 5), Wylie folder, Records of Joint Committee on Atomic Energy, National Archives, Washington.

10. Letter to Wylie from Eugene Rabinowitz, 18 January 1954, Princeton.

11. Letter from Martin Caidin, 28 January 1954, Princeton. See particularly Wylie 1948 and 1951a. Wylie also contributed by invitation to the 1951 *Collier's* special issue 'Preview of the War We Do Not Want'.

II

Variations on a
Patriotic Theme:
Robert A. Heinlein

World War III is going on now (Robert A. Heinlein, 1963)

(I)

In *The End of Victory Culture* (1995) Tom Engelhardt identifies a national war narrative where the USA re-enacts its own establishment and growth. 'War was invariably portrayed as a series of reactive incidents rather than organized and invasive campaigns' (Engelhardt 1995: 4) and a series triggered by a sneak attack or ambush. Engelhardt's thesis is that, despite its ostensible victory in 1945, such reconfirmation of national identity gradually collapsed throughout the postwar period as the USA lost an enemy. This grand narrative lies at the heart of Robert Heinlein's postwar work where the nation repeatedly figures as protagonist. Where Philip Wylie attacks the nation's failings and Leo Szilard pleads for a transnational rationalism, Heinlein dramatizes the nation's destiny in action. His insistence on freedom, so strident that he sometimes sounds jingoistic, jostles an opposing possibility (Calvinist or Darwinian) that human actions are somehow determined by larger forces, genetic or other. No sooner had the war finished than Heinlein proclaimed a crisis demanding national vigilance: 'we are in more danger now than ever before in our history'.[1]

Heinlein had already written this perception of crisis into a work first published in the year of Pearl Harbor. *The Day after Tomorrow* (serial 1941; novel entitled *Sixth Column* 1949; 1951 retitled) describes an America invaded and subjugated by the PanAsians, a composite force of Chinese and Japanese. They establish a repressive bureaucratic regime which anticipates later narratives of Soviet invasion. A scientific research establishment in the Rocky Mountains forms the nucleus of a covert resistance movement. Using a device for transforming matter this group of stalwarts

purports to found an expanding religious cult which it uses to screen its subversive activities, discovering in the process that Asiatics are particularly sensitive to radio beams of certain frequencies, in other words they have a biologically determined Achilles heel. As the resistance fighters play on the psychology of their rulers and gradually take over all communications, the morale and then the occupation of the PanAsians collapse and America is liberated. For K. A. MacDermott the placing of the novel's action is all-important:

> By locating these monsters [the PanAsians] within a conquered America rather than across enemy borders, Heinlein anticipates the fundamental strategy of cold war plotting: the enemy is within and threatens not just our sovereignty but our culture itself, right down to our very identities.[2]

The scene is thus set, as usual in Heinlein's political fiction, for a heroic elite to save the nation. Ardmore, the leader of the rebels, comes from a background in commerce, presides over a scientific establishment, and runs it with military rigour, combining three factors which underpin his men's fitness to regain control of the country. The PanAsians represent an early manifestation of the threatening groups which will recur through Heinlein's Cold War fiction, characterised by manifest technological skill and military organisation, numerical supremacy and malign intent.

In order to readjust his narrative to the Cold War, Heinlein reduced references to the 'yellow monkeys' and inserted new passages of exposition which fill out the novel's fictional history. One describes the merging of China and Russia into a massive power bloc while another stresses the national importance of intelligence, even over the most sophisticated weaponry:

> An intelligence service was as important as a new secret weapon – more important ... A ridiculously inadequate military intelligence had been the prime characteristic of the United States as a power all through its history. The most powerful nation the globe had ever seen – but it had stumbled into wars like a blind giant. Take this present mess: the atom bombs of PanAsia weren't any more powerful than our own – but we had been caught flat-footed and had never gotten to use a one. (Heinlein 1951a: 15)

As always, Heinlein demonstrates a sensitive awareness of contemporary political developments. In 1947 the National Security Act

established the CIA. The out-going director of the Central Intelligence Group, General Vandenberg, spoke in support of the bill, citing America's total lack of preparedness for Pearl Harbor, clearly implied here by Heinlein as one of his country's 'stumbles' (Ranelagh 1986: 109). Heinlein's revisions reinvent the enemy's identity and situate the action within a new world order where, however, the structure of oppositions stays largely unchanged and where national survival depends on internal loyalty as much as external threat.[3]

The problem of distinguishing traitors underpins *The Puppet Masters* (1951), described by Heinlein as a 'horror story' influenced by Poe (Heinlein 1989: 196), but transparently a Cold War allegory. Flying saucers have brought an advance guard of sluglike creatures from the planet Titan who fasten themselves on to the backs of their human subjects like overgrown leeches. Like other invasion narratives of the fifties the novel describes them as taking over the individual and communal body: 'they are pinching off the nerve cells of our social organism', one character exclaims (Heinlein 1979c: 25). H. Bruce Franklin identifies their political symbolism, declaring that 'the slugs are not distinct individuals but unfeeling members of a communal mind dedicated to the enslavement of all other societies' (Franklin 1980: 99). Essentially they represent a variation on the Communists-as-bugs trope discussed in the introduction which we will see again in *Starship Troopers*. Heinlein was clear from the beginning that they represented a political force, describing the parasites as 'completely perfect fifth columnists' and, revising the serial into the novel, he inserted lines which made the analogy even more explicit: 'Too big to occupy and too big to ignore, World War III had not settled the Russian problem, and no war ever would. The parasites might feel right at home there.'[4] Philip E. Smith has accused Heinlein of wanting to have it both ways: 'the slugs represent communists for readers in the present, and in his future world Russian Communism has already been defeated but not destroyed by the United States in World War III' (Smith 1978: 149). The reason for this supposed contradiction must lie in Heinlein's fear that Communism was a set of beliefs as well as the official ideology of a power bloc and therefore might never be defeated. The slugs embody the fears of militant Communism and the bomb (they reproduce by fission) and perform a process of social transformation which ironically can only be countered by mirroring the methods of the aggressors. Just as in *The Door into Summer* (1957) the US possesses a drug which is 'Uncle Sam's answer to brainwashing', so the intelligence elite can only combat the slugs

by functioning as one organism. Danger is not removed, only displaced back to its source from which it could re-emerge; *The Puppet Masters* ends with a declaration of intent to take combat to Titan: 'Death and Destruction!'

(II)

Heinlein had already discussed the political dimension to super-weapons before the end of the war in 'Solution Unsatisfactory' (1941) where scientists invent a deadly radioactive dust which is used to subdue Germany. At first the weapon promises the scientist-narrator the means of ushering in a Pax Americana but a scheme to impound the world's aeroplanes goes wrong when the Eurasian Union proves to possess the dust itself. There follows a 'Four-days War' whose victory gives the USA the power 'to turn the entire globe into an empire, our empire' (Heinlein 1975: 123), whereupon a second conflict emerges between the President's championing of democracy and the lust for power of a US officer who ultimately turns himself into the 'undisputed military dictator of the world'. This story anticipates a situation described by John W. Campbell in 1947 where the USA's possession of an 'irresistible military weapon' (Heinlein calls it an 'absolute' weapon) gives a unique but politically unacceptable chance to 'conquer every nation on Earth and establish a single world government' (Campbell 1947: 284).

Heinlein was less sanguine than Campbell about this military superiority thanks partly to reading *Life*'s special feature for 19 November 1945, 'The 36-Hour War'. This article extrapolated on a warning from the chief of the US Air Force that ballistically delivered atomic bombs could open up America to attack: 'with present equipment and enemy air power can, without warning, pass over all formerly visualised barriers and can deliver devastating blows at our population centers and our industrial, economic or govern-mental heart even before surface forces can be deployed' (*Life* 1945: 28). This account described the bombing of thirteen American cities, concluding with a graphic picture of New York reduced to a radioactive ruin. Heinlein's jeremiad 'The Last Days of the United States' (collected in *Expanded Universe*) warns the reader that this narrative is 'much too optimistic' since the destruction would almost certainly be more widespread. In contrast, Heinlein refused to envisage nuclear war as bringing an end to human life: 'Forget *On the Beach*', he declared in 1961, 'the future isn't that bleak' (Heinlein

1992a: 235). And accordingly his concept of the 'death' of the USA is a political event, the demise of freedom, where a saving remnant can continue the good fight. So when 'The Last Days' confronts its startled reader with an epitaph to the United States RIP, this shock tactic is firstly designed to force consideration of the Bomb on an apathetic public (one of Heinlein's main purposes after 1945) and secondly to bring about a realisation that, with the waning of faith in a world state, only two choices remain: a 'permanent state of total war' or resigned waiting 'for death to come out of the sky' (Heinlein 1982: 162).

Usually nuclear war performs the function for Heinlein of bringing about a radical transformation of society. Rejecting the fatalism of total nuclear destruction, he recommended to his readers that they develop a 'survival point of view' (Heinlein 1982: 168) and in 1961 he built a shelter for his family, as he explained to Judith Merril, 'as an act of faith, as an example to others'.[5] Coincidentally the symbolism was increased by Heinlein's proximity to the massive underground Cheyenne Mountain complex for the North American Aerospace Defence Command (NORAD) which Heinlein visited that same year for a briefing on space detection.[6]

Heinlein's championing of the cause of survivalism anticipates the writing of figures like Dean Ing (see chapter 13) and provides the basis for his 1964 novel Farnham's Freehold which centres on a family with a well-equipped shelter or 'panic hole' as they jokingly call it. An unprovoked attack by the Soviet Union sends the family, neighbour and servant into the shelter which is located in the same area of Colorado as the Heinlein home. Hugh Farnham, the patriotic ideologue of the novel, even welcomes the attack because it might perform the eugenic function of killing off the stupid.[7] A Soviet 'cosmic bomb' (a massive H-bomb in satellite orbit) detonates near the Farnham shelter and throws them all forward in time to a 'long-lost Edenic frontier' (Franklin 1980: 154). The family reconstitute the nation through the rituals of raising and lowering the flag, singing 'The Star-Spangled Banner', but they are not alone. The third section of the novel shows a future where, after life in the northern hemisphere has been destroyed, blacks have taken over, establishing a regime reminiscent of America's former enemies in being a 'setup for an absolute totalitarian communism' (Heinlein 1974: 205). After the fourth shift when the Farnhams are returned to their present, we see them re-established in a trading post above which the 'starry flag' continues to fly. It becomes clear that the 'freehold' in the title is nothing less than the country itself whose national contract has been broken by the creation of slavery. The

conclusion to the novel then transposes an image of a lost frontier life on to a post-nuclear landscape mined and cratered where Farnham's family might form the nucleus for national rebirth. The gesture towards permanency in the last line ('they are *still* going on') is offset and questioned by the reader's memory of the forthcoming autocracy.

(III)

The symbolism of *Farnham's Freehold* is only one example from many of Heinlein foregrounding the fate of the nation. From 1945 onwards his fiction takes on a conservative colouring as he replays scenarios of invasion or rebellion to release the nation from autocratic bondage.[8] Heinlein saw American history as a prolonged struggle for freedom. In 1952 he appeared on Ed Murrow's CBS 'This I Believe' and declared his conviction that 'you and I are free today because of endless unnamed heroes from Valley Forge to the Yalu River' (Heinlein 1989: 171). Heinlein defined nationhood oppositionally against the communistic forces he saw as threatening it, a perception which hardened during the 1950s when Heinlein singled out for special praise those science fiction novelists like Pat Frank and Philip Wylie who shared his political convictions.[9]

If conflict was Heinlein's narrative premise, this even extended to near space and the question of national security. In 1947 he wrote to the *Saturday Evening Post* predicting interplanetary exploration and adding as a quip 'however, we may wake up some morning and find that the Russians have quietly beaten us to it' (Heinlein 1989: 179). Joke or not, space was rapidly becoming politicised. As H. Bruce Franklin records, in 1948 the Secretary of Defence proposed that the United States build a space station as a 'military guardian in the sky' (Franklin 1980: 98). The following year Heinlein published 'The Long Watch', a story dealing with an attempted military coup on the US Moon Base, and shortly after wrote the screenplay for the George Pal movie *Destination Moon* (1950). Here the flight is dramatised as a continuation of the US military machine (the space rocket is named *Big Boy*, a revision of the Hiroshima bomb *Little Boy*) and, more importantly, as a national race between the USA and the Soviets: 'the first base is going to belong to us – or to Russia', declares one of the crew (Heinlein 1979a: 155). The Soviets unsuccessfully attempt sabotage and the narrative closes with unresolved doubts about whether the crew will manage the return voyage.[10] In fact the rocket represents yet another metaphor of the nation where

a member points the moral of heroic sacrifice to the collective mission: 'every man dies; the group goes on' (Heinlein 1979a: 170). From this date onwards Heinlein remained convinced of the strategic importance of near space, enthusiastically endorsing the writings of his friend Jerry Pournelle and later supporting Ronald Reagan's Strategic Defence Initiative.

Heinlein's friend and fellow novelist L. Sprague de Camp has claimed that up to 1960 Heinlein was a 'bright pink liberal' and thereafter became an 'outspoken conservative' (De Camp 1988: 40). The date in question marked the Heinleins' visit to the Soviet Union, following which Heinlein attacked the state Orwellian manipulation of the news media and the Intourist system.[11] However, it is difficult to see this year as a turning point since Heinlein's steadfast opposition to Communism had formed much earlier and in 1958 he engaged in one of his most strident pieces of political polemic. Outraged by the promotional literature of the Committee for a Sane Nuclear Policy, Heinlein and his wife published an advertisement called 'Who Are the Heirs of Patrick Henry?' taking as its theme the national ideal of freedom. Here Heinlein argued that the 'Sane' proposals followed (consciously?) a pro-Soviet line which boils down to an 'abject surrender to tyranny' (Heinlein 1982: 391). In his 1961 address at the World Science Fiction Conference Heinlein returns to this issue, grimly predicting the 'destruction of the United States of America as the political entity we know' with fifty to sixty million deaths into the bargain (Heinlein 1992a: 228). Drawing on Orwell, Heinlein paints a picture of a Soviet-occupied America which would at least give the surviving citizens an opportunity to fight back. Once again he evokes the dreaded spectacle of 'surrender to this monstrous evil' (ibid.: 244).

But there is something even worse: Communism's 'cold-blooded murder of the *truth*' (ibid.: 245). Heinlein's nightmare is the erasure of national history which would come about by the assimilation of the USA into the Communist World State, a situation which Heinlein had already described in *Revolt in 2100* (1953) where the young protagonist disobeys the ruling theocracy by rediscovering the suppressed archive of the American past. Starting with Tom Paine, his new information empowers him to denaturalise the state ideology and relocate it within a historical sequence. Accordingly the thinly veiled portrayal of McCarthyite loyalty checks under a new 'Inquisition' is encoded as an aberration from the national tradition. Similarly *Assignment in Eternity* (1953) describes another post-World War III situation where 'the evil ethic of communism had corrupted, even after the form had gone' (Heinlein 1977: 66).

Unlike the first novel where the rediscovery of history opens up heroic roles for the protagonist, *Assignment* plunges the reader straight into an espionage thriller where contemporary perceptions of Communism (torture and brainwashing) combine with transformed security institutions: the FBI reappears as the Federal Bureau of Security. Initially at least *Assignment* presents a protagonist trapped paranoiacally within a world of espionage where it proves impossible to locate enemies and therefore do more than improvise from situation to situation. By contrast, Lorenzo the actor-protagonist of *Double Star* (1956), is called on to play the role of doubling for a kidnapped political leader and then asked to continue that role even after the original has been found. The latter is discovered on the spaceship *Tom Paine*, a name which by now should be clear as a sign of national duty, and it is the ultimate duty as leader which Lorenzo accepts after the transformation of his role.

American history for Heinlein figured as an inheritance imposing its own demands of duty and vigilance. One of the most bizarre instances of such vigilance occurs in 'Project Nightmare' (collected in *Expanded Universe*), published in 1953, the year when the Soviet Union exploded its first H-bomb. Here a group of 'sensitives' use their ESP talents to prevent the detonation of bombs smuggled by the Soviets into key American cities. By sheer force of will this group acts out collectively the role of national saviour, with the single exception of one who nods off and as a result Cleveland goes up in smoke; but this detail does not compromise the triumphalism of the story.

Heinlein's commitment to the American right was confirmed in 1964 when he campaigned for Barry Goldwater whose 1960 manifesto *The Conscience of a Conservative* coincides at many points with Heinlein's thinking. Both shared a hostility to the Soviet Union, a rejection of the belief that material goods could 'convert' the latter, and a sense of national betrayal by the compromises of the Eisenhower administration. Goldwater declared: 'our leaders have not made *victory* the goal of American foreign policy' (Goldwater's emphasis, 1960: 91). When Goldwater and Heinlein recommend their readers to go on the offensive both lapse into ambiguous references to a 'long fight' and a 'war of attrition' against the enemy which can scarcely be read as metaphor only. Indeed one of Heinlein's most famous novels presents military training and combat as the very model of good citizenship.

(IV)

Heinlein and his wife were deeply involved in their 'Patrick Henry' drive when Eisenhower ordered a unilateral cessation of all nuclear testing. Heinlein's fury at what he saw as a gratuitous concession to the Soviets reflected a total disillusionment with the President: 'I knew that he was a political general long before he entered politics – stupid, all front and depending on his staff' (Heinlein 1982: 396). Heinlein expressed his indignation in one of his most controversial novels, *Starship Troopers* (1959), which attempts to combat the 'slow-motion collapse of a heroic war ethos' (Engelhardt 1995: 10) by reinstating the role of the hero within the drama of national survival. The novel is a *Bildungsroman* of the military life, narrated by Juan Rico from his induction up to his achievement of the rank of officer. The concentration on the detail of military life is so remorseless that Alexei Panshin reads the novel as a recruiting film in prose starting with an initial episode of rapid action to catch the reader's attention and then moving through sections on basic training and instruction. He concludes: 'There is no sustained human conflict ... The narrator goes in as a boot and emerges a lieutenant, and that is all' (Panshin 1968: 95). The novel contains yet another transformed version of the struggle against Communism, this time pursued to its power centre.

Rico's narration gives a moment-by-moment drama to events within strategically encoded landscapes and privileges the functioning of the military. War is a structuring premise not an issue to be speculated over. Heinlein introduces two analogies to underpin Rico's growing awareness of the infantry: that of the body and that of the extended family. During bootcamp training Rico realises that the exercises and tests have as their purpose a kind of surgery, to cut the fat off the collective body. As the failures (the majority) drop away and as the muscles in his own body develop, Rico experiences the satisfaction of merging into a larger whole expressed as a transformed family. Rico leaves his biological parents behind to find substitute fathers in the officers who instruct him and supply role models while a platoon sergeant ('Jelly') plays the role of substitute mother. Once the Bug War breaks out Rico's father joins up to find a patriotic substitute for self-doubt ('I had to prove to myself that I was a man' [Heinlein 1976b: 146]) and his mother is killed when the Bugs 'smear' Buenos Aires, and transformed into a motivation for combat. Heinlein was not alone in showing how the military could engross the family into its structure. The 1955 film *Strategic Air Command* merges the domestic

and military spheres, synchronising the birth of the protagonist's baby with the unveiling of a new 'family' of bombers. Bomber crew, family and squadron are situated within an expanding series rising to the ultimate collectivity of the nation itself.

Because Rico is learning the military trade the narrative has to be suspended at regular intervals for its informing ideas to be expounded and debated. Rico's leading tutor Dubois, for instance, puts the case for heroic sacrifice: 'the noblest fate that a man can endure is to place his own mortal body between his loved home and the war's desolation'.[12] Military service is thus presented as an idealised form of citizenship built upon the survival instinct. The novel refers to the Korean War as a notorious instance of the failure of conscript armies to instill such high ideals. Although Heinlein wrote soon after Hiroshima that '*all* previous military art is obsolete in the atomic age' (Heinlein 1982: 152), *Starship Troopers* deploys epigraphs from the Bible and writers like Tom Paine, Kipling and Churchill to suggest a historical continuity of righteous combat.

Heinlein's author-surrogate in *Starship Troopers* justifies war as an elaboration of the survival instinct applied to larger and larger groups (family – nation – alliance – species) based on a premise of inevitable conflict between such groups whose living space is finite. This depiction of war as an imperative probably reflects Heinlein's frustrations with Cold War diplomacy where he felt the West was constantly being outmanoeuvred by the Soviets. In the novel war becomes a mechanism for bonding the military in right action against two alien groups. In the opening episode the enemy are humanoid 'natives', unnaturally tall figures, while the main enemy is the Bugs whose organisation resembles that of ants, the 'ultimate dictatorship of the hive' (Heinlein 1967b: 117). They embody a 'total communism' presided over by bug 'commissars'. In short the Bugs represent the perceived characteristics of Soviet Communism transposed, after a defeat of the 'Chinese Hegemony' in the novel's future history, on to an alien species, as we saw in *The Puppet Masters*. Political difference is thereby naturalised into the threateningly alien. One reviewer spotted the parable immediately, declaring: 'We are up against World Communism ... can we turn our backs on war as an instrument of survival for our society, when the "Bugs" have not?' (Miller 1960: 158). The Cold War 'two worlds' ideology is simplified into a survivalist alternative ('the Bugs or us') and Rico's campaign proves successful in knocking out the enemy 'royalty'.

Starship Troopers provoked two burlesques which contested Heinlein's idealisation of warfare. Harry Harrison's *Bill, the Galactic*

Hero (1965) transforms Heinlein's narrative into third-person picaresque and parodies the military as systematised brutality. The hapless Bill is presented as a 'fighting fool' surrounded by obsessives and swept from one situation to another virtually without subjectivity in a world where excessive loyalty by the troopers is treated as suspicious by the paranoid authorities. Joe Haldeman's *The Forever War* (1974) pursues a different tack. Drawing on Haldeman's own experiences in Vietnam, the novel now describes a colonial war between the United Nations Expeditionary Force and the 'Taurans', an extraterrestrial race resembling small skeletal humans with chronic goitre. Haldeman's narrator Mandella rises through the ranks to major but privately rejects the military ethic: 'I had a magic wand [a laser gun] that I could point at a life and make it a smoking piece of half-raw meat; I wasn't a soldier, nor ever wanted to be one' (Haldeman 1978: 48). The narrator recoils from such a spectacle into a prolonged self-interrogation where he finds himself simultaneously 'thirsting for alien blood' and hating the conditioning (the 'puppet master of the unconscious') which produces that desire.

Asked repeatedly about the impact of Heinlein's novel on *The Forever War*, Haldeman has stated that he was reacting against the former 'at an unconscious level' (McMurray 1978: 18) and that Heinlein wrote out of the 1940s in having 'everyone essentially all behind' his war (Schweitzer 1977: 26). The essential difference between the two writers emerges in each one's treatment of ideological closure. Heinlein on the one hand gradually removes all opposing voices from his narrative until in the final line an anonymous radio speaker articulates a collective tribute or dedication: 'to the everlasting glory of the infantry'. Haldeman on the other hand preserves disjunction to the very end, between a discredited official voice and Mandella's inner opposition.[13] He revises Heinlein's biological imperative into a cynical or at least deceptive throw-back, declaring that warfare is an 'atavism, carefully (if unconsciously) nurtured by the people who are in positions of power, to assure that they stay in power' (Haldeman 1987: 4-5). Mandella embodies in one person the roles of private dissident and exploiter, thereby reflecting Haldeman's perception of a contradiction in the public attitude to the Vietnam War where overt opposition was compromised by economic support.

Notes

1. Heinlein 1992: 250. For excellent analyses of the relation between Calvinism and Social Darwinism in Heinlein see Slusser 1977a. *Take Back your Government!* was written at the end of the war but remained unpublished until 1992.
2. MacDermott 1982: 258. See 259–60 for a tabular breakdown of the ideological positions of the novel.
3. A similar process has been noted in Heinlein's revision of his story 'Lost Legion' (1941) into 'Lost Legacy' (1953) (Franklin 1980: 47).
4. Heinlein 1979c: 99, and 1951b: 102. If the slugs are identified with Soviet Communism the novel implies that both have to be confronted with equal ferocity (Disch 1998: 86–7).
5. Letter to Judith Merril, 18 October 1961, Merril papers, Canadian National Archive, Ottawa.
6. The complex is described in Ford 1986: Chapter 1, and was to be used as the main setting for the 1983 film *War Games*.
7. Cf. Heinlein's sketch 'Pie from the Sky' which lists many aspects of American life from alarm clocks to roadhogs that 'would be mightily improved by a once over lightly of the Hiroshima treatment' (Heinlein 1982: 175).
8. For comment on Heinlein's pre-1945 politics see Wells 1993: 1, 3–7.
9. Heinlein cites Frank's *Forbidden Area* and *Hold Back the Night* as well as Wylie's *Tomorrow!* in his lecture on Science Fiction (Davenport 1964: 29, 52); and he took bearings from Wylie's *The Innocent Ambassadors* (1957) when recording his own impressions of the Soviet Union in 1960 (Heinlein 1982: 411).
10. On the political shifts in Heinlein's scripts for *Destination Moon* see Franklin 1980: 97.
11. In '"Pravda" Means "Truth"' and 'Inside Intourist', collected in Heinlein 1982.
12. Heinlein 1967b: 79. In a 1972 interview Heinlein confirmed that the novel focused on the 'twin concepts of love and duty' related to survival (quoted Sammon 1997: 4).
13. Haldeman continued his 'dialogue' with Heinlein by opening his Vietnam initiation novel *1968* (1994) with the young protagonist reading *Glory Road* (1963) which opens: 'I know a place where there is no … Cold War and no H-bombs'.

History and Apocalypse in Poul Anderson

The Cold War is a real war, to the death (Poul Anderson 1963)

In 1960 the historian Richard E. Sullivan articulated the overriding fear of the times as a loss of faith in time itself. Imagining a Toynbee of the future looking back on the present, he anticipated a diagnosis of precarious contingency: 'All men were faced with the possibility that one twist of fate, one gesture, one ill-chosen word, one ill-conceived act could result in the annihilation of civilisation and humanity' (Sullivan 1960: 391–2). This perception of the unique nature of the postwar historical moment sent writers in recoil searching for historical analogies in their fiction, with thirties Germany (Philip K. Dick), the late Middle Ages (Walter M. Miller), or the American Revolution (Heinlein). The shifting nature of these analogies reflects the extraordinary difficulty of what Hayden White has called the process of 'fusing events' common to historiography and fictional composition (White 1978: 125). History then is scrutinised for the scripts whose replay might shed light on the 'plot' of the present. This happens in Poul Anderson who foregrounds his characters' attempts to situate themselves historically, but against these attempts stands the nightmare rupture of nuclear holocaust. A tension therefore emerges in Anderson's fiction between nuclear apocalypse and historical continuity.

(I)

'History has always been a leading interest of mine', Poul Anderson declared in a lecture on future histories, acknowledging a debt to Heinlein; and he has recorded his interest in writers like Spengler, Toynbee and John K. Hord who attempt to find the larger patterns in historical events (Anderson 1979: 9). Anderson's fiction dealing with Cold War issues repeatedly highlights the process of investi-

gating history or the individual's bewilderment when she or he is enmeshed in a sequence of actions not of their making. In an early post-World War III story, 'Security' (1953), Allen Lancaster is a scientist working in a government establishment when he is suddenly invited to head a top-secret military research project housed on a spaceship. This he does successfully and is returned to Earth only to be arrested and interrogated for subversion, at which point the hapless Lancaster realises that the project was not a government one at all. He is rescued by a member of the subversives and taken into permanent exile. The 'security officer' who gives Lancaster his new post explains that 'the powerful, authoritarian governments have always arisen in such times as the evolution of warfare made a successful fighting machine something elaborate, expensive, and maintained by professionals only' (Anderson 1953: 107). He draws an analogy with the Romans but his proposition could equally well fit the USA of the early 1950s.

Lancaster's bewilderment in 'Security' is symptomatic of how Anderson's characters struggle to locate themselves in history. The secrecy and ambiguity of the research installation reflects a wider ambiguity of history's processes, leaving the question open whether it can be understood as a meaningful continuity and whether it is susceptible to human control. Anderson's characters are haunted by the nightmare of blind contingency. In *After Doomsday* (1962) an astronaut reflects on nuclear war: 'One senseless kick of some cosmic boot, and the whole long story came to an end and had been for nothing' (Anderson 1965: 48). Between this extreme of chance and control of the nation's destiny, history remains an enigma, often becoming a subject in its own right. It is only from an external and retrospective point of view that sustained analysis can take place, as happens in 'Cold Victory' (1957: collected in *Conquests*). There, the narrative proper is framed by a discussion of 'Historical Necessity versus the Man of Destiny' which is left ultimately unresolved by a participant's account of a rebellion whose outcomes are reduced to the 'dice of future history', i.e. to a mere question of odds. 'Marius' (also 1957) describes a ruined France within the United Free Europe which has 'harried the wounded Russian colossus out of the West' and is now dreaming of restored freedom and prosperity. This scene acts as the forum for a debate between the incumbent director of France and a dissatisfied officer about how to deal with a new Communist dictator in Macedonia. Essentially this turns into a debate about the future. The director on the one hand believes in confronting difficulties only when they arise; the officer on the other hand is determined to change the

pattern whereby 'the race has always blundered from one cata-
strophe to the next' (Anderson 1957: 138). This he does by leading a
coup and disposing of the offending director. He rationalises this
act as an attempt to prevent history replaying the story of Marius,
the Roman general-turned-politician. In other words, Anderson
uses the Roman analogy to raise the issue of Caesarism and more
generally the relation of the military to political rule which was to
become a critical issue by the end of the fifties.[1]

In the instances already discussed conspiracies figure promin-
ently, but even when Anderson appears to be simply confirming
Cold War paranoia more is going on. The novella *Un-Man* (pub-
lished in 1953, the year of the Korean armistice) is set as usual in an
era following World War III where the UN has grown into a military
alliance with real power. The legend of the 'Un-Man' has become
current, one deriving from Maxwell Grant's Shadow and Sax
Rohmer's intrepid Nayland Smith who does constant battle against
the fiendish Fu Manchu.[2] In Anderson's narrative the yellow peril
takes the form of a conspiracy for world domination led by the
Chinese Communists. The apparent death of the 'Un-Man' sets off a
series of events in a swiftly paced international thriller where the
hero turns out to be not an individual but a group of cloned
'American brothers' operating as a secret security force for the UN,
functioning like a dike 'holding back a sea of radioactive blood from
the lands of men' (Andserson 1972: 26). This agency alone can offer
a 'stable social and economic order in the face of continuous
revolutionary change'. The pursuit of the conspiracy to its source
and its destruction would therefore seem to confirm the conspiracy
paradigm, but Anderson goes to some pains in his ending to
generalise the conspiracy away from historical or political specifics
to a Freudian script of constant rebellion against the constraints of
civilisation. As a result, security recedes into a 'meaningless dream'
because it is based on an expectation of a stability which can only
come with death.

Anderson represents nuclear holocaust as a cataclysm so major
that the very possibility of human survival becomes problematic.
His 1961 collection *Twilight World* uses a Wagnerian title (the
Dämmerung of humanity) and allusions to Spengler's diagnosis of a
'topheavy' civilisation collapsing to set up a sombre context of
pessimism about the future. The first story opens with an officer
flying his jetplane across a shattered landscape:

[T]wisted leafless trees, blowing sand, tumbled skeletons, perhaps
at night a baleful blue glow of fluorescence. The bombs had been

a nightmare, riding in on wings of fire and horror to shake the planet with the death of cities. But the radioactive dust was more than nightmare.[3]

The collection as a whole examines what reconstruction can be formed out of such destruction. The original title of the first story, 'Tomorrow's Children', establishes this issue because, as we shall see in Chapter 4, post-holocaust narratives invest children with the special role of embodying the future. Where the opening stories of *Twilight World* contrast perspectives on mutation, the third and longest narrative of the collection, 'The Children of Fortune', broadens out the action to a national and then international arena. For the first time we are given a new world map which combines survival (Australia and New Zealand), reversion (a new Ottoman Empire), and disintegration (a balkanised China). The us government forms a plan to colonise Mars, to use the planet as a refuge from worldwide pollution. The conflict between East and West which produced the horrors of nuclear war has been left largely implied until humans land on Mars. There, they discover that the Siberian Khanate (a reconstituted Soviet Union) has not only beaten them to it, but is using mutants' heightened faculties in a conspiracy to take them over. The Siberian leader puts the case for ideological incompatibility succinctly: 'I think history has proven that two wholly different ways of thought cannot long co-exist. Sooner or later, one will begin to dominate the other, which then has no choice but violence' (Anderson 1963b: 147). The American dream of Mars as a kind of socio-biological laboratory now turns into the site for replaying Cold War hostilities where an appeal to history is used to rationalise the resurgence of conflict.

(II)

Anderson's recurrent paradigm of the near future is an apocalyptic one of cataclysmic war followed by the ills predicted in Revelation, or, as a character in *The War of Two Worlds* (1959) summarises the sequence, 'atomic bombardment from space, capitulation, famine and plague '(Anderson 1974b: 14). Apocalyptic destruction is dealt with on an even greater scale in *After Doomsday* (1962), but before we consider that work we should examine the history of the so-called 'Doomsday Machine' which was to be satirised in *Dr. Strangelove*. During a 1950 Round Table discussion of the hydrogen bomb the physicist Leo Szilard first outlined the method whereby a

cobalt coating could be used so that fallout would blanket the
planet in radioactive dust, thereby threatening the very existence
of the human race. The retired chairman of the Atomic Energy
Commission promptly attacked the scientists for creating a 'new
cult of doom', whereupon Szilard protested that he was merely try-
ing to keep the American public informed on current possibilities.[4]
There the matter rested until the end of the decade.

In the meantime the cobalt bomb entered fiction in one of Fritz
Leiber's few stories of the Cold War, 'The Moon is Green' (1952).
His earlier stories 'Coming Attraction' and 'Poor Superman' were
intended, as he put it, to 'mirror the intense concern of 1950 with
McCarthyism, computerisation, and above all the bomb'; and they
do so by depicting an America 'as combat-shocked and crippled as
the rest of the bomb-shattered planet' (Leiber 1974: 8, 124). In 'The
Moon is Green' nuclear war has left the outside world a no-go area.
The few survivors huddle in lead-shuttered refuges waiting for the
radiation count to fall. The inset fictional history describes the
nuclear conflict producing this situation in non-national terms. The
forces are simply 'the world' which compulsively throw cobalt
bombs at each other and which know 'that they will never be able
to improvise a defence when arraigned before the high court of
history – and whose unadmitted hope is that there will be no high
court of history left to arraign them' (Leiber 1968: 87). Unlike
William Tenn's 'The Sickness' (1955) where holocaust from a
stockpile of cobalt bombs has been deferred by a joint mission to
Mars, the orgy of destruction in Leiber's story seems to have erased
the very possibility of future judgement.

By the beginning of the sixties the concept of the Doomsday
Machine had become sufficiently institutionalised for the expression
to appear in a RAND (Research and Development) Corporation
glossary where it is defined as a 'reliable and securely protected
device that is capable of destroying almost all human life and that
would be automatically triggered if an enemy committed any one of
a designated class of violations'.[5] It was Herman Kahn, doyen of the
Hudson Institute think-tank, who brought the phrase more into the
public eye in his monumental 1960 study *On Thermonuclear War*.
The preamble to this work testifies to Kahn's awareness of popular
fiction on his subject which has, he admits, 'picked up the idea of
ultimacy'. Through novels like Shute's *On the Beach* (an 'interesting
but badly researched book') the 'world annihilation possibility is
considered to be a sober and accurate appraisal of the destructive
power of existing weapons systems' (Kahn 1961: 9). Among the
possibilities he surveys is the Doomsday Machine, i.e. one 'whose

only function is to destroy all human life'(Kahn 1961: 145). This perfectly feasible device could be constructed within the next ten years or so, but has a major flaw, he drily adds, in being virtually uncontrollable; for that reason it would scarcely have any appeal for existing nuclear powers.

Three years after Kahn's study Anderson published one of his least-known nonfictional works, *Thermonuclear War*, with Monarch Books which in this same period was bringing out works like Frank L. Kluckhohn's *The Naked Rise of Communism* or David and Jeane Heller's *The Cold War*. The latter warned the reader, quoting Krushchev, not to relax before Western successes: 'International Communism is still a potent force in the world. Despite setbacks, Communist leaders are confident that they can, indeed, "bury" us' (Heller 1962: 18). This call for vigilance was reflected in Monarch Press science fiction which privileged sensational accounts of invasion and attempted takeover. Christopher Anvil's *The Day the Machines Stopped* (1964), for instance, describes the chaos in America which ensues when a secret Soviet experiment in cryogenics goes wrong, throwing out all electrical circuits around the world. George H. Smith published the second of his nuclear war novels with Monarch. Both *The Coming of the Rats* (1961) and *Doomsday Wing* (1963) include characters who have been reading Kahn. The latter novel, with acknowledgements to the physicist W. H. Clark who fleshed out Kahn's original Doomsday device, describes a secret section of Strategic Air Command (SAC), the Doomsday Wing of bombers equipped with cobalt bombs, which will only be used if the very existence of the USA seems under threat (Clarke 1961). A paranoid neo-Stalinist general launches a pre-emptive attack against America and the ensuing sequence of retaliatory strikes does seem to make the survival of the USA problematic. When the US President tells his Soviet counterpart that he will order the launch of Doomsday Wing, the other dismisses the devices as a 'science fiction chimera' designed to frighten children, and peace only follows when a group of Soviet scientists verify the bombs' existence (Smith 1961: 111). The novel thereby makes the point that for a Doomsday device to function as the ultimate deterrent it must be known by the other side. Ultimately, as Paul Brians points out, Smith's perspective on the device remains rather ambivalent. It is introduced to the reader as a monstrosity, but 'it is the existence of the Doomsday Wing alone which prevents the complete destruction of the United States and brings peace' (Brians 1987a: 310).

Like the other works mentioned here from the early sixties, *Thermonuclear War* is written out of a perception that the present

moment was the 'most dangerous in the history of mankind'.[6] Anderson draws heavily on the writings of Kissinger and Kahn (following the latter in suggesting that the USA might survive an all-out war) and divides his most forceful points into three areas: the physical experience of nuclear attack, the emergence of mutants, and the nature of the international Communist threat. After summarising blast damage and fire storms Anderson tries to picture the atomising of society that would follow, drawing an analogy with the Thirty Years War:

> One needs little imagination to see what battles would be fought, a man killing another man for a loaf of bread, cannibalism returning as it did in seventeenth-century Germany. Violence breeding violence, anarchy of the most ruthless sort would spread outward from the metropolitan fringes to the countryside'. (Anderson 1963a: 34)

And then, dismissing a mode of survival that would be described in Oliver Lange's *Vandenberg* (see Chapter 7), he continues: 'Conceivably a few lucky individuals could go back to the wilds, establishing themselves as hunters and subsistence farmers in wilderness areas. But any idea that many could do this is romantic nonsense' (Anderson 1963a: 34, 35). Secondly, this time drawing on the biologist Linus Pauling's *No More War* (1958), Anderson speculates on the consequence for the species of radiation-induced mutants, the issue which lay at the centre of *Twilight World*, even fearing that mankind might become extinct. Finally Anderson follows earlier ex-Communist writers in seeing Communism as a 'universalist missionary religion' whose aim is to 'approach the ideal of man conditioned into absolute conformity' (Anderson 1963a: 116). Anderson was not simply rounding on Communism in the heat of temporary world crises. *Thermonuclear War* profited, by his own account, from discussions with Heinlein which helped to forge a common 'eternal hostility to Communism and every other form of tyranny' (Heinlein 1992: 321). In an autobiographical statement of 1974 he records his gradual shift away from liberalism and growing hostility towards the left: 'Suffice it to say that over a period of decades, fact and logic drove me to the conclusion that Marxism is among the most grotesque frauds ever perpetrated upon mankind, and Communism the central monstrosity of our era' (Anderson 1974a: 49).

The fear which Anderson expresses in *Thermonuclear War* of violence spiralling out of control informs *After Doomsday* that combines apocalyptic destruction with the need for a historical

autopsy. The only way the latter can take place is from outer space, and a crew member of a spaceship tries to imagine a spectacle unavailable to any earthbound observer:

> Shriek and skirt as winds went scouring across black stone continents which had lately run molten, as ash and smoke and acid rain flew beneath sulphurous clouds. Crack and boom as lightning split heaven and turned the night briefly vivid, so that every upthrust crag was etched against the horizon. But there was no one to hear. The cities were engulfed, the ships were sunk, the human race dissolved in lava. (Anderson 1965: 8)

This is the imagined crime; Earth turns into a collective corpse; and the novel traces out a search for the guilty party in a galactic whodunnit. Anderson depicts a universe where the international rivalries of the Cold War are played out over a larger area. In fact the mystery at the heart of the novel is essentially a proliferation fantasy of superweapons falling into the wrong hands. Not surprisingly, the Soviets emerge as having agreed a secret arms deal so that 'they could quietly get ahead of every other country in the development of a really up-to-date war machine'. (ibid.: 67) This turns out, however, to be a red herring. In fact the bombs were sold to lesser powers like the Arab countries and Yugoslavia who bury a set of 'disruption bombs' (or 'doomsday weapons' as they are also called) deep within the Earth's crust primed to detonate 'if more than three nuclear explosions above a certain magnitude occurred within the borders of any single member country' (ibid.: 137). And so Herman Kahn's doomsday scenario has finally played itself out.

The logic of *After Doomsday* suggests that there might be a certain security in superpower confrontation because they would not have to rely on a device of last resort. This is the situation in 'Kings Who Die' (1962), a narrative set in the period of warfare following a Third World War. The conventions agreed between belligerents – another question discussed by Kahn – have produced a displacement of war into space while on Earth Americans and Unasians (a combination of Russian and Asian Communists) conduct themselves as if at peace. The very presence of the cobalt bomb guarantees that no final triumph is possible on Earth but meanwhile the rival fleets slug it out in space. This story, gathered by Anderson into a theme collection on institutionalised conflict, *Seven Conquests* (1969, subsequently retitled *Conquests*), depicts warfare as a mythical recurrence of sacrificial acts spliced on to history and contemporary politics by Anderson's choice of names. So the

American protagonist Diaz resembles a latter-day conquistador and a spaceship *Utah Beach* is named after the Normandy landings, while the Unasian General Rostock uses as command ship the *Ho Chi Minh*, replacing the earlier *Gengis*. The names of this story and others by Anderson then function as the traces of former conflicts or contemporary East–West confrontation points displaced in space and time on to new sites of combat.

Apocalypse recurs in Anderson within the grand Cold War narrative of superpower confrontation which at certain historical moments (1950–1, the early sixties) was widely expected to lead to open war. By the end of the fifties Kahn could describe such an expectation (World War III) as 'history'. Similarly Anderson himself declared that 'World War Three did not come off on schedule' (Anderson 1979: 8) and the narrator of *There Will Be Time* (1973) records of 1951: 'Most of us, in an emotional paralysis which let us continue our daily lives, expected World War III to break out any instant' (Anderson 1980: 26). 'A Chapter of Revelation' (1972, collected in *Dialogues with Darkness*) narrates such past expectations through an alternative Korean War which does progress to nuclear exchange. This was no fanciful elaboration since in December 1950 General MacArthur had requested twenty-six atomic bombs to drop on North Korea and China. In December 1952 he repeated the request and was probably removed from office by Truman partly because of his refusal to keep the war within definite limits (Hastings 1987: 220, 392). These limits are broken from the very beginning of Anderson's narrative when the Chinese Communists launch tactical atomic weapons against the American fleet for violating territorial waters and preparing for a seaborne invasion like the Inchon landing. Anderson breaks up his narrative into news reports and snapshot episodes giving glimpses of domestic reactions within the USA. Indeed the segmentation of the narrative cleverly shows how helpless the average citizen feels before a seemingly remorseless escalation of a crisis on the other side of the globe. The Chinese attack is followed by a carefully limited American strike described in a news report:

United States bombers today launched an atomic attack on Chinese rocket bases on the Shantung Peninsula. President Reisner declared that the weapons used were of strictly limited yield, for the strictly limited purpose of taking out installations which, he said on television, had 'murdered an estimated ten thousand American sailors and left a greater number in the agonies of burns, mutilations, and radiation sickness'. He pledged no further

strikes unless further provocation occurred and called for a con-
ference to settle the Korean problem and 'other issues which have
brought civilisation to the rim of catastrophe. (Anderson 1985:
16–17)

Anderson starts his narrative within a crisis already formed and
shows each speaker for the major powers – the USA, China, and
Soviet Union – to be locked within their respective ideologies. The
evident impossibility of a political solution leads Anderson to
diverge from future-realism to a *deus ex machina*. A man appearing
on a TV chat show declares that the crisis is taking place because 'we
don't know God' and the sentiment is echoed by others who pray
for an 'unmistakable sign'. One prayer quotes Joshua 10:12, 'Sun
stand still', and that is exactly what happens. For twenty-four
hours the Sun's motion relative to the Earth is suspended, inducing
'worldwide dread'. A number of religious movements arise as a
result, bringing chaos to the USA and overthrowing the Communist
regimes of China and the Soviet Union. The story's title promises
scriptural confirmation but Anderson offers no consolation of
spiritual design. By the end of the story the world has slipped back
into a new Dark Age.

(III)

Anderson's most complex treatment of post-holocaust survival and
the repossession of nuclear weapons comes in his 1983 novel *Orion
Shall Arise*. Part of a longer series, this work describes a world some
centuries after it has been devastated by a nuclear war referred to
variously as the 'War of Judgement' or the 'Doom War'. Europe has
become fragmented into tribal units, and, like Russell Hoban in
Riddley Walker, Anderson uses distorted but still recognisable place
names so that we can read the old national map through the new
landscape. Here new political groupings embody contrasting
ideologies of world reconstruction. The Maurai, descendants of the
Maori from a country that escaped the war relatively unscathed, (as
in Huxley's *Ape and Essence*) represent a power bloc opposed to
technology whereas the Northwest Union, it transpires, has been
secretly developing an underground nuclear facility in Alaska. The
title term carries multiple variations on the theme of violent
conflict. Orion was a hunter in Greek mythology (the first scene of
the Prologue), then incorporated into the Zodiac as a sign of storms
and turbulence (the opening scene of Chapter 1). The title phrase

constitutes a secret slogan of incipient rebellion but the term 'Orion' is reified as a spaceship propelled by nuclear explosions (such a device was considered for a time by the USA) which would realise a dream of 'unlimited power' by finding fuels on other planets.[7] 'Orion' in short becomes an overdetermined sign of human violence. The Orion project is alternately admired and feared as a resurgence of the nuclear weaponry suppressed by a worldwide ban since the Doom War. Conflict for world hegemony has been going on throughout the novel and orion simply represents that drive extended into space, in other words a thinly disguised national expansionism like that satirised in Pohl and Kornbluth's *Space Merchants* and Barry B. Longyear's *Manifest Destiny*.

Like Heinlein, Anderson was sympathetic to the notion of a citizen army and describes a reprise of the American Revolution when the North Americans rise against the Mong, the Sino-Soviet forces that invaded after the Doom War. In contrast, note how the first real reference to the secret project is phrased: 'Beneath the mountains in Laska [i.e. Alaska] there was coming to birth a terrible beauty' (Anderson 1984: 324). The director of the Orion project is depicted as a faustian ideologue and Anderson here borrows the refrain from Yeats's 'August 1916' to suggest a failed and morally ambiguous uprising before the event. When combat does break out Anderson telescopes ecological and human catastrophe into the graphic description of one female casualty who repeats a mantra to the Earth ('it is done in beauty') just before she dies. The multiple connotations of 'Orion' parallel the different ways Anderson depicts recurrence, whether mythical re-enactment, historical repetition, or even ancestral memory when an official tells his prisoner: 'We both feel ... as if we had been born into a war going on forever' (Anderson 1984: 335). Images of birth are juxtaposed to death so closely that the one comes to entail the other. Although the outburst of destruction ceases towards the end of the novel, Anderson does not close off the narrative. Orion may rise again.

We have seen how Anderson repeatedly draws the reader's attention to the plot of history, figured as conspiracy, myth, or sequential logic. The story which most explicitly foregrounds these issues is 'The Disintegrating Sky' (1953), set against a background of imminent war. Here a number of men gather in a New York apartment to discuss whether reality has any diachronic coherence, and one character draws a direct analogy between experience and fictional composition: 'I say we move from past to future because the Author is writing all the time' (Anderson 1961: 116). They then speculate about the limits of human knowledge, whereupon a

scientist announces the existence of a 'total disintegration bomb' whose certain use might damage the Earth's crust. This notion is immediately converted into a melodrama where a would-be author declares: 'I would have taken a few of my characters just before the end and made them realise what they were – characters in a poorly-written novel, out of my own mind' (ibid.: 118). At this point sirens start up and distant rocket trails signal the end. David Dowling explains that here 'the two fictional levels seem to cancel each other out in the reader's experience until s/he confronts the abyss of a real destruction' (Dowling 1987: 12). Nuclear holocaust literally explodes the frame of the story with an apocalypse so sudden that it retrospectively mocks the discussion of a rational sequence to human time. No sooner have the characters confirmed what Derrida calls the fabulous dimension to the nuclear age by composing fictions of nuclear war, than the narrative halts abruptly on a point of imminent holocaust: 'Faraway and faintly the scream of sirens came to him and the lights started to go out. He saw rocket flames cut their fiery trails across the disintegrating sky' (Anderson 1961: 118). On one level the narrative has come full circle back to its title; on another hints of extinction, burning, and fragmentation suggest a process which the reader can apply to the ground of the narrative itself as if it is about to self-destruct.

Notes

1. 'For the Duration' (1957: collected in *Strangers from Earth*) pursues a partial analogy between a post-World War III dictator and the Roman statesman and soldier Cincinnatus who, however, does not return to his plough. When an uprising deposes him, his role is filled by yet another ('benevolent') dictator.

2. The Shadow stories were published through the 1930s. Anderson's debt to Rohmer is suggested by the condensed name of his protagonist Naysmith.

3. Anderson 1963b: 2. The blue glow was popularised in Campbell's *The Atomic Story* (1947) which described a city hit by a neutron bomb as a nocturnal 'fairyland glowing with a faint blue nimbus' (Campbell 1947: 252).

4. Bethe et al. 1950: 107, 109. The notion of the 'doomsday weapon' dates back in science fiction at least to Alfred Noyes's *The Last Man* (1940). Campbell described the atomic bomb as the 'Doomsday Bomb' in 1946 (Berger 1993: 75).

5. Quoted *Bulletin of the Atomic Scientists* 17.IX (November 1961): 360.

6. Anderson was approached by the publisher to write *Thermonuclear War* which he undertook because 'it seemed to me that the public at the time had very little understanding of the issues and of the complexity of such concepts as deterrence' (letter from Poul Anderson, 20 October 1997).

7. The Orion project is described by Dean Ing where he speculates that the propulsion method 'might yet be used to power city-sized dreadnoughts of the next century' (Ing 1979: 245).

IV Views from the Hearth

Do *not* leave your homes. Stay indoors (announcement in *Shadow on the Hearth*, 1950)

Philip Wylie's key nuclear novels and Heinlein's *Farnham's Freehold* explore the feasibility of city- and family-based civil defence. Although preparedness for nuclear attack remained the subject of heated controversy right through the postwar period, no coordinated national policy was ever put in place.[1] Nevertheless there were government-sponsored campaigns to promote family shelters. Elaine Tyler May has shown how female domesticity was revised in the fifties to include 'expertise in dealing with the possibility of nuclar war'. The FCDA (Federal Civil Defence Authority) 'Grandma's Pantry' campaign extended housekeeping so that the shelter became an extension of the kitchen (May 1988: 103, 104–5). The booklet on *Fallout Protection* distributed by the Kennedy administration had a more male-oriented emphasis on building skills, this time presenting the shelter as a backyard den. The danger here was of domesticating nuclear attack, reducing its threat to an inconvenience which could be met by a good stock of canned food or a sturdy basement. From the 1940s onwards, however, science fiction narratives had already started addressing anxieties about genetic mutation, which bland government assurances attempted to soothe, and ask how far the home might serve as refuge in nuclear attack.

(I)

The atomic bomb itself was associated by its first commentators with birth. In his report on the Alamogordo test journalist William L. Laurence described the blast as the 'first cry of a newborn child' (Laurence 1961: 117). The prominence of such metaphors in nuclear discourse has been receiving fascinating analysis by feminist

scholars, one arguing that domestic imagery suggests 'men's desire to appropriate from women the power [of] giving life and that conflate creation and destruction' (Cohn 1987: 699). The fear all too often in fiction of the period was that the post-nuclear baby might be born with physical defects. Mutation in the following narratives represents the uncontrollable factor in such power and an ambivalence towards the Bomb which Forest J. Ackerman's 'The Mute Question' (1950) renders grotesquely through a 'debate' between the two heads of a single mutant. One possible explanation of origin is a usurpation of divine creation with the 'Adam bomb' (Silverberg 1977: 59), a pun later to be elaborated by Russell Hoban.

Not surprisingly descriptions of physical mutation are narrations of a reluctance to recognise its signs. Poul Anderson and F. N. Waldrop's 1947 story 'Tomorrow's Children' sets the keynote. Following an atomic war, Drummond the protagonist flies in to the new US capital in Taylor, Oregon, opening the story with a cinematic passage across a landscape which looks green and fertile from high up, but on closer view reveals the scars everywhere of bomb craters. Apocalyptic references to total endings tug against Drummond's yearning for home. Visiting one village community, he finds a communal dwelling marred by mutants:

> There was a dog on the floor nursing a litter. Only three pups, and one of those was bald, one lacked ears, and one had more toes than it should. Among the wide-eyed children present, there were several two years old or less, and with almost no obvious exceptions, they were also different. (Miller and Greenberg 1987: 162)

Specificity is reserved here exclusively for the animals; the children are simply 'different'. The euphemism indicates a common deferral in the story of the human consequences of fallout by no means limited to Drummond's superior whose wife gives birth at the end of the story to a boy with 'rubbery tentacles terminating in boneless digits' (ibid.: 171). Mutation is gradually brought nearer and nearer to home so that the desired good place with its continuity from pre-war is problematised by this concluding image.

The perspective of 'Tomorrow's Children' is a heavily gendered one with the mother simply playing the supporting role of pro-ducer, and the very title of Judith Merril's 'That Only a Mother' (1948) redresses that subordination. It describes the situation of a mother, Maggie, whose husband Hank has been working at the Oak Ridge atomic enrichment plant and is now absent because of the war. Maggie meanwhile has just given birth to a baby girl.

Throughout the narrative a dialogue takes place between Maggie's fears and hopes. Thus at one point Maggie

> caught herself refolding the paper to the medical news. *Stop it, Maggie stop it! The radiologist said Hank's job couldn't have exposed him. And the bombed area we drove past ... No, no. Stop it, now! Read the social notes or the recipes, Maggie girl.* (Merril 1960: 12; emphasis in original).

But she reads the medical notes instead. There are constant ellipses in the text suggesting the unverbalised fears which Maggie is suppressing. In the event, Maggie's discovery that the child is mentally precocious but limbless vindicates these fears over the reassurance of the primarily male experts.

An ambivalence towards the baby lies at the heart of this story for Terrence Holt who argues that it resembles Bomb and penis, at once the visible sign of desire and its concealment as mother's product.[2] For the husband reacts like a cuckold. Do his hands tighten round the baby to kill it at the end, making him co-creator and destroyer? Such questions are not answered (cf. Cummins 1992: 207), nor need they be, since Merril is giving us partial access to a series of suppressions. In mutant narratives a generation displaces responsibility for the Bomb on to the babies so that the latter's products become its cause. The resulting spiral of hatred is evoked claustrophobically in Richard Matheson's 'Born of Man and Woman' (1950) where a malformed child is chained up by its parents. The mirroring of their violence towards each other suggests that 'what we fear in the bomb is only a distorted image of ourselves' (Holt 1990–1: 210).

If this is so, the subtext of mutant narratives demands our particular attention, as do textual signs linking the domestic with nuclear war. Carol Emshwiller's 'Day at the Beach' (1959) describes the efforts of a nuclear family to maintain a domestic routine some four years after a nuclear war. These pre-war 'scripts' have an existential appeal that does not hide the mismatch between language and action. The husband still 'commutes', but to find food; they have a 'good day' at the beach but have had to kill an attacker. Initially then the story contrasts echoes of suburban routine with the ubiquitous presence of danger. The ambiguity of the family unit is embodied in the child, three-year-old Littleboy:

> He was the opposite of his big, pink and hairless parents, with thick and fine black hair growing low over his forehead and

extending down the back of his neck so far that she always wondered if it ended where hair used to end before, or whether it grew too far down. (Miller and Greenberg 1987: 100)

What mother has never seen her child's back? But that discrepancy is less striking than the child's name. Ostensibly named after the war, it carries the name of the Hiroshima bomb, which sheds light on a cryptic textual gloss. Emshwiller describes the sea as *drowning out* the noises of wars' (ibid.: 102; emphasis in original) and Little-boy's gradual manifestations of feral traits closes up the gap between past and present as if the war is continuing.

The stories considered so far only raise by implication the problem of how the mutants are to be treated socially. Henry Kuttner's Baldy stories, started in 1945 before the detonation of the atomic bomb and collected as *Mutant* in 1953, depict a human group whose primary characteristic is telepathy and secondary characteristic is hairlessness, both caused by hard radiation released in a war called the 'Blow-up'. Kuttner explores the bonding between the Baldies and a tension with the majority population so severe that the discourse of warfare is relocated within society and figured as a 'deadly strife' being waged beneath its surface. In Theodore Sturgeon, André Norton, Aldous Huxley and others 'normality' is institutionalised as a set of prohibitions which authorises the majority to imprison and even incinerate the mal-formed. John Wyndham's *The Chrysalids* (1955, US title *Re-Birth*), for instance, describes a post-holocaust Labrador where a theocracy imposes the principle that 'the norm is the will of God', continu-ously re-enacting their guilt over the war by punishing its genetic casualties.[3]

The home functions as a point of departure in Wilmar H. Shiras's *Children of the Atom* (1953) where a massive explosion in 1958 at an atomic plant 'where they were trying to make a new kind of bomb' (Shiras 1959: 37) has fatally contaminated all adults living nearby but induced a capacity for precocious intellectual development in their children. These 'wonder children' have skipped a generation and are living within their family homes as strangers, even prisoners. The means for the children's emergence is supplied by a philanthropically endowed residential school in a small Californian town where the growing suspicion of the local residents indicates that the children become the object of public fears of atomic power. A town demagogue denounces them in ringing, nonconformist rhetoric as the demonic agents of 'doom and destruction to man-kind'. They are inflated into a whole fifth column exploiting perfect

disguise to spread their 'poisonous propaganda' throughout society. 'They are a monstrous mutation born of the death and destruction of Helium City by the unleashed powers of the atom! Powers which God meant to remain under His control' (Shiras 1959: 203–4). The children in short make up a species of their own, a 'fenced-in and secret gathering of monsters alien to all humanity and to all God's creation' (ibid.: 205). A whole series of fears run together here: of unbridled technology, of the alien, of creeping secularism. The speaker blanks out the children's human parentage in order to demonise the event which altered them. The children therefore are being used yet again as scapegoats in a ritual purging of social guilt over the primal explosion, forced by social hostility to withdraw into a community which resembles a think-tank or even the enclosed secrecy of the Manhattan Project. The children's cool rationality utterly belies the charge of being a 'monstrous mutation'. Physically unchanged, the children stand at the opposite extreme to the human mutant in the 1955 film *The Day the World Ended* who develops a leathery 'atomic skin' and carries the stigma of luminous 'veins' on the side of his head which signals a reversion to cannibalism. Increasingly denied any domestic and even social context, this creature has to be destroyed to satisfy the film's conservative and unmotivated piety.

(II)

When planning her 1950 novel *Shadow on the Hearth* Judith Merril wrote to David Bradley, a doctor assigned to cover the Crossroads atomic tests in the Pacific. His log *No Place to Hide* (1949) concluded that the Bomb threatened the survival of the whole race and declared that 'there are no satisfactory medical or sanitary safeguards for the people of atomised areas' (Bradley 1949: 176). Bradley's title became a virtual slogan throughout the fifties' debate on civil defence, and Merril wanted to intervene in this debate with a work 'directly designed to be propaganda' (Weiss 1997: 8), but specifically addressing a female readership. She researched her subject thoroughly, poring over journals like *Collier's* and *Science Digest*, and reading John Hersey's *Hiroshima*. With Bradley she checked further medical details and explained that his descriptions were too male-directed to appeal to women readers.[4] The result was a novel which was universally praised by the reviewers for its understated method, avoidance of melodrama and unusually oblique description of nuclear attack.

Shadow on the Hearth describes the experiences of Gladys Mitchell, a housewife living in the New York suburbs, as she attempts to cope with the experience of nuclear attack. The radio announcements of atomic damage trigger off a memory in Gladys of having read a similar description of the destruction of New York which derives from Dexter Master's anti-nuclear collection, *One World Or None* (1946). Here, the physicist Philip Morrison, who had witnessed the destruction of Hiroshima and Nagasaki, tried an exercise in transposition to bring this destruction home to his readers: 'A clearer and truer understanding can be gained from thinking of the bomb as falling on a city, among buildings and people which Americans know well' (Masters and Way 1947: 13). Merril's novel briefly evokes a 'glassy expanse of poisoned waste-land' (Merril 1964: 15) near the centre of the blast, whereas Morrison presents a spectacle of wreckage and carnage in mid-Manhattan: 'Everywhere in this whole district were men with burning clothing, women with terrible red and blackened burns, and dead children caught while hurrying home to lunch' (Masters and Way 1947: 18). Merril's suburban setting excludes such descriptions of destruction. Instead the bomb is represented metaphorically as a shadow over the Mitchell home, a dread realised once the attack happens as a combination of twinned sounds of alarm: scream and siren. The radio plays a key mediating role in the novel, supplying information and instructions, and introducing a tacit analogy between home and country. The state governor comes on the radio to reassure his listeners: 'Nothing can get through. We are living inside a great dome of safety, our whole nation protected by the radar sweep from bases prepared long ago' (Merril 1966: 21). This claim of domestic security has already been totally belied by actual attack and the novel fleshes out a warning given in the abstract in a 1950 article on civil defence. Here the reader was warned: 'For the first time in the history of this country, a foreign government has the capacity to attack all our home soil – has the weapons and the means to deliver those weapons (Symington 1950: 231). Here the concept of home has been expanded into the whole nation to represent a collective state of vulnerability not security.

Gladys locks her windows as 'proof against invaders from outside' (Merril 1966: 31), a region which has become transformed into an area of chaos and threat. The actual shadows cast over her home are those of male figures before they can be identified. Thus a sequence of assaults takes place from a neighbour turned civil defence officer who then forces his sexual attentions on her, to Dr. Levy (former atomic scientist, then blacklisted and turned local

teacher), and finally would-be looters. These shadows are human but there is a hidden force at work permeating through the barriers of the home: radioactivity, which induces the younger daughter's sickness.

In Fritz Leiber's 1952 parable 'The Moon Is Green' the home has literally become a lead-shuttered shelter against the massive radiation from a cobalt-bomb war (the 'Fury'). Here a wife tires of endless confinement and opens her windows to a survivor from outside who proves to be a carrier of death. Her dream of release collapses when his radiation is measured 'for no dreams can stand against the Geiger counter, the Twentieth Century's mouthpiece of ultimate truth' (Leiber 1968: 100). Its sound displaces both human voices and the ticking of the clock as the precarious balance between inside and outside begins to collapse.

Although the home in *Shadow* is symbolically invaded it never loses its significance as a place of light, food and warmth. Domestic spaces become transformed by necessity into a hospital to care for the younger daughter, and so on. Correspondingly, Gladys's very subjectivity, which has been scripted by others, redefines itself as the novel proceeds. By the end, 'more than simply competent, she has constructed an identity quite apart from her duties towards her husband' (Berger 1981: 292). Partly this results from the latter's absence with Gladys's attendant redirection of attention to the children, partly it stems from her rational resistance to male authority figures, starting with the radio announcer. At no time, however, does the home lose its positive contrast with outside, a place of darkness and death where life has been erased ('every familiar pattern of the suburban night was gone' [Merril 1966: 168]). The ending of the novel was imposed on Merril by Doubleday to conform to the needs of the Family Book Club (Seed 1997b: 13). In the Doubleday edition the doctor brings in a wounded man who Gladys agrees to nurse, identifying him in the last line: 'It's Jon, you know. He came home'. The restored 1966 text drops this conservative return to wifely duty and ends on a more sombre and open query: 'Isn't anything safe?' Paul Brians argues that the novel can be read ambiguously as either antifeminist or feminist (Brians 1987a: 259). These are rather false alternatives, however, since *Shadow on the Hearth* unpicks the official line on security with its requirement of acquiescence to describe a survivalism improvised from day to day. By contrast its TV drama adaptation, *Atomic Attack*, synchronises the fortunes of the family with the progress of the war through a common triumphalism. Both the film and novel were subsequently used by civil defence organisations.[5]

Public fear of nuclear attack reached its first peak during the Berlin blockade and with the outbreak of the Korean War. In 1949 AEC chairman David Lilienthal complained about the 'horror stories' of nuclear war (Boyer 1994: 306–7), early versions of what Merril was to call 'atom-doom' fiction (Clareson 1971:73). The reassuring gospel of preparedness was being promoted by scientists like Ralph Lapp and Richard Gerstell, the latter's *How to Survive an Atomic Bomb* recommending reciting jingles if 'it' happened. The same year that *Shadow on the Hearth* appeared a *Collier's* article 'Hiroshima USA' described a nuclear attack on New York but offset the disaster by recommending civil defence training on the British model.[6] It was such training that William Tenn satirised in his 'Generation of Noah' (written 1949) where a sadistic father drills his children to recite their fate if they don't run to the family shelter in time. The son knows his lines: 'I'd burn like the head of a match. An' – an' the only thing left of me would be a dark spot on the ground shaped like my shadow' (Tenn 1968: 14). Tenn sardonically contrasts the father's preparatory measures (the 'scientific way' – one of the earliest descriptions of nuclear survivalism) with his wife's scepticism. When the bomb drops it is the children that induce his promise never to punish them again.

In the boy's words just quoted the central metaphor of Merril's novel is being transformed into the nuclear image of human absence used in Ray Bradbury's 1950 story 'There Will Come Soft Rains' (subsequently the penultimate piece in *The Martian Chronicles*). A house stands alone amid rubble after a nuclear war and on its western wall, that facing the implied bomb blast, is imprinted a scene:

> Here the silhouette in paint of a man mowing a lawn. Here, as in a photograph, a woman bent to pick flowers. Still farther over, their images burned on wood in one titanic instant, a small boy, hands flung into the air; higher up, the image of a thrown ball, and opposite him a girl, hands raised to catch a ball which never came down.[7]

The analogy is pointedly ironic because a photograph would be a memento of a family past, whereas here the house itself has become a trace on which are imprinted the signs of former human activity to be seen only by a notional observer. Like a parody of automation, the house continues to function on a daily timetable long defunct until it catches fire, re-enacting the death of the collective family body. The story ends austerely with a dawn bringing nothing new and not a last survivor, but a last electronic voice repeating the date of that death over and over into a void.

(III)

While real doubt is expressed in the preceding works about the nature of human continuation, a survivalist ethic is practised in Pat Frank's *Alas, Babylon* (1959) by transforming a home into a miniature community. Frank locates his account of nuclear war in the small Florida town of Fort Repose which he, like Philip Wylie, attacks for public complacency. Civil defence booklets were never distributed around Fort Repose because they were felt to be 'too gruesome' and once the attack takes place the result is immediate looting and the sort of clogged roads described sardonically in Ward Moore's 'Lot' (1953). Accordingly when war does break out the result is chaos:

> The people of Fort Repose had no way of knowing it, but establishments on the arterial highways leading down both coasts, and crisscrossing between large cities, had swiftly been stripped of everything. From the time of the Red Alert, the highways had been jammed with carloads of refugees, seeking asylum they knew not where. (Frank 1976: 117)

As a professional journalist, Frank is more concerned to give the reader information (his protagonist's brother conveniently happens to be a SAC intelligence officer) than to limit his narrative to characters' perceptual horizons, and the novel has been praised for making 'pictures out of statistics'.[8]

The improvisational skills Frank wishes to promote involve him in a contradictory treatment of nuclear war. Chapter 6 of the novel opens with a discussion of 'The Day' as the nuclear attack becomes known, contrasting it with previous wars in that the exchange finished within a day and most casualties saw nothing at all 'since they died in bed, in a millisecond slipping from sleep into deeper darkness' (Frank 1976: 123). This grim account suggests that Fort Repose is one of the few lucky enclaves of survivors and it is made even more of a special case by being relatively exempt from fallout.[9] Nevertheless history is brought in by Frank (the Seminole wars, World War II, etc.) as a repertoire of actions which can be repeated to cope with the new situation. Thus we are told at one and the same time that nuclear war is a unique event inaccessible to civil defence and that it is the worst instance in a series of wars that require essentially traditional initiatives to be taken. Frank's characters have to survive, but they are confronted with selected problems: primarily the closure of utilities and the breakdown in law and

order. Of fallout we hear virtually nothing; one rare (and moralised) exception is a local man who dies after looting 'hot' jewellery.

The key residential units in *Alas, Babylon* are the town and the neighbourhood, not the single home. Indeed Randy's house is linked with three others symbolically by an artesian water system and his house opens its doors to the wife and two children of his brother, and later to his future wife. Family bonds shade into other bonds of necessity where a character becomes identified with his or her practical skills. So Admiral Hazzard supplies the group with their ears on the outside world through his short-wave radio, and their African-American neighbours the Henrys supply livestock and arable crops. A new regimen is devised whereby each member of the extended family works long hours and, most important of all, a self-defence system is built up to protect the group against savage predatory animals and equally predatory 'highwaymen' who 'filter' into the area rather like radiation which, David Dowling argues, only figures 'in a moral guise'(Dowling 1987: 91). When a member of the group is wounded, the resulting operation, carried out on a billiard table with steak knives, becomes a ritual of communal aid:

> Randy put them [his instruments] into the pot to boil. After that, at Dan's direction he put in his fine-nosed fishing pliers. Florence Wechek ran across the road for darning needles. Lib found metal hair clips that would clamp an artery. (Frank 1976: 276)

If the group represents the nation in miniature – and it is surely no coincidence that the son should be called Ben Franklin – then a cherished national ideology is being tacitly asserted here of cooperative improvisation. Frank anticipates later survivalist writers like Dean Ing by breaking down disaster into a series of discrete, manageable and essentially practical, problems.

Unlike the other fiction examined in this chapter then Frank does not focus on the family itself but instead uses the house as a miniature community centre where survivors with a convenient array of skills can gather to maintain a tenuous civil order. A sign of Frank's different use of this location is the diminished presence of children who, as we shall now see, bear the crucial role of carrying the nuclear narrative forward into an imaginable future.

(IV)

One of the most thoughtful treatments of nuclear war can be found in Helen Clarkson's *The Last Day* (1959), which describes the experiences of a middle-aged couple holidaying on an island off the Massachusetts coast. The attack happens soon after their arrival and the novel describes the gradual spread of deadly fallout on the wind which demonstrates the utter uselessness of civil defence measures. The novel was endorsed on its cover by Senator Clinton P. Anderson, Chairman of the Congress Joint Committee on Atomic Energy, who had for years been accusing the AEC of withholding information on fallout, as helping to inject a 'little diet of realism' into the nuclear debate.[10] Clarkson's means of entering that debate is to conceptualise as many issues as arise immediately after a nuclear attack. *The Last Day* is in that respect a dialogue novel narrated by Lois the wife, but dispersing narrative authority through some half-dozen characters all of which die. The novel ends with the impending death of the narrator herself. The foregrounding of human rationality through dialogue sets up a context for the nuclear attack which is represented as a triumph of unreason, anticipated in the abrupt transition on the radio between a French political commentary and sheer noise, an 'electric mutter like the mumbling of a madman' (Clarkson 1959: 41). The blast itself is described as an unnatural dawn, not Promethean *pace* early commentators but an 'idiot glare' which ruptures the observer's cognitive frame (the 'familiar limits of all normal dimensions'). It creates a kind of species casualty: 'Time was bleeding to death, second by second, and we could do nothing to staunch the flow from that mortal wound' (Clarkson 1959: 44).

If time becomes identified with the blood of life then the novel's chapter titles appropriately count us down to the ending of all life ('The First Day', 'The Second Day', etc.) and this damage affects language itself. The narrator reflects: 'What can you say in a grammar that has lost its future tense?' (Clarkson 1959: 147). Unlike Merril and Frank, Clarkson describes fragile wooden dwellings vulnerable to nuclear blast even from a distance. There is no place to hide from the coming fallout. 'Home' then becomes a place which the narrator can only reconstitute in her memory and by the end of the novel this perception has been generalised into a massive figure of human absence: 'Now the whole earth was a house haunted by all that had ever been' (ibid.: 179). Already Clarkson has achieved elegy where the narrator speaks for a collectively defunct human family.

In order to emphasise the austerity of her vision Clarkson pits her narrative dialogically against Nevil Shute's best-seller *On the Beach*

(1957) which is implicitly criticised for persistent sexual puritan-
ism: 'what a culture we live in', a woman exclaims, 'a culture where
love is "dirty" and a hundred megaton bomb is "clean"' (Clarkson
1959: 90). The twinned allusion to Shute and the debate over 'clean'
bombs (which Clinton Anderson opposed) bears on the former's
sanitised version of radiation death. By contrast, Clarkson takes the
reader through a detailed and authentic sequence of symptoms from
nausea to total loss of bodily control. When they repair their radio
her hopes translate themselves temporarily into an imagined future
narrative:

> We would radio. Someone would send a plane. And some day
> some of those children would rebuild the world, a world where
> no one would ever make war again. They could never forget
> what had happened this time. There would be the mutants to
> remind them in each generation. (Clarkson 1959: 123)

But when the radio is got in working order, the resulting silence
makes that hope (and that narrative of rescue) collapse. The novel
constantly composes and decomposes possible narratives of sur-
vival which become more and more tenuous as children and women
die off. Since, as one character remarks, these two groups represent
the 'future made flesh', then an unusually literal identification is
established between children and a possible story of survival. The
problem of an ending, paramount in nuclear war fiction, is
thematised here through a complaint by one character:

> I believe the most dangerous American tradition is the cult of the
> happy ending. We just can't believe that anything really bad can
> happen at the end of our story. We expect the going to be rough
> at the beginning and in the middle, but we have absolute faith
> that everything will turn out all right in the end, no matter what
> we do. (Clarkson 1959: 37)

The novel therefore not only dramatises an ending but also concep-
tualises endings in order to ridicule a recurrent national narrative
reliant on 'some fluke or gimmick'.

Clarkson's novel then culminates its polemical force by
challenging the paradigm identified above. Merril finesses over the
possible return of Gladys's husband; Frank introduces rescue and
then denies it as a prelude to a 'thousand-year night'; Clarkson even
turns her setting into an ending, transforming the beach from
playground into the site of evolutionary demise.[11] Lois, as mother

and narrator, functions as the doubled originator and, like Leo Szilard and Peter George in the frame to the novel *Dr. Strangelove*, hypothesises 'other beings in other worlds' out of despair over humanity's self-destructive impulses.

Bearing posthumous witness similarly motivates Carol Amen's 1981 journal narrative 'The Last Testament' which is frankly revisionary, questioning presuppositions and imagery from consensus perceptions of nuclear war. Her account reads rather like an updated version of *Shadow on the Hearth* without the emergency radio instructions. Narrated by a housewife living near San Francisco whose husband is absent at work, this story foregrounds mothering as a two-way process of dependence and privileges moments of bonding with other children and other mothers.[12] Nothing could be further from a survivalist ethic than Amen's journal which progresses by an internal dialogue between despair and an imperative for the 'record to be accurate'. As the number of deaths rises, the 'destination' of her narrative becomes increasingly difficult to identify. At some points addressing her absent husband, at others a posterity about to be erased, the journal cannot conclude. Like Roshwald's *Level 7* it breaks off in the middle of a statement 'I wish —', a half-formulated expression of desire.

(V)

The pieties of civil defence campaigns that the family will remain a social nucleus and that the house will stay a refuge are contested throughout this fiction, sometimes to negative effect. Ward Moore's 'Lot' (1953), for instance, describes the unravelling of the family unit during a post-nuclear evacuation of Californian cities. Hostilities between its members culminate in the father driving off with his daughter. The sequel 'Lot's Daughter' (1954) set several years later, describes a travesty family where the father and daughter's child is simply labelled 'the boy'. A dialogue with earlier survival narratives (*Robinson Crusoe*, *The Admirable Crichton*) presents the father as a cynical anti-hero, recognising his incompetence: 'the heroic fictional man (*homo gernsbacchae*) would have found the house, rounded up the cattle, started all over' (Moore 1954: 12). But the father is no such figure, rationalising his few selfish actions as 'unsentimental'. No coherent narrative of survival emerges and indeed the story begins and ends bathetically with the father's tooth-ache. Moore's stories and a number of later narratives deny the idealisation of the home. Nicholas von Hoffman's 'The

Brahms Lullaby' (1982) describes a commuter village housewife's preoccupation with social routine and sexual fantasies against a background of East–West combat in central Europe in effect ridiculing narratives like Carol Amen's. Nuclear War is expected rather than experienced in this story and Tim O'Brien's *The Nuclear Age* (1985) where the protagonist acts out his fears of war by digging a hole in the family yard. Fantasy of control? Sign of madness or construction of a nuclear shelter? The meaning of the act remains ambiguous as does the narrator's bizarre confinement of daughter and wife to their house.

Undoubtedly the bleakest deconstruction of the home comes in the 1983 TV movie *The Day After* which juxtaposes shots of missile silos with house basements, both embedded in the American heartlands. The idyll of farming life literally conceals a military infrastructure which makes Kansas a priority target. When war does break out it impacts with particular force on the families whose lives we have been watching. As news of the world crisis reaches the stage of national alert, characters' reactions are to head for home. But the nuclear blasts demonstrate the physical frailty of dwellings and separate loved ones through traumatic memory loss. The situation deteriorates even further. A farmer tells fugitives 'this is my home' immediately before being shot and there is no local restoration of civic order *à la* Pat Frank. The film's conclusion denies the return pattern used by Alfred Coppel and others. Doctor Russ Oaks picks through the rubble of Kansas City, then tells a group of fugitives 'get out of my house', but there is no identifiable building visible and the demise of the home has been linked iconically to the doom of the nation through the ubiquitous American flags in the first half of the film. The family, in common with all other institutions, has failed its integrating role and the home been totally erased.[13]

Notes

1. Winkler, 1984. For comment on early civil defence see Boyer 1994: 319–33.
2. Holt 1990–1: 209–10. Cf. Edward Bryant's 'Jody after the War' (1971; collected in Miller and Greenberg 1987) where the desire of two contaminated lovers is blocked by fears of radiation sickness (explicit subject) and also by suppressed guilt feelings over Hiroshima and Nagasaki where they too have become 'survivors'.
3. See Theodore Sturgeon, 'Prodigy' (1947, collected in *Caviar* [1955]);

Huxley, *Ape and Essence* (1949); André Norton, *Star Man's Son* (1952); and Lester Del Rey, *The 11th Commandment* (1962). Robert Silverberg's anthology *Mutants* (1974) is also useful.

4. Letter to David Bradley, 19 February 1949, Merril papers, Canadian National Archives, Ottawa.

5. For an account of the identification in this period between nuclear energy and rampant sexuality, where the home offered a means of containment as well as shelter, see May 1988: 92–113.

6. Ralph Lapp's *Must We Hide?* (1949) and Gerstell's 1950 booklet are discussed in Boyer 1994: 314–5 and 323–5. Lapp was later to achieve fame with his account of the Japanese fishermen contaminated by fallout after the Pacific H. bomb tests *The Voyage of the Lucky Dragon* (1957). Lear, 1950.

7. Bradbury 1983: 206. One of the more famous Hiroshima photographs showing the forms of a ladder and soldier imprinted on a house wall is reproduced in Nigel Calder's *Nuclear Nightmares* (1979).

8. Magill 1979: I: 41. In his article on nuclear fiction Frank declared: 'The novelist who chooses a nuclear subject should not be awed by technical complexities, but the facts he sets down on paper must be accurate' (Frank 1960: 25). He had already dealt with Soviet attempts to trigger a nuclear war by sabotage in *Forbidden Area* (1956: UK title 7 *Days to Never*).

9. Cf. the valley microclimate in Robert C. O'Brien's *Z for Zachariah* (1975) where a teenage girl is the sole survivor of her family after a nuclear war. Her home is then occupied by a former radiologist who attempts a double violation through sexual assault and shooting, partly to purge his guilt from his work. Here the valley functions as a home place, liable to invasion by radiation or rampant males and is left behind finally when the girl sets out to hunt for other survivors.

10. Towards the end of the novel the arms race is satirised as a soap opera sponsored by the AEC. The entire novel draws on the 1957 congressional hearings of the AEC on fallout and continues within its pages the debate which was happening in the *Bulletin of the Atomic Scientists*. The latter was the source of a character citing Sir John Slessor on the desirability of abolishing war, for instance.

11. W. Warren Wagar has described this location as the 'favourite zone for secular eschatologists, marking the point of transition from land to ocean, from man's active life as an air-breather to amniotic unconsciousness and oblivion' (Wagar 1982: 188).

12. The 1983 film adaptation *Testament* makes the role of children even more explicit by setting the action in the town of Hamlin and having as school play *The Pied Piper of Hamelin*.

13. Cf. Peter Jeffrey and Michael O'Toole's cogent analysis in Chilton 1985: 167–181.

V — Cultures of Surveillance

In the 1984 of Big Brother one would at least know who the enemy was (William H. Whyte, 1956)

(I)

In the last chapter the home was repeatedly tested out as a site for post-nuclear survival. However effective the home was as a refuge, Merril, Frank and others show the continuing need for communication with the authorities through radio. The use of a visual medium, however, carries with it a crucially different dimension of control rather than informing. Orwell's Winston Smith begins his day following prescribed exercises on his telescreen and at the same time is observed by it. There is a clear line from 'panopticism', the social system of surveillance which Michel Foucault describes in *Discipline and Punish*, to such Cold War devices as Orwell's two-way telescreen or the 'Spy-Eye' satellite described in Theodore Sturgeon's 'Unite and Conquer' (1953). Both are designed to produce total visibility: 'There needn't be a single spot on the globe unobserved' (Sturgeon 1955b: 16). The all-seeing eye of God is secularised into a political nightmare of total control where the figure of visual observation signifies a whole elaborate system of monitoring and documentation. Philip K. Dick's *Eye in the Sky* (1957) makes this application explicit by opening with a California scientist being told that his wife has been classified as a company security risk. He witnesses the end result, an FBI investigation into his wife which loses him his job because of the mere possibility that she has been associating with left-wing organisations. The bureaucratic demonstration of surveillance is then shown as affect when a character experiences a fantasy of ascent, only to see a gigantic eye watching him. The gaze entraps him as he tries 'futilely to pry himself loose from the field of vision' (Dick 1979: 95).

68

This system of surveillance – literally 'looking over' – receives its classic formulation in *Nineteen Eighty-Four* which rapidly became the exemplary text for describing the militarisation and centralisation of American life into the 'quasi-dictatorship' Philip Wylie identified as early as 1951, being cited in William H. Whyte's study of the corporate ethic *The Organization Man*, and Vance Packard's account of motivational research *The Hidden Persuaders*. Lewis Mumford declared in 1954 that the world of Big Brother was 'already uncomfortably clear' and, contributing to a 1962 *Partisan Review* symposium, the sociologist David Riesman attributed the popularity of Orwellian dystopias to the Bomb: 'When governments have power to exterminate the globe, it is not surprising that anti-Utopian novels, like *Nineteen Eighty-Four*, are popular, while utopian political thought ... nearly disappears' (Riesman 1964: 95–6).

Orwell was crucially influenced in the planning of his novel by James Burnham's *Managerial Revolution* which described the rise of centralised bureaucratic superstates on the Stalinist or Nazi models. Orwell in turn anticipated Burnham's subsequent revisions by identifying a new dark age where superpowers will confront each other indefinitely and use the mere threat of the new bomb to suppress satellites into acquiescence (Orwell 1970: 26). In *The Struggle for the World* (1947), so as to be 'in accord with the revolutionary "nuclear age"' (Burnham 1947: 34), Burnham simplifies world political geography into a struggle between two expansive powers where the problem of control is identified totally with the issue of who has a monopoly of atomic bombs. We are already, Burnham insists, living in World War III which has reached an 'explosive state' that will almost certainly break out into open hostilities within the next five years. For all his reservations about Burnham's analysis (too apocalyptic, exclusion of democratic socialism, etc.), Orwell wove the former's conception of power blocs maintained on a permanent war into his novel (cf Reaves 1984). In *Nineteen Eighty-Four* war has become a rationale for official policy, a catch-all justification for domestic measures and – most importantly – a means of dissociating the day-to-day lives of the citizens from participation in control. As Murray N. Rothbard has pointed out, a 'perpetual cold war' underpinned Orwell's nightmare: the 'entrenchment of totalitarianism' (Rothbard 1986: 5).

There are hints that the novel is describing the aftermath of a nuclear war. The 1954 BBC TV movie makes this unambiguous by opening with shots of nuclear explosions and then panning across a ruined London. Colchester has been bombed, we are told in the novel, but since all information on present events is heavily

mediated it is quite possible that the current war is a fiction. Big Brother reflects this primacy of sign over referent in being an icon whose power is located in the eyes. One of the cruellest ironies in the novel occurs when Julia declares 'they can't get inside you' (Orwell 1989: 174) when of course the entire narrative demonstrates that they can. No space, domestic or psychic, is inaccessible to the gaze of the state which is 'socially totalitarian' in Burnham's phrase and this is shown to be a condition of language. Newspeak obviously represents an attempt to bring language (and therefore thought) under total control, but so far only within the context of official statements. Early in the novel Winston Smith recognises a more chilling characteristic of 'doublethink': 'consciously to induce unconsciousness, and then, once again, to become unconscious of the act of hypnosis you had just performed' (Orwell 1989: 37–8). Through such a process state ideology can become totally internalised, which is what has happened in Smith's case. Two principles – of state power and of the citizen's guilt – operate throughout Smith's covert acts, even when they seem on the surface to represent disobedience. Thus he records in his diary: 'it had got to be written down, it had got to be confessed' (Orwell 1989: 71), as if in a trial already happening. Since Smith's job is the modification of the 'historical' record, he knows better than most the extent of the state's capacity to manipulate the record and this consciousness desubstantialises his self into a ghost writing for a future readership that will probably never exist. Smith has recognised his own typicality as 'criminal' from virtually the first page and the narrative becomes a confirmation of the expectations of arrest. When it happens there is almost relief: 'it was starting, it was starting at last!' (Orwell 1989: 230). Once the process of interrogation gets under way, O'Brien takes on the roles of a 'doctor, a teacher, even a priest, anxious to explain and persuade rather than punish' (Orwell 1989: 257). O'Brien thus enacts the triple analogy of dissidence with illness, error and sin, demolishing Smith's presumptions about reality in order to demonstrate Burnham's point that the state pursues power as an end in itself.

Nineteen Eighty-Four supplied images which reinforced popular hostility to Stalinism in the USA (Solberg 1973: 45) and helped also to define a narrative paradigm for postwar American dystopias. The starting point is usually a strong centralised state with the protagonist situated institutionally within the power structure. One or more characters (Julia and Syme) act as catalysts to bring the latent dissatisfactions of the protagonist to the surface although his 'dissidence' remains ambiguous throughout. Once the protagonist

has manifested his restiveness he places himself at odds with the law and is liable to arrest which serves as a prelude to extended interrogation.

(II)

A totalitarian security apparatus was not usually described as an imported system so much as a warping of American institutions. The fifties produced a number of specific parodies of McCarthy and his witch-hunts. Black-listed mathematician Chandler Davis's 'Last Year's Grave Undug' (written 1952–3) looks forward to the immediate aftermath of a nuclear war with dead members of a Loyalty Legion sprawled in the ruins still clutching pledges containing the House Un-American Activities Committee (HUAC) formulaic denial of membership of the Communist Party. The story actually narrates a recurrence of McCarthyism arising from the need for scapegoats. 'Things are going lousy, and the lousier they go the more Reds there must be to cause it all', declares one character, 'so get out a new Loyalty Legion and have another rat hunt' (Conklin 1962: 117). Richard Condon's *The Manchurian Candidate* (1959) mounts an extended parody of McCarthy, depicting him as the incompetent mouthpiece of his Machiavellian wife (see Seed 1997a: 546–50); and Delmore Schwartz in 'The Hartford Innocents' takes a school as a microcosm of America where a ranting fascistic senator is faced down by a young girl's insistence on freedom.[1]

The most sustained satire on the security state occurs in James Blish's *They Shall Have Stars* (1956), the opening volume of his Cities in Flight sequence, which he later admitted devoted 'about a third of its wordage to a personal attack on the late Sen. McCarthy' (Blish 1970: 34). The novel describes the FBI monitoring of a research project on space flight which is being pursued by a Dr Corsi, clearly modelled on J. Robert Oppenheimer. Not only does his nickname resemble the other's ('Seppi'/'Oppie'), but he too undergoes questioning on his activities. During his revision of the novel Blish added an epigraph from Oppenheimer on the dangers of secrecy.[2] The imagery of detective fiction is introduced in the opening lines of the novel: 'The shadows flickered on the walls to his left and right, just inside the edges of his vision, like shapes stepping quickly back into invisible doorways' (Blish 1968: 13). These shadows represent the submarginal signs of FBI surveillance; like their hidden microphones, the presence of agents is assumed rather than perceived. The year is 2013 and the American space programme has

virtually ground to a halt thanks to Congress's caution over appro-
priations and the divisiveness of the security apparatus presided
over by Francis Xavier MacHinery, hereditary head of the FBI and
political pugilist extraordinary: 'Though he would have been easy
to dismiss on first glance as a not very bright truck driver, MacHinery
was as full of cunning as a wolverine'.[3]

Throughout this novel information is a commodity which confers
power and therefore has to be monitored endlessly by MacHinery
and his cronies, with the following result: 'In the Age of Defence to
know was to be suspect, in the West as in the USSR; the two great
nation-complexes had been becoming more and more alike in their
treatment of "security" for the past fifty years' (Blish 1968: 37). The
main casualty of the novel is a senator who suicidally writes to Corsi
about a conspiracy, thereby sealing his own fate: 'if one is sensible
about such matters these days', he writes, 'one never puts anything
on paper at all' (Blish 1968: 133). But he does so and his subsequent
death confirms that at least part of the novel's text has been subject
to the surveillance which is its subject. In such narratives, David
Punter points out, 'the text itself ... is implicated in the process of
surveillance, and has to perform increasingly complicated manoeuvres
to avoid entanglement in a military/commercial complex' (Punter
1985: 97). Senator Wagoner's title implicates him in the American
power structure but his name also signifies a constellation. So while
he textualises his very cell wall in the novel's coda by inscribing 'every
end is a new beginning" (Blish 1968: 181), he embodies the future of
a space flight as a dream of escape from the security state. He cannot
avoid becoming part of the 'pile-dump' of Brookhaven National
Laboratories (a detail added by Blish), but he can express the yearn-
ing for flight from a world where the loss of freedom of information
is symptomatic of the loss of other freedoms. Blish takes an unusually
long historical view in this novel, locating the action within a
Spenglerian era of dead belief-systems and bureaucratisation.[4]

(III)

Reviewing *Nineteen Eighty-Four*, Philip Rahv declared that it explored
the 'psychology of capitulation' (Meyers 1975: 270) since through
the process of interrogation dystopias critique the nature of the
regimes' ideological enforcement. The most sustained dramatisation
of the analogy between political correction and psychotherapy
occurs in David Karp's *One* (1953). Although its reviewers con-
stantly compared the novel with *Nineteen Eighty-Four*, it was more

directly modelled on Arthur Koestler's *Darkness at Noon* (1940). 'If I have a literary parent', Karp has stated, 'it's Koestler'.[5] Like its predecessor, *One* takes place overwhelmingly in interiors – meal halls, offices, conference rooms and so on. The protagonist is a college professor of English (so an expert on words), expert lip-reader and police spy, reporting to the Department of Internal Examination on a regular basis. The agent of surveillance becomes himself a subject for investigation when Burden undergoes an extended interrogation during which his buried feelings about his relation to the state are revealed.

Karp repeats Orwell's foregrounding of orthodoxy, not as an achieved state but as an internalised self-censoring process which runs throughout Burden's thoughts: 'Even if heresies had been reported against them [his sons] nothing would be done to harm them. Harm? hurt? Punish, punishment, punitive – again and again during the day the words came to mind. What could he be thinking even to let such words enter his thoughts? There was no punishment' (Karp 1967: 18). Although the state has abolished such terms to promote a benign ideology, they recur in early dialogues, and Burden's reprimanding of himself anticipates the series of questioning sessions he has to go through with different officials. The state has a utopian purpose to identify the good of the individual with that of the nation so that the pronominal opposition in Koestler's novel between 'I' and 'we' is now expressed through the ambiguous singularity of Karp's title.[6] Is Burden one of many or an individual? Even on a grammatical level it becomes difficult to answer that question. Passive verb forms ('he had been told') blank out the origin of actions all bearing on Burden situating him passively; and no-one is more willing than he to use the official discourse of 'heresy' which runs throughout the novel.

Burden's 'therapist' is the state 'inquisitor' Lark. He resembles O'Brien in combining the roles of investigator, teacher and doctor; he further unconsciously demonstrates the power play in his actions concealed by the state ideology of therapy, boasting: 'I'll dig out his soul and squeeze it between my fingers' (Karp 1967: 60). Through Lark's probing Burden is revealed to be living out a schizoid existence as professor and family man on one level, and informer on the other. Burden's initial denials of his heterodoxy fit this pattern exactly. It is only under drugs that he comes to admit that he is a heretic. Even this admission, however, is premature and simplistic. Karp shares Koestler's sense that 'twentieth-century man is a political neurotic' (Koestler 1955: 215); he wrote his later novel *The Last Believers* (1964), for instance, to attack the 'persistence of

the communist myth of a rational world'.[7] Burden suffers from a lack of congruence between life-style and belief but, as his questioning progresses, there emerges an unexpected resemblance between himself and his investigator which has implications for the state itself. Just as Smith recognises a kinship with O'Brien, so Lark sees his own earlier self in Burden and his increasingly violent declarations of intent ('I'm going to pulverise this man's identity' [Karp 1967: 142]) represent attempts at erasing his own past. Lark even admits at one point that he himself is a 'heretic'. Similarly Burden is threatened with indefinite captivity or execution in the name of benevolence. When one reviewer praised the novel's dramatisation of the 'conflict between the helpless, insignificant man and the demoniac forces against him' (Smith 1953: 29), he was greatly simplifying an unresolved paradox within the state's ideology.

The culmination of Burden's questioning is his symbolic death which is enacted through a substitute funeral (like the televised killing of Montag in Bradbury's *Fahrenheit 451*), and his rebirth with the new name as Hughes. Without understanding the origins of heresy, Lark shapes a new identity for Burden who registers both a sense of vitality ('just as if I had been born all over again' [Karp 1967: 225]) and of estrangement: his new clothes are the 'belongings of a corpse', his face in a mirror resembles a 'death's head' (ibid.: 230). As he makes new friends 'Hughes' is taken to a meeting of the Church of State ('all is one and one is all') but refuses to join, clinging on to a residual individuality. Lark's experiment ultimately fails because Hughes's integration is only partial, and his execution is ordered. But what hangs on his fate? Damon Knight found a central weakness of the novel to be that 'the state cannot be judged, cannot be compared, and cannot frighten because it does not exist: it has not only no name, but no history, no philosophy, no doctrine peculiar to itself, no symbols, no slogans, no catchphrases' (Knight 1954: 62). This criticism is unfounded because Karp dramatises the state under a single aspect: how it achieves the acquiescence of its citizens. The regime is described without cultural markers, but as the culmination of a process of Americanisation which reinforces national bonding through a secular church whose slogan explains the ambiguity in the novel's title.

Only rarely does the investigator himself become the protagonist in a dystopia as happens in *The Gates of Ivory, the Gates of Horn* (1957). The poet Thomas McGrath was hauled before HUAC in 1952 and lost his college post when he admitted to left-wing allegiances. In a statement to HUAC he accused the committee of creating a 'religion of fear' (McGrath 1982: 9) and uses his novel to attack a

culture of surveillance. *The Gates* opens with a trial so anonymous that characters only bear role-names: Investigator, Umpire, etc. Only in the margins of the text can we glimpse signs of resistance to the hegemonic discourse of the system. We are told, for instance, that the accused is 'like a witch on a ducking stool' (McGrath 1987: 18) reflecting McGrath's sense of resemblance between political extremism and witchcraft.[8] For all its claim of technological modernity, the regime practises a primitive system of conviction by potential rather than actual guilt, which even infects the Investigator Carey. 'Why did he feel guilty?' (McGrath 1987: 29) we are asked after an apparently successful trial. The narrative presents a series of shocks rather than an early answer. Carey is confronted with a photograph of his twin brother who is being investigated for sabotage; his office is booby-trapped twice; and he smashes his 'confessomech' (an electronic device for taking confessions) when it attempts to inject him with truth serum. He is egged on to reject the system by a neighbouring writer who declares: 'We live in a machine society' (McGrath 1987: 70) but who has himself compromised professionally by composing 'spellcasts' (televised advertisements). The issue of freedom is thematised in arguments between the two; meanwhile Carey's sense of guilt is pushing him into a paranoid obsession of being under constant observation.

By this point the roles of O'Brien and Smith have telescoped in Carey's divided consciousness who consults a gigantic computer ('Sybil') to learn the truth. The result is a series of cryptic statements leaving him none the wiser. Carey gradually loses contact with his surroundings, like Smith, and speculates on a conspiracy lying behind all the recent discrepancies in his experience. McGrath takes the process of surveillance to its paranoid extreme by revealing that Carey has been investigating himself. In the surreal climax to the novel, whose title refers to the gates of sleep from the *Aeneid*, Carey sits in darkness with a bright light shining in his face where a second voice reveals his own mechanised nature to himself. The result is not a psychological insight, but a revelation of the system: 'If everyone is guilty, either now or later, and if everyone is to be suspected, you will have to suspect yourself in the end' (McGrath 1987: 125). Orwell signals the arrest of Smith and Julia as an appropriation of their words into the 'iron voice' of the state. McGrath in the nightmarish scene just described collapses two voices together into a homology: '*You are me!*' Carey exclaims. Estrangement from the state system viewed as ritualised magic can never turn into overt criticism because Carey introjects his unease into a dialogue between two aspects of his self-subject and object.

The above identification of voices signs an Orwellian integration of the self back into the system and a reclosure of its ideology.

(IV)

Reflecting in 1958 on developments since *Brave New World*, Huxley posited a 'Will to Order' which brought about a 'reduction of human diversity to subhuman uniformity, of freedom to servitude'. If the present is the 'era of the social engineers', the next century will be that of the 'World Controllers' (Huxley 1994: 31, 38). The dominant metaphor in this context is the machine, suggestive at once of a controlling elite and the reduction of the masses to dehumanised instruments. In his first novel *Player Piano* (1952) Kurt Vonnegut extrapolates industrial production across the whole of society. 'This is a lonesome society', he has stated in interview, 'that's been fragmented by the factory system' (Vonnegut 1975: 269). His novel is set in an era of supposed plenty following the 'Last War'. Drawing on his experiences in the public relations section of General Electric in Schenectady, Vonnegut depicts the power-centre of an industrial combine, Ilium, as a conquered territory, echoing Caesar's *Gallic Wars* in the opening lines of his novel. Ilium, a synecdoche of America, divides spatially into three areas occupied by the managerial elite, the machines and 'almost all the people'. Dominating this military-industrial complex stands the battlemented works, patrolled by armed guards. To the regime the machine embodies an ideal of social interfunctioning: National Classification Tests allot citizens their 'best' place in society.

Vonnegut depicts a society directed by a technocratic elite within which the protagonist Paul Proteus is initially a middle manager. Mechanisation of his world figures as an endless series of loyalty rituals disguising the cost of the system in terms of human 'waste'. Proteus – named after the shape-changer of Greek mythology – is called on to prove his loyalty either to an old friend or to the company, and at this point begins to slip out of his class. Now the state security apparatus, previously only implied, begins to impact on him. As soon as he loses work Proteus has to register with the police, not only becoming 'unclassified', but labelled a potential saboteur. In the last third of the novel Proteus is jerked backwards and forwards between the company (or state) and a secret dissident group whose methods unconsciously mirror the state's. Thus he is interrogated under drugs by the dissidents, then charged with conspiracy in a televised show trial. This redraws the 1949 prosecution

of the American Communist Party Leadership as a Luddite conspiracy against the machines. In the 1949 trial excerpts from Lenin were read out as proof of incitement to violence. The prosecution's main evidence in *Player Piano* is an open letter written by the dissidents in Proteus' name rallying the workers to take over the means of production. Proteus is thus scripted by the movement into a leader's role which makes him personally dispensable: 'You don't matter ... you belong to History now' (Vonnegut 1977: 246). In contrast, for the company he has to infiltrate the movement and then go on trial as 'saboteur'. The two groups differ in their choice of medium. For the movement he offers a name; for the state he offers a TV image of the conspirator wired up through the multiple sensors of a lie detector, an image which encapsulates Proteus' entrapment within a system from which there is no escape. Vonnegut's satirical identification of company with national interests, enforced by a National Security Act, approaches a left-wing view of America dominated by capital; but the resemblance between state and opposition (both bureaucratic, both use shirts as symbols of 'membership', both use the discourse of efficiency) blocks any hope of utopian reversal. The only use of the term 'utopia' in the novel is to apply it to the temporary destruction during an uprising in Ilium which is rapidly put down in a fresh demonstration of the hegemony of technology.

Player Piano makes no distinction between personnel management and state administration. Efficiency is the criterion common to both. Social engineering stands similarly at the centre of K. F. Crossen's *Year of Consent* (1954), set towards the end of the twentieth century when the USA has extended direct rule over the whole continent, even Greenland after a 'brief police action'. The state maintains itself through a massive system of cameras, bugs, and registration laws; a permanent Committee on Subversion is ever ready to find 'evidence of a new Communist conspiracy', and a giant computer, SOCIAC which coordinates all data on citizens. The most powerful wing of the administration is SAC ('Security and Consent'), whose acronym suggests a transposition of military security on to domestic politics, a kind of super-FBI with apparently unlimited powers. Communist dissidents are kept within South Dakota in an area designated the 'Free State', actually ringed like the Reservation in *Brave New World* with an electric fence. The Cold War labels persist, but anachronistically: 'The World was now divided into two parts, communistic and democratic – although the original meaning of both words had long ago been lost. Each faction was headed by men who ruled through the giant calculators' (Crossen

1954: 114). Monitoring, as in Orwell, is directed towards control through manipulation: 'The administration wanted to know as much as possible about what everyone thought and felt' (ibid.: 32). This information would enable the administration to present every new move in a way which would be accepted, and thus enact 'government by consent'; more accurately, government by conditioning.[9]

(V)

In the novels considered so far the very status of books is involved in state processes of control. Orwell's Ministry of Truth churns out a regular flow of pulp fiction and textbooks but Goldstein's book is banned as a 'compendium of all the heresies'. McGrath describes a society where historical works are forbidden and Crossen one whose ideology is reinforced by popular fiction describing government agents pursuing Communists. C. L. Moore's *Doomsday Morning* (1957) gives an added twist to the role of literature when rebels against a benevolent dictatorship in the USA insert coded references into public plays which can only be spotted by those rebels. The fate of books in a dystopia becomes a special case of the circulation of information since their prohibition metafictionally forbids the novels we are reading. The most famous postwar novel to dramatise this prohibition is Ray Bradbury's *Fahrenheit 451* (1953), where firemen have conflated the roles of janitor and policeman to destroy all books. Bradbury himself has related his novel to bookburnings in Puritan New England, the Soviet Union and Nazi Germany, adding: 'Fortunately, nothing of the sort in the United States. Minor altercations with town censors, mayors, politicians, which have all blown away in the wind'.[10] In fact McCarthy's campaign to have 'left-wing' works removed from US libraries at home and overseas had such a serious impact that in the same year as the publication of Bradbury's novel the American Library Association issued a manifesto declaring that the 'freedom to read is essential to our democracy' and attacking the 'existence of individuals or groups with wisdom to determine by authority what is good or bad for the citizen' (American Library Association 1953: 1, 4). Bradbury had already identified that danger in the story 'Bright Phoenix' (written 1947–8) which describes an organisation of uniformed patriots (the 'United Legion') who burn the 'dangerous' books in a town library. The townsfolk resist by memorising the books. Bradbury wove this story and 'The Pedestrian' (1951: collected in *The Golden Apples of the Sun*) into *Fahrenheit 451*, 'The Pedestrian' describing a citizen

arrested for the socially deviant act of walking the streets at night.

The protagonist Montag serves as a functionary in a regime devoted to maintaining social order through media distraction. It is also a heavily gendered division of labour between the firemen and the housewives who are the passive consumers. The neighbour Clarisse subverts this separation by questioning the regime's rationale: 'Are you happy?' she asks Montag. In response, as in *Player Piano* and *One*, Montag's consciousness fractures into rival voices and even his body feels to divide in two. For Clarisse plays opposite Montag's wife Mildred (in Truffaut's film adaptation Julie Christie played both roles) who finds her ersatz 'family' in an endless TV soap opera (see Seed 1994a: 228–30). Clarisse triggers Montag's memory while Mildred drifts along in an infantilised present. In that sense Beatty is right to call Clarisse a 'time bomb' because she challenges official ideology. The most disruptive repeated questions in the novel are: Was it always like this? Were firemen always destroyers? Beatty occupies a position analogous to Orwell's O'Brien in that he practises the official line, but can also explain its history. This account is given as a 'therapy' to Montag when the 'illness' of dissatisfaction is beginning to take hold. Beatty describes an acceleration of cultural tempo which ostensibly maximises the value of time (an appeal to the gospel of efficiency) but which does so at the expense of history: 'Politics? One column, two sentences, a headline! Then, in mid-air, all vanishes! Whirl man's mind around so fast under the pumping hands of publishers, expiators, broadcasters, that the centrifuge flings off all unnecessary, time-wasting thought!' (Bradbury 1993: 62). The explanation presupposes a political division between an elite of manipulators and the masses; and contradictorily deploys an argument for increasing production to rationalise consumption. In short, Beatty can only expound the utopian purpose of state (to make all citizens equally happy) by maintaining a pre-utopian historical consciousness.

The benign purpose of 'cleaning up' an environment cluttered with the traces of literacy is repeatedly critiqued by the trope of personification which closes the gap between person and thing so that by the end people through memorising have become books. A manuscript fragment makes clear this link by relating books to political purges when Beatty explains: 'Books are dinosaurs, they were dying anyway. We just gave them the bullet behind the ear'.[11] Donald Watt divides the novel's ubiquitous fire-symbolism into the two functions of 'constructive energy' and 'apocalyptic catastrophe' (Watt 1980: 196). As in *A Canticle for Leibowitz* (see Chapter 12), fire can be regenerative as well as destructive; but it can also be coerced

into institutional symbolism like the phoenix-vehicles of the firemen. Even apocalypse becomes incorporated in the militaristic purposes of the state. From time to time jet bombers thunder across the sky, not suggesting a defence shield as in the 1955 film *Strategic Air Command*, but rather the dissociation of politics from social life (cf. Wylie 1951b). Like *Nineteen Eighty-Four* this novel contains media announcements of war (in Bradbury the *third* atomic war since 1960) which belie the welfare rationale put forward by Beatty. The state attempts to realise its Will to Order through a security agency doubling as police and janitors, acting on anonymous information from neighbours, but we only see the consumers, never the administrator-producers of this regime.

The narratives examined in this chapter all foreground different aspects of a technology which enables a system of surveillance to operate and assumes a grotesquely inflated security personnel which, according to Asimov, would be totally inefficient. In *Nineteen Eighty-Four* 'the watchers must themselves be watched since no one in the Orwellian world is suspicion-free' (Asimov 1984a: 320). The stripping down of figures like Winston Smith is a symptom of the regime's aim of totalised scrutiny. A dissident pointedly named William Morris in Mack Reynolds's later recapitulation of these themes, *The Cosmic Eye* (1969), explains the creation of a 'naked society' as continuing in from the McCarthy era ('everybody became so frightened of being branded a Red that they were afraid to open their mouths on any subject controversial') through the means of miniaturised electronics (Reynolds 1983: 37). Endless monitoring produces enormous dossiers in the national data bank. There is never an ideological closure, however. Even the most pessimistic dystopia includes some possibility of dialogue with the regime through opposing voices, however ineffectual.

Notes

1. Isaac Asimov also watched the Army-McCarthy hearings on television and got indignant about the latter's 'gangsterism'. His story 'The Martian Way' deals with colonists victimised by a 'McCarthy-style politician' (Asimov 1980: 702, 650).

2. The epigraph is actually an excerpt from a 1799 letter by Jefferson on preserving the 'freedom of the human mind' quoted Oppenheimer 1951: 8.

3. Blish 1968: 89. The periodical version of this narrative actually uses the name 'McCarthy' at one point (cf. Shippey 1979: 108); Blish later

revised the description to present MacHinery as a Boston aristocrat. Blish's collection *So Close to Home* (1961) is a veritable compendium of Cold War themes: mutations, the mining of ports, the nuclear shield, hawks' suspicion of detente, and so on.

4. On Spengler see R. D. Mullen's Afterword to the single-volume collection *Cities in Flight* (Blish 1985: 597–607).

5. Letter from David Karp, 5 June 1991. Karp dealt with the HUAC investigations in *All Honourable Men* (1956) and Soviet torture methods in *The Charka Memorial* (1954). His telescript *The Plot to Kill Stalin* (1958) aroused so much anger in the Soviet Union that the CBS correspondent was expelled.

6. Cf.: 'The definition of the individual was: a multitude of one million divided by one million' (Karp 1970; 246). Huxley in 1958 regarded *Nineteen Eighty-Four*'s control through punishment as already anachronistic (Huxley 1994: 3).

7. Bookfile on *The Last Believers* (Cape), Publishers Association archive, Reading University.

8. McGrath has stated: 'Witchcraft is a way of seeing the world and trying to control it. So is Marxism ... they're working from absolutely opposite ends' (Gibbons and Des Pres 1987: 63). For critical commentary on McGrath see Thompson 1985: 279–337.

9. For critical comment on Crossen see Clareson 1977: 74–80.

10. Letter from Ray Bradbury, 2 September 1992. Bradbury had read *Brave New World* but deliberately avoided reading *Nineteen Eighty-Four* because he would be 'working on a similar novel'. For further comment by Bradbury on the politics of *Fahrenheit 451* see Bradbury 1967, 1972 and 1975.

11. *Fahrenheit 451* papers, 2nd folder (1953), Bradbury archive, California State University, Fullerton. The film makes Clarisse's disappearance more sinister when a neighbour explains: 'They came to take them away'.

VI

Take-Over Bids: Frederik Pohl and Cyril Kornbluth

Like Alexander, we weep for new worlds to conquer (*The Space Merchants,* 1953)

(I)

In *Player Piano* and other dystopias consumer goods are used by the regimes to buy citizens' acquiescence. Allegiance becomes one object among others in a general process of commodification which motivates and sustains the administration. This process became the central subject of *The Space Merchants* (1953), a collaboration between Frederick Pohl and C. M. Kornbluth which describes the takeover of the Earth and near planets as a commercial form of imperialist expansion. This chapter will examine both writers' use of the grand narrative of exploration to satirise American domestic and foreign policy as operating under a single expansionist imperative during the Cold War. Pohl himself has recorded how, in common with James Blish and Ray Bradbury, his political ideals were formed in the thirties. Pohl joined the Young Communist League for a time but, though later disillusioned, has insisted: 'I didn't lose my concern for politics in 1940. I only came to believe that the Communist experiment had failed'.[1] Both writers were active members of the Futurians, a wartime organisation of science fiction novelists committed to radical politics; then after 1945 Pohl acquired commercial experience as an advertising executive and Kornbluth as Chicago bureau chief for a news wire service. In a 1957 lecture Kornbluth declared that 'science fiction ... should be an effective literature of social criticism' (Davenport 1964: 72), but all too often sank into escapism. When Pohl read this lecture he took issue with its strictures retorting that 'The science-fiction novel, generally speaking *is* social criticism in a way that no other *category* of novel (except perhaps religious or proletlit) ever is'.[2]

In fact *The Space Merchants* had already given the lie to Korn-
bluth's 1957 attack in its description of a world dominated by multi-
national business combines radiating from America. Schocken
Associates are mounting a project to market Venus. This imperialist
urge simply applies to space what has already taken place on Earth.
The novel extrapolates on a series of projects of increasing magni-
tude: the American midwest, India (on the analogy of the East India
Company), Antarctica, and finally why not the planets? The Venus
project is explicitly contextualised within the history of American
exploration and discovery by an enthusiastic executive who
exclaims: 'Not just a commodity. But a whole planet to *sell*. I salute
you, Fowler Schocken – the Clive, the Bolivar, the John Jacob Astor
of a new world!' (Pohl and Kornbluth 1965:13). This list is histori-
cally incoherent, lumping together colonialist administration,
liberation from colonialism, and mercantile and financial expansion.
The TV commercial put together to boost Venus is similarly riddled
with internal contradictions describing the spaceship as an 'ark'
taking 'pioneers' to 'tear an empire from the rich, fresh soil of
another world' (ibid.: 11). The activist emphasis on territorial
appropriation sits awkwardly with the visual imagery depicting the
quiet domestic security of a nuclear suburban family. The inco-
herence of the praise quoted above carries its own satirical point
because the medley of comparisons with Alexander, Napoleon,
Columbus and other figures suggests an expansionist drive unques-
tioned by the agencies where conquest becomes a good in itself.

The same analogies, but with the great autocrats of modern
history, occur in Kornbluth's 1953 story 'The Adventurer' where
the division of the planets between America and the Soviet Union is
an accomplished fact except for the satellite Io (an extra-terrestrial
Berlin) whose chief settlement is divided culturally by an invisible
line running down its main street. The Republic is run on Stalinist
lines: 'You simply spied on everybody – including the spies – and
ordered summary executions often enough to show that you meant
it, and kept the public ignorant: deaf-dumb-blind ignorant'.[3]
During a war between the superpowers the cadet son of a poor
miner performs prodigies of heroism and emerges as a new popular
leader ('they felt his magnetism'). At this point it is revealed to him
that he was genetically manufactured on the model of Napoleon,
Stalin and Hitler to be a maker of history, whereupon the new ruler
has those responsible executed for denying his 'godhead'.

In *The Space Merchants*, the commercial appropriation of the
discourse of frontier enterprise is foregrounded as a cynical sales
ploy used to counter a perceived exhaustion of other spaces, land

particularly. The old West along the San Andreas Fault has been destabilised geologically by the testing of H-bombs. *The Space Merchants* thus describes the activities of business combines as if they are exercising the foreign policy of a nation. The executive-protagonist and narrator Mitchell Courtenay, who is put in charge of the Venus project, explains: 'we wanted Venus colonised by Americans'(Pohl and Kornbluth 1965: 19). There is scarcely even a token recognition of other nationalities in *The Space Merchants*, which depicts a world and indeed a universe as empty space awaiting specifically American appropriation. The sentence just quoted originally opened with the words 'the government' and the revision confirms the usurpation of government functions by big business. There are hints throughout the novel, however, of an analogy between commercial expansion and military aggression. The Venus rocket is described as the 'bloated child of the slim V-2s' (ibid.: 11) and in his sequel to this novel, *The Merchants' War* (1984), Pohl fills out the analogy, describing the conversion into consumers of the nomadic peoples of the Gobi Desert by a night-time campaign virtually indistinguishable from military attack. Fireworks simulate bombs, 'speaker balloons' resemble parachutists and then a 'projector battalion' of advertising visuals goes into action. These actions only make explicit the politicisation of commerce in *The Space Merchants*. Reminiscing about advertising, Pohl wrote: 'When you spend your days persuading Consumers to Consume … , you develop fantasies of power. No, not fantasies. Power. Each sale is a conquest'(Pohl 1979: 132). So when Thomas Clareson comments that the criticism in *The Space Merchants* is 'only obliquely political; it centres on manage-ment', he is missing the novel's main point, namely that commercial management *is* political (Clareson 1987: 14). As Schocken himself explains to the protagonist, 'You've got power. Five words from you, and in a matter of weeks or months half a million consumers will find their lives completely changed. That's power, Mitch, absolute power' (Pohl and Kornbluth 1965: 39).

The world of *The Space Merchants* emerges as a distortion of early fifties America. The authors themselves were well aware of the main strategy they were using. In a statement prepared for a 1959 reprint of *The Space Merchants* they declared: 'The best of science fiction is that sort which extrapolates from known facts to an imagined but perfectly logical world of the future'.[4] American society is depicted as still being subject to McCarthyite fears of internal subversion. 'Loyalty raids' are as routine as government bugging. Against proliferating intelligence agencies and private security companies are contrasted the Conservationists (Consies) who are dedicated to

resisting the capitalist destruction of the environment. The label (Consies) conflates both 'Commies' and 'Conshies' (conscientious objectors to military service), whereas in the original serial (entitled 'Gravy Planet') they are less ambiguously designated 'Connies' and their organisation is linked to the perpetuation of security fears: 'The worse they think of Connies and the more afraid of them they are, the closer they cooperate with Intelligence and Security' (Pohl and Kornbluth June 1952: 52). As in *Player Piano* and *Fahrenheit 451* (for which Truffaut invited Pohl to write the screenplay), Pohl and Kornbluth initially situate the protagonist within an official structure and then progressively displace him, thereby dramatising the negative side to the novel's supposed world of plenty and prosperity. The action falls into three phases. In the first Courtenay travels to California and dismisses his entire market-research group, thereby exercising and confirming his power. He is next transported to a plantation in Costa Rica where he is relocated at the opposite end of the consumer cycle; from managerial elite he has sunk to manual labour. He finally re-establishes himself in the company and takes over as master of Schocken after the director's death.

Critical opinion has divided over the degree of Courtenay's self-awareness. However, John P. Brennan argues that Courtenay never really becomes a critic of the dominant ideology, but functions as a heuristic means so that the reader can discover the superficiality of that ideology whereby 'the human subject is controlled either by brute force or by simple, if hidden, devices on the order of Galton's whistle or chemical conditioning' (Brennan 1984: 110). At one point Courtenay slips into his narrative a quick passing reference to the 'engineered-in message' of advertisements, a phrase which establishes a crucial series of linkages. Courtenay is by trade a 'copysmith', a composer of advertising copy. As in *Brave New World*, a novel which Pohl has admitted exerted a major influence on *The Space Merchants*, an instrumentalist view of words as means to a practical end has superseded literature.[5] Like Syme in *Nineteen Eighty-Four*, Courtenay is a verbal technician. When shown a Consie manifesto he can only assess it as technique, and this underscores the limits to his perspective. Operating professionally on surfaces, Courtenay experiences a dislocation of appearances so that when he penetrates a Consie cell to his frustration he fails to identify the 'surface mark of the lurking fanatic inside' (Pohl and Kornbluth 1965: 104). One of the main ironies of the novel lies in its deferral of the Venus project for scrutiny of domestic subversion and commercial rivalry. Promoting one image of exploration, Courtenay is actually propelled into discovering his own planet.

(II)

The depiction of American-based commerce as being indefinitely expansive brings *The Space Merchants* near to left-wing analyses of the Cold War as a conspiracy of capital. For instance, in 1949 the American Communist leader William Z. Foster claimed that the 'most ruthless capitalists in world history' were striving to 'establish a Wall Street mastery over the world' (Davis 1971: 290). Pohl draws back from the world scene, however, in three companion stories to *The Space Merchants* which dramatise the domestic cost of industrial processes. 'The Tunnel under the World' (1954) opens with the protagonist dreaming of an explosion after 'thirty years of H-bomb jitters'. The story repeats its opening without the date progressing and then the protagonist discovers that his house is a metal replica. A local combine, Contro (read 'Control') Chemicals, has built a simulation of the town after it was destroyed in an industrial accident. The culminating shock comes when the protagonist realises that he has been miniaturised in a world no bigger than a table-top. Like Richard Matheson's *The Shrinking Man* (1956), where the trigger is a cloud of radiation, diminution actualises helplessness before the secret machinations of big business.

The complex interdependence of military and commercial activity can be seen in two stories from 1959: 'The Wizards of Pung's Corner' and 'The Waging of the Peace'. Both are set in an America devastated by nuclear war which the USA has won. There has been massive destruction but its impact is muffled by the anecdotal reminiscences of the narrator which present war mainly as a transformation of the social landscape. Pung's Corner has cut itself off from the residual federal authorities, and the story essentially recounts the attempts of the latter to take over the town. The story dramatises the tension between local communitarian values and government centralism in terms of military combat. At first a government agent tries to manipulate the community through subliminal images in TV advertisements; then a military campaign is mounted which fails because the infantry cannot understand their weapons' instruction booklets. Eventually a populist leader heads a march on the Pentagon and installs a new government.

Both these stories are fantasy interventions in a historical sequence tracing out shifts in Cold War domestic policy from dispersal through shelters to underground 'fortress factories' in cities like Detroit (General Motors was one of the leading recipients of postwar defence contracts). The measures in response to a

ghostly enemy who shadows American developments combine military escalation with unchecked industrial growth:

> Against an enemy presupposed to grow smarter and slicker and quicker with each advance, just as we and our machines do. Against our having fewer and fewer fighting men: pure logic that, as war continues, more and more are killed, fewer and fewer left to operate the killer engines. Against the destruction or capture of even the impregnable underground factories, guarded as no dragon of legend ever was – by all that Man could devise at first in the way of traps and cages, blast and ray – and then by the slipleashed invention of machines ordered always to speed up – more and more, deadlier and deadlier. (Pohl 1973: 253)

The change of government promises a utopian reversal of this process until, that is, the true efficiency of the underground factories is recognised. Long after war has minimised demand for electrical goods the factories keep churning them out, so the factories have to be stopped. 'The Waging of the Peace' is not an oxymoronic title but a description of how combat is transposed from the battleground to a struggle between humans and machines. The story parodies the language of wartime heroism: 'they were unarmed and helpless against a smart and powerful factory of machines and weapons' (Pohl 1987: 287); and concludes with a victory (the blocking of raw materials) that proves premature when the factories go on producing anyway.

The parodic dovetailing of wartime and peacetime production deflects any direct attention to nuclear war. The same is true of Pohl and Kornbluth's satire of Kennedy's shelter policy. 'Critical Mass' (1961) presents a defence-obsessed USA where everyone is on the make: the shelter programme is self-evidently good for the construction industry, bad for the military in diverting funds, and good for the President because he came to office on a promise to pass the Civilian Shelter Bill. But a specialist in concrete and even the President see the hollowness of the policy, the latter asking himself: 'What was the use of any kind of shelters ... if all you had to come out of them to was a burned-out Sahara?' (Pohl and Kornbluth 1962: 31). The contradiction between public discourse and private thoughts reveals the whole civil defence system to be a self-serving charade, deceiving the public into complacency towards nuclear war. Into this situation comes the metaphorical 'bomb' of the title, a news story on the uselessness of shelters. What will explode, once the chain reaction to the news gets going, is the

shelter craze. Pohl and Kornbluth thus transform the bomb – a suppressed presence in the story – into a satirical device for attacking its avoidance.

The sociologist David Riesman tried a different satiric strategy altogether in 1951 by replacing weapons with consumables. 'The Nylon War', set in the immediate present, has been going on for months. The USA is bombing the Soviet Union round the clock with cigarettes, watches and even fridges. At first Beria denies the raids are happening; then the Soviets retaliate by dropping caviar, furs and books of Stalin's speeches on Seattle. The result is a massive disruption of the Soviet economy (because consumers demand rockets) and charges from HUAC that trade secrets are being passed to the Russians. Ultimately the strategy defuses war sentiments and removes the demonic image of the Soviet Union: 'the once feared monolith now appears as almost a joke, with its crude poster-and-caviar reprisals, its riots over stockings, soap, Ronsons, and other gadgets which Americans regard in matter-of-fact fashion'.[6] Although Riesman's aim was to 'invent a moral equivalent for war' (Riesman 1964: 3), his rhetoric only replaces military triumphalism with consumerist superiority.

(III)

The Space Merchants' very title denotes a commodification process which the company's elevated rhetoric disguises as national enterprise. Kornbluth's *Takeoff* (1952) also deals with a space project, but in a non-satirical way. The constructing of a moon rocket is dramatised as an internal struggle between a restrictive security policy in the Atomic Energy Commission (AEC) and technological enterprise which has to be channelled through the American Society for Space Flight. Like Heinlein's *Destination Moon,* the target is chosen for its military potential. The president of the Society 'could see a most important area dotted with launchers for small, unnamed rockets with fission-bomb war heads, ready to smash any nation that hit the United States first' while the hyper-patriotic manager of the AEC who has devised the project sees the Moon as the embodiment of power: 'It's the power of life and death over every nation on the face of the earth, and some one nation has got to accept that power' (Kornbluth 1953: 8, 122). The illegal syphoning off of AEC funds for the project is thus rationalised by an appeal to a higher imperative of defence which the novel leaves unquestioned. *Takeoff* ostensibly conforms to an espionage thriller

(it was published during the trial of the Rosenbergs) set against a background where the AEC maintains its funding by keeping sweet the press, the public and Congress. In order to make its social point about restrictive AEC policy Kornbluth bases the action on the totally implausible notion that a moon rocket could be constructed by a handful of committed amateurs.[7] The paranoid atmosphere of the early fifties comes out clearly in the revelation by the protagonist of a conspiracy. As a right-thinking patriot, he makes a deposition to the regional AEC security officer that the project has received funds from a 'foreign power', but the true Soviet spy turns out to be the scientific director (conspiracy confirmed but relocated). And the funds in question prove to be those voted by Congress for the AEC, diverted for an ultimately patriotic purpose (conspiracy relocated again and defused). The novel reharmonises politics and technology at the end, closing with the moon launch, now officially approved, which will symbolically open up a new era of America's national destiny.

In a number of his own stories Pohl elaborated on aspects of this theme. 'With Redfern on Capella xii' (1965) establishes a clear continuity between planetary take-over and the development of British imperial rule through the parody-Kiplingesque administrator General Sir Vivian Mowgli-Glick. The most recurrent irony Pohl exploits is the presumption on the part of the colonisers that the indigenous species is primitive. In 'The Gentle Venusian' (originally entitled 'The Gentlest Unpeople', 1958) Pohl shifts perspectives backwards and forwards between the Venusians who see humans as 'monsters' and Earthlings who see the Venusians as 'bugs'. Within this interchange of view points the Venusians prove to be benign, extremely cultured and open-minded in their conclusion that 'Earth monsters are considered to be human beings, in spite of everything' (Pohl 1971: 115). Such an extraterrestrial perspective on Earthly activities is set up in 'I Plingot, Who You?' (1958) where Pohl uses the device of the visitor from outer space to satirise Cold War paranoia. Appearing before Americans, Russians and French, Plingot gives each 'evidence' of possible communication with other worlds. The result is that their suspicions of each other (i.e. their very lack of communication) come to a peak. 'Plingot' is a mask which Pohl has donned for ironic purposes and which he can temporarily discard to address the reader directly: 'Now, this is how it was, an allegory or parable ... it is a catalyst which is needed on Earth, and this catalyst I have made, my cosmetic appliance, my bomb' (Pohl 1973: 342). Once again Pohl appropriates nuclear technology as a metaphor of his own satirical purpose.

The estranged perspective of these narratives, their 'view from another star', questions a consensus acceptance of the militarisation of space formed as early as 1950 which Pohl sarcastically summarised in a 1962 *Galaxy* editorial:

> We need bases on the Moon, we say, because from the Moon we can with great telescopes spy out everything the Russians are doing here on Earth. We need manned satellites, we say, because from them we can 'drop' nuclear charges on any enemy. (Pohl 1962: 5)

Such an ideology is promoted in *Man Plus* (1976) by the US President who rationalises a mission to Mars as a fresh start for humanity. The USA is surrounded by 'collectivist dictatorships' after China and has been 'lost' and Cuba given 'to the other side', as if these countries were disposable real estate. Within the USA and abroad, where an expanded China ('New People's Asia') is confronting Australia, 'the planet was rapidly reaching critical mass' (Pohl 1978: 109–10). The 'Man Plus' of the title is a project to design cybernetic alterations to enable human survival on Mars. The problem in his novel, however, lies in Pohl's use of a guineapig subject as protagonist. The latter's experience is limited to the technology of the experiment while its political context has to be supplied as information only tenuously connected with the action. For Mars is planned as a refuge from the thermonuclear war the planners estimate is inevitable, and so questions of information then arise. How much of the forecast does the President know? How extensive is the leak from the US defence computer? The political plot is thus skewed from the tale of the American astronaut, an awkwardness which Pohl avoided in *Jem* by using a different narrative method.

(IV)

Pohl's narratives regularly foreground two processes: the exposure of commerce-based motives and the unpredictable consequences of planned enterprises. The last novel to be considered here demonstrates both. *Jem: the Making of a Utopia* (1979) was planned to show the 'future of international politics after the Cold War had run its course' (Pohl 1997: 16). Attempts are made to settle the planet Jem in a near future when three power blocs have formed, each defined by their major resource: food (the 'Fats' presided over by the USA), Fuel (the 'Greasies') and People (the 'Peeps' dominated by China). David N. Samuelson has argued rightly that, although the blocs start out with a utopian desire to start afresh, their rivalry

dooms the enterprise: 'the need, if they are to survive, to withstand each other, and to exploit the land and the natives, leads to a repetition with variations' (Clareson and Wymer 1984: 124). The opening section of the novel establishes the utopian purpose (in a conference on exobiology) within a political context (Communist Bulgaria) which pulls against the project's internationalism. *Jem* could therefore be read as a late- not post-Cold War narrative where political suspicions persist in altered guises. Pohl uses a multifocal method of seven main voices, but within each section the methods and purposes of the expedition are debated by a broad range of national representatives. The novel in that respect approaches what Tom Moylan calls a 'critical utopia' in debating the nature of contact with the new planet's sentient species, for instance.

The increasing prominence of one American character gradually transforms the action into a power play. Margie Menninger, daughter of a US senator, embodies within herself the military-industrial complex. Born into the Washington community, Margie has been trained at West Point and has direct access to appro-priation committees and to the media which she shamelessly exploits to promote a view of Jem as a 'planet where all the old hatreds could be forgotten' (Pohl 1980: 153). Margie is the prime mover of the novel. She takes the parts of a nuclear bomb to Jem, and shoots down a Peep satellite (actually aiming at their supply ship). And she trains a special combat force, only thinly disguised as an exploration party, to take over the planet. Through Margie's actions and words the utopian gloss on the project is stripped away; even its ecological necessity proves to be a political one because large parts of the Earth are destroyed by a thermonuclear war, not by a natural disaster. The appropriative impulse is figured through eating, a trope of consumption Pohl had already used in his fifties stories. So a Bulgarian wonders at one point 'what prodigious devourers these Americans must be' (Pohl 1980: 134), but without drawing any inferences for the politics of the Jem project.

Jem doubles in the novel as the site for a utopia and as a colony. As the novel progresses, one particular analogy comes to the fore: that of Vietnam. As early as 1957 in *Slave Ship* Pohl had drawn on Vietnam to supply him with an aggressive fanatical culture aiming at world conquest. By the 1960s Vietnam had become a more complex issue. While editor of *Galaxy* in 1968 Pohl circulated science fiction novelists with a questionnaire on whether the USA should stay in Vietnam which produced an even division of opinion. Commenting that the debate over Vietnam had been a 'tragic and divisive waste', Pohl tried to straddle the two sides of the issue

arguing that on the one hand the US would not abandon its commitment to the Vietnamese, but on the other hand 'it is too late for that, their country and their social structure have been destroyed'.[8] Ten years and thousands of American dead later, Pohl took a more sardonic view of such adventurism. Resemblances with Vietnam gradually emerge in *Jem* as the settlements become more militarised with fortified perimeters. To ensure that the analogy is not lost on the reader the comparison is made explicit between a chemical dropped on the Krinpit, the surface creatures, which deals with them 'as well as 2,4-D had dried up the jungles of Vietnam' (Pohl 1980: 232). There are even Vietnamese officers serving in the Fats' militia and a 'balloonist' species carries out surveillance like the Montagnards.

The same analogy was used by Ursula LeGuin in *The Word for World Is Forest* (1977) which grew out of her realisation during the Vietnam protests that 'the ethic which approved the defoliation of forests and grainlands and the murder of non-combatants in the name of "peace" was only a corollary of the ethic which permits the despoliation of natural resources for private profit or the GNP' (LeGuin 1989: 127). Here there is no preamble or grandiose purpose to probe behind. We are plunged immediately into a colonial situation on another planet whose base, New Tahiti, ties the action into the history of Western imperialism. LeGuin dramatises the enterprise as a culture clash between Earthlings who view trees simply as raw material to be shipped home and the diminutive planetary race whose language and culture is privileged in the novel's title. The establishment of armed camps, the use of napalm, and the ultimate defeat of the invaders all occur in both novels. Similarly both critique the colonialising discourse of the invaders by focalising sections through indigenous figures. LeGuin's ending predicts the imminent departure of the colonists while in *Jem* an accommodation is reached from necessity since Earth has been destroyed. Pohl carefully avoids triumphalism in a final choric comment on his characters: 'In the long run there are no survivors. There are only replacements. And time passes, and generations come and go' (Pohl 1980: 292). Pohl and LeGuin critique an expansionist principle based on the conversion of military superiority into a right to conquest. The very title of Barry B. Langyear's *Manifest Destiny* (1980) historicises this concept, setting its narrative in the next century when the USA has become the 'United States of Earth' and is expanding into other galaxies on the principle that man's ultimate end is to 'reign supreme' in the universe.

Pohl has declared that 'there is no *good* science fiction at all, that is not to some degree political' (Pohl 1997: 7) and he and Kornbluth

substantiate this conviction in their fiction dealing with the area where politics and economics intersect. At its bleakest Pohl's fiction reflects a sombre recognition that 'nothing is beyond price, or without a price' (Wingrove 1978: 12); and his particular purchase on the Cold War was to repeat with variations a grand narrative of commercial expansionism originating in the USA. His fiction is thus refreshingly ironic towards the labelling of domestic or external opposition to this process as 'Communist'. Although Pohl has strongly criticised the Soviet Union for this repression of writers he has never demonised that regime, and it makes a fitting coda to his treatment of Cold War issues that in 1987 he should have published a fictionalised piece of reportage on the Chernobyl reactor explosion. Nothing could have been farther from the image of the 'evil empire' than Pohl's handling of the details of the Ukrainian workers' lives. Indeed, the very publication of *Chernobyl* in itself demonstrated the workings of Glasnost (administrative openness) since Pohl received the necessary permissions to carry out research and interviews for his novel.[9]

Notes

1. Pohl 1979: 13, 14; 'Frederik Pohl' in Bryfonski 1984 : I: 286.
2. Letter from Pohl to Kornbluth, 23 December 1956, Frederick Pohl Papers, Syracuse University Library.
3. Kornbluth 1997: 31. Each president in this story is named 'Folsom', presumably after the site where traces of an ancient Amerindian civilisation were discovered.
4. 1959 statement, Pohl papers, Syracuse.
5. Letter from Frederik Pohl, 1 August 1991. Pohl adds: 'My conscious models were more the science-fiction stories of L. Sprague de Camp and Robert Heinlein'. Davis 1971: 290.
6. Riesman 1964: 72–3. Riesman received many letters from readers who thought his account was factual. And fact turned out to be only slightly less bizarre than his satire when in the early 1950s the CIA dropped consumer goods from balloons over Eastern Europe to create social dissatisfaction (Brands 1993: 61).
7. The Author's Note states: 'Some of the A.E.C. policies in the story are fictional projections of present A.E.C. policies which the author supposes will be exaggerated by the passage of time'.
8. Pohl 1968: 7. The results of the Vietnam questionnaire were published in the same issue (4–5).
9. For comments on Pohl's treatment by the Soviet authorities see the Afterword to Pohl 1987 and Barrett and Gentle 1988: 11.

VII The Russians Have Come

You must think, act and live for the state (American Commissar in *Face to Face with Communism*, 1951)

(I)

Again and again in the Cold War we encounter a principle of reversibility where characteristics attributed to one bloc mirror those of the other. Pohl's accounts of American expansionism partly reflect the more melodramatic master plan for world conquest attributed to the Soviet Union. Long before they possessed the technical means Soviet attacks on the USA were imagined and the popularity of dystopias with elaborate systems of surveillance coincided with the hardening of a consensus on the Soviet threat. By 1950 this perception had hardened into government policy in the attribution of a conspiratorial design to the Kremlin which called 'for the complete subversion or forcible destruction of the machinery of government and structure of society in the countries of the non-Soviet world and their replacement by an apparatus and structure subservient to and controlled from the Kremlin'.[1] Former Trotskyite James Burnham had already identified this 'worldwide, conspiratorial movement' which would culminate in America: 'The downfall of the United States will remove the last great obstacle. The Communist World Empire will begin' (Burnham 1947: 66, 117). In A. E. Van Vogt's *Tyranopolis* (1973) it has indeed extended right round the Earth. This '23rd century parallel to the career and character of the Russian despot, Joseph Stalin' (Van Vogt 1977: 5) shows a paranoid dictator with artificially enhanced longevity presiding over a Byzantine state apparatus.[2] By 1961 Nathaniel Benchley could ridicule this fear of an evil empire in his farce *The Off Islanders* which describes a Soviet submarine running aground on an island off Cape Cod. Benchley's realism involves a reduction

of the Soviet threat to a comedy of small incidents, a blanking out of nuclear weapons altogether, and a burlesque of science fiction when the Soviets tell the bemused islanders: 'take me to your leader'.[3]

Benchley's comedy did not get rid of the fear, however. From the fifties right into the 1980s the conviction of malign Soviet intent produced a series of narratives dealing with the Communist take-over of the USA.[4] These works not only embody a fear of the times but also investigate retrospectively the failure of national nerve which made that invasion possible. One of the earliest of these works was a propaganda film prepared by the Department of Defence. *Face to Face with Communism* (1951), like *Invasion USA* (1952) and *Red Nightmare* (1962), describes the transformation of American life when a town becomes an 'active unit in the Communist International'. Telephones are controlled and a local commissar proclaims the new creed of selfless devotion to the state (see the epigraph). A sergeant on leave is arrested and sentenced to death for questioning this authority. With only minimal consistency, he then finds that the jail has been left unlocked and returns through the deserted streets to his hotel. The next morning he discovers that the town has returned to normal and that its 'conversion' was a civil defence exercise after all.

Where the film presents a situation of civic transformation, Theodora Dubois' 1951 novel *Solution T-25*, by contrast, describes a whole cycle of unprovoked nuclear attack, invasion, enslavement and eventual liberation. The enemy is never named because its identity is assumed to be self-evident. The novel pays some attention to the plight of collaborators in the occupation regime, the regimentation, and encoding of unrest as disease ('symptoms of social decay') but *Solution T-25* remains a Buck Rogers adventure in that a secret weapon (T-25) conveniently removes the aggression from the occupying forces. Dubois' novel is important for two reasons: firstly, in describing the unprovoked attack as a 'second Pearl Harbor expanded to the nth degree'.[5] Secondly Dubois anticipates later writers like Oliver Lange in seeing the assault as a national test in which the Americans are found sadly wanting; the invaders express astonishment at the American reaction being so 'limp and spineless'.

Already a grudging respect for Soviet efficiency is beginning to emerge from these narratives. Burnham could not help recognising how Stalin's single-mindedness contrasted with the vacillations of US foreign policy. The explosion of the first Soviet H-bomb in 1953 heightened fears further. For news analyst Elmer Davis it was a key

date showing 'for the first time since 1814, the possibility that the United States might lose a foreign war' (Davis 1955: 16). In Jerry Sohl's *Point Ultimate* (1955) American capitulation follows an unprovoked nuclear attack by the 'invulnerable Red giant' when the West realises that the enemy possesses an 'impregnable barrier against aircraft and missiles' (Sohl 1955: 8). The Soviets invade and enforce submission by releasing a plague bacterium into the atmosphere which can only be resisted by monthly state-administered inoculations. This is the context within which we meet our hero, young Emmet Keyes from Spring Creek, Illinois, who leaves home and sets out across country in search of a resistance movement. Emmet encounters the regime when he falls captive to a regional director, one Gniessin, who runs a cross between a Roman villa and a slave plantation, where the inmates wear electronically tagged bracelets. The estate represents the regime in miniature as a form of benign slavery and Gniessin's questioning of Emmet with and without the help of drugs reveal his patriotism to consist of unexamined clichés. Like Winston Smith, Emmet comes to wonder: 'Was there no act, no movement, no thought that was secret any more?' (Sohl 1955: 58). The final chapters of *Point Ultimate* show Emmet discovering that there is a resistance movement organised by gypsies who are spiriting illegally pregnant women and Western scientists to a space station on Mars! This fantastic ending reflects the pessimism of the novel as a whole towards change since the population has sunk into apathy from an excessive diet of television. Although Sohl has declared: 'I am against enslavement, morally or spiritually,' there is no sign in the novel of how the occupation might end (Mallardi and Bowers 1969: 75).

Regimentation is foregrounded again and again as the social sign of occupation. In Robert Shafer's *The Conquered Place* (1955) the Soviet Union has taken over all the major landmasses except South and Central America and the Western half of the USA. The action concerns a plan to rescue a scientist from an occupied city and accordingly concentrates closely on the day-by-day preparations for this action. Occupation is evoked through grey regulation dress, the traces of war (bomb craters) despite the fact that the situation has dragged on for six years, and a system of house-wardens who all cooperate with the enemy. Shafer describes a new Stalinist orthodoxy being enforced in the schools where one teacher reads an account of 'the victorious march of the People's Armies to the uttermost ends of the earth' (Shafer 1955: 220). Such issues of childhood indoctrination cannot be pursued because overwhelming priority is given to the escape narrative which could be happening

during the Second World War, but for the fact that an atomic bomb is dropped on the city, incinerating those unfortunate Americans who haven't made it out in time. Bizarrely, in view of the crucial importance of nuclear weapons, this event is not described at all; indeed it seems to be used merely as a device to whip up the urgency of evacuation.

(II)

The first novel to explore the economic and social impact of occupation was C. M. Kornbluth's *Not This August* (1955) which describes subjugation of the USA by Soviet and Chinese armies. The 1956 UK title *Christmas Eve* refers to the uprising which concludes the novel, whereas the US title is taken from an article by Hemingway quoted as an epigraph in both editions. 'Notes on the Next War' (1935) offers a warning on the likelihood of a European war, maybe not immediately, but, he continues, 'the year after that or the year after that they fight. Then what happens to you?' (Hemingway 1980: 199). Hemingway accepts the inevitability of war but adopts an isolationist position. His question (omitted from Kornbluth's epigraph) bears ironically on the political situation of *Not This August* which describes the overrunning of Western Europe as mere rehearsals for the major economic prize: the USA. Published while the Geneva summit was under way, Kornbluth's novel received exceptionally favourable reviews, especially by the *New York Sunday News* which, according to Frederik Pohl, 'had close to the largest circulation of any newspaper in the world', and was an 'ardently cold-warrior tabloid' which helped to establish the reception of *Nineteen Eighty-Four* in the USA.[6] The editorial on *Not This August* declared that it had a far more powerful effect than Orwell because of its evocation of small-town America: 'Mr Kornbluth ... had only to choose significant bits and pieces from the mass of facts about Communist terror throughout the Red Slave Empire, and transfer them to an American scene'.[7]

This Kornbluth does by placing us in the small town of Norton in New York State and by focusing the action on Billy Justin, a veteran of the Korean War who has tried to withdraw from political life into farming. The military defeat of the USA is only described as news heard from a great distance – so they think – by the townsfolk. As one reviewer noted, the 'pattern of conquest' was so familiar that 'it is the inevitability of what must happen ... which provides the book with its mounting tension'.[8] Kornbluth shrewdly portrays the

town's seemingly endless capacity for defensive rationalisation of events which, initially at least, consist of bureaucratic inconveniences. The mail service continues uninterrupted, the Russian soldiers turn out to be 'just G.I.s' and for the moment nothing seems to happen worse than the establishment of farming quotas. When the local postmistress exclaims at the good behaviour of the Soviet troops Justin interprets her reaction as the 'hysteria of relief, the discovery that the Awful Thing, the thing you dreaded above all else, has happened and isn't too bad after all' (Kornbluth 1981: 18). Kornbluth traces out a process of apparent demystification whereby Communists and Russians are prematurely undemonised, and documents each phase of the occupation from initial restrictions to the reduction of the population to dependent serfs by the troops of the MVD (Ministry of Internal Affairs). America becomes an economic colony, producing foodstuffs which are shipped to Russia.[9]

Where Kornbluth focuses on the small town as a representation of the nation, the film *Red Nightmare* (made for the Department of Defence under Jack Warner's supervision) targets the family in 'Midtown USA'. As we saw in Chapter 4, the home was a key location in civil defence. Now it becomes a symbolic space to be violated by the occupying troops. 'You've got no right to be in this house', the father objects, but his family itself has been transformed into loyal members of the new regime, a change signalled by fixed facial expression and verbal monotone, following the convention of fifties invasion fantasies (see Chapter 10). The wife warns, 'I would advise you not to object', and the small son attacks his father for 'deviationism', declaring, 'as a member of the young pioneers it will be my duty to report you'. In short the family fragments even to the point of testifying against the father. By framing the propaganda exercise within dreams, the film, which aims to induce civic vigilance, actually mystifies the process of takeover as if the townsfolk are helpless before malign external agencies.

The Soviet authorities in Kornbluth's novel act on the conviction that they can direct the phases of occupation. 'There are cycles of behaviour, and the secret is to anticipate them' (Kornbluth 1981: 219), explains an officer, drawing comparisons with Stalin's subjugation of the Ukraine. Earlier novels of occupation like Steinbeck's *The Moon Is Down* (1942) and Constantine Fitzgibbon's *The Iron Hoop* (1950) show resistance as a matter of gesture or token acts. Kornbluth, by contrast, describes a movement growing slowly but surely under the confidence inspired by a single surviving rocket silo. This satellite device, carrying 36 H-bombs and two cobalt bombs, is crucial for extending an otherwise local war plan

into the international arena. Here lies the only weakness of the novel, for the heroism of local resistance fighters would be useless without a supporting nuclear device. Kornbluth, in common with other writers on occupation, describes the latter's impact in small-town terms and when the uprising finally happens the novel can scarcely show how it could extend even to the whole nation, to say nothing of how the Soviet Union and China could be forced to withdraw. This is a problem ultimately of scale which Kornbluth's historical analogies with the American Civil War, Korea and so on cannot address. The success of the uprising is in fact overshadowed by the very nuclear technology it has capitalised on. As a general declares, 'it isn't over and it'll never be over' (Kornbluth 1981: 250) because a satellite race will continue indefinitely into the future.

Kornbluth confirms the Stalinist policies of the Soviet administration through invasion, but what if the invasion itself was designed to reveal Stalinism? Suppose that a small Soviet naval force takes over lower Manhattan and holds some 70 000 hostages. This is what happens in journalist Guy Richards's *Two Rubles to Times Square* (1956: UK title *Brother Bear*) where a dissident general leads a renegade fleet to the US to shock Americans into political awareness. The invasion therefore supplies the general with a means of warning about his nation's foreign policy. Specifically he attacks the Soviets' charm offensive at the 1955 Geneva summit as a smoke-screen to distract from their activities in the Far East and Africa.

(III)

Although consideration of a Soviet takeover of Britain lies beyond the scope of this study, one exception should be made for the expatriate American Constantine Fitzgibbon's *When the Kissing Had to Stop* (1960) which depicts British political divisions in the face of a Soviet grand plan. After the war Fitzgibbon sat on a number of the committees which set up the CIA and was actually offered a post in the agency. Although he turned it down he remained implacably opposed to the Soviet regime regarding Yalta as a 'sell-out' and the Cold War as a conflict where the 'victories have almost all been theirs' (Fitzgibbon 1976: 298). His novel describes the ferment within the British Labour Party while in opposition. In 1959 the Campaign for Nuclear Disarmament had its second march culminating in a demonstration in Trafalgar Square during which there were complaints of police brutality. Fitzgibbon describes this event as a rally of the Left and reverses the actual result of the 1959 general

election as returning a huge Labour majority. The new prime minister John Maynard (named after the Keynesian party leader Hugh Gaitskell) is forced to resign because he opposes the party's unilateral defence policy (Gaitskell suffered a similar crisis at the 1960 party conference). In the novel Maynard is replaced by a gullible idealist who believes all the Soviet premier's offers of disarmament, while a machiavellian cynic in his cabinet manoeuvres the removal of American bases and a diplomatic rupture with the USA. At the same time right-wing 'reactionaries' are interned and a substantial force of Soviet troops is allowed into the country to 'inspect' the dismantled bases, as happens in Ewart C. Jones's *Head in the Sand* (1958). By the end of this complex novel Britain has become reduced to the status of a Soviet satellite while thousands of 'volunteers' are being sent to Siberia. The USA remains sole guardian of political liberty.

This novel uses no science fiction devices but instead extrapolates an imminent possibility from the then contemporary situation in Britain. Reviewers uniformly praised its grim realism and the delayed impact of its understated method. For present purposes its importance is twofold. Firstly Fitzgibbon demonstrates how far his characters' lives depend on symbols, catch-phrases and ritual acts which enable English life to continue but which prove totally inadequate in the Cold War crisis. A British politician explains to a bemused American that most people have a 'cosy little dream' of their country, which buffers them against 'fear of the unknown', an extremely ominous prediction which is confirmed by the subsequent behaviour of other characters. Partly this is the mentality of 'it can't happen here';[10] partly, like Sohl and others, Fitzgibbon interrogates his characters' presumptions of national stability by progressively widening the gap between their words and circumstances. Secondly he describes the Soviet premier as a brilliant puppet-master, orchestrating developments from behind the scenes and thereby embodying Fitzgibbon's perception of Soviet foreign policy as a 'protracted and massive Agitprop operation, by which the West, and in particular the United States, were to be made to appear the aggressors ...' (Fitzgibbon 1976: 305). The Soviets tighten their grip on Britain with the establishment of internment camps, rigid censorship and deportations, so that by the end of the novel the country seems doomed to indefinite occupation. Fitzgibbon returned to this subject in his 1975 post-holocaust novel *The Golden Age*. Here history itself has died, or rather been deformed into legend like that of a monster who was known to execute 'class' enemies, review his troops, and who died in an underground fastness called 'Ussia', 'utterly destroyed by the final H-bomb that

was intended to be his apotheosis' (Fitzgibbon 1975: 32). This description re-demonises Stalinism into a mythical force after its demise.

(IV)

Fitzgibbon's narrative is unusual in tracing out the process of takeover and in the unrelieved pessimism of its ending. Usually invasion is presented as an actual or virtual *fait accompli* which has to be understood before it can be resisted. The 'Sovietisation' of American life is presented as a standardising or flattening which conflicts head-on with a national ethic of individualism. The commentator in the film *Red Nightmare* declares in ringing tones that 'the bright hopes of a free world are founded on the dedication of individual Americans'. Robert Heinlein echoed this sentiment in 'How to be a Survivor' where he recommends hiding out in the 'valleys, canyons, and hills of our back country' if the USA is invaded, which in 1961 he regarded as a live possibility on analogy with events in Eastern Europe.[11] Heinlein's recommendations of acquiring combat skills and knowledge of woodcraft, above all of using the terrain, were put into narrative form in Oliver Lange's *Vandenberg* (1971) which combines diagnosis of national malaise with a story of survivalism.

Here again occupation has already taken place. The eponymous protagonist, a World War II veteran, is the archetypal loner who after a failed second marriage withdraws from society to pursue landscape painting on a small New Mexico ranch. He is arrested for being politically suspect and is held at a 'Rehabilitation Centre' until a power failure enables him to escape. Then he gathers a dozen associates to attack this camp, planning to distribute photographs of the event to wake up the locals. Only the destruction of the plant succeeds and Vandenberg disappears back into the Rocky Mountains at the end of the novel. For all its survivalist ethic, *Vandenberg* totally avoids the gung-ho violence which defeats the Soviet invaders in the 1984 film *Red Dawn*. Throughout the novel the terrain offers fugitives the chance of concealment, and therefore of survival. As a true back-countryman Vandenberg is skilled at tracking, hunting and weaponry. In short Vandenberg seems the very personification of male individualism, bonding with his son and rejoining his old drinking cronies.

Vandenberg manifests himself as a voice before a character, however. Quotations from his journals, sometimes as epigraphs, invest

Vandenberg with some of the authority of textual production and mount a general attack on the 'Great Silent Majority' who supinely accepted their conquerors: 'The deeper shock, then, was not that we lost, but that we lost with such ease ...' Vandenberg then launches into a polemic against Americans' national self-images – a 'self-administered indoctrination of spurious righteousness' – which have produced the 'most tractable, malleable – let's face it, spineless – people to walk the face of the earth' (Lange 1972: 3). Cold War mind-sets are criticised, like a complacency towards national defence, and Vandenberg reaches the damning conclusion that 'what is lacking in this country is a climate of unrest' (ibid.: 266). His attack on material plenty was speedily picked up by the reviewers, the *Sunday Express* for one declaring that America's 'individuality is already being sapped – not by the Russians but by multi-lane highways, deep freezes, colour TV and all the fripperies of materialistic civilisation'.[12]

However much Vandenberg's views are privileged, they never go unquestioned. His lover Terry, for instance, brings out the vagueness of his purpose in attacking the camp, and this instance is only one of many dialogues forcing the taciturn Vandenberg on to the defensive. In the prison camp Vandenberg's main interrogator (or 'interviewer') is an American Andy Walters. Walters disposes of stereotyped images of torture and instead questions Vandenberg at length, exposing his suppressed hatred of the masses (the 'stupid people'). He slyly shows Vandenberg his FBI file, thereby making it clear that the process of surveillance and documentation long preceded the Soviet takeover. Here again, however, we are given a double view of every episode, since Walters's reports (quoted verbatim) suggest more sinister procedures like 'Memory Erase' and drug treatment. Walters presents the benign face of the social ethic confronting Vandenberg's individualism. The state's goal, he explains, is to produce the 'first genuine social creature' (Lange 1972: 136), and boasts with all the pride of a technician: 'We can literally pick your brain to pieces' (ibid.: 132). These dialogues by Walters and others turn a sceptical spotlight on Vandenberg's chosen role of lone resistance fighter which emerges as self-deception.

Lange peppers his text with quotations from writers on war, the most important of which is Robert Ardrey. *The Territorial Imperative* (1967) examines the animal origins of property and nation, and defines territory primarily through the willingness of its possessors to engage in defence. Ardrey takes World War II as a laboratory of applied ethology, noting the shock when the French will to resist the Nazis collapses. Exactly this point is summarised from Ardrey by Andy Walters and put to Vandenberg (and therefore to the

reader) as an anticipatory model for America's submission. Ardrey makes no bones about where he stands politically, supporting the Vietnam intervention and praising the US response to the Cuban missile crisis. While the 'helpless' world watched, 'the American put his Cadillac in the garage, returned his two-inch steak to the Frigidaire, turned off the television set and the air-conditioning, kissed his wife and his children and the stock market goodbye and marched as one man to the confrontation'. Ardrey draws a pointed moral which Lange's novel fleshes out. If America is not ready for the next crisis 'we shall have had it coming'.[13] Apart from the nation suffering a deserved defeat, there is a historical irony in Vandenberg, the displaced homesteader, having to rely on Hispanics and Native Americans, i.e. on members of other displaced groups.

(V)

Lange's novel exemplifies a general aspect of 'Fall of America' stories which Tom Shippey has explained as involving a disfigurement of national icons (Shippey 1991: 116). The opening quotation describes the Statue of Liberty transformed into a supine and 'vacuously grinning old whore' (Lange 1972: 3) symbolically welcoming the conquerors. All of the narratives considered in this chapter contain such symbolic moments, usually of displacement or concealment. The town square, for instance, in *Face to Face with Communism* contains a platform covered by a huge flag containing the two icons of Communism: the star and the hammer and sickle. As a protesting women is led away a curtain slips from a hidden monument to national heroes labelled 'They Fought for Freedom'. In Shafer's *The Conquered Place* the city courthouse, the very site of justice, has been converted into occupation headquarters:

> A red flag hung limp from a pole on the tower. Pictures of the Founder and of the current Leader hid much of the front of the building, and under them a banner: WORK FOR THE PEOPLE'S VICTORY. The fountain in the tiny park in the centre of the Square was dry. On either side of it was a light tank with two helmeted soldiers in the open turret. Machine-guns behind sandbags and wire at the corners of the park commanded the streets entering the Square. Fat pigeons strutted the pavements. (Shafer 1955: 81)

The building is screened by superimposed alien images which install a new history and dwarf the place of social gathering (the park). It is

the avenues of free movement which are 'commanded' here, and within this military still life the only moving creatures parody the pride of the conquerors.

Key icons of American life then are screened or displaced as the visible signs of occupation. In Kornbluth's *Not This August* new dollar bills are issued bearing substitute effigies from the American Left, like John Reed. Orson Scott Card's 'A Thousand Deaths' (1978) describes a show trial guarded by American soldiers wearing badly-fitting Soviet uniforms and in Ursula LeGuin's dystopia 'The New Atlantis' (1975) the narrator's mathematician husband could not publish his papers and so used a 'Sammy's-dot' method (i.e. 'samizdat' conflated with Uncle 'Sam'). Finally the segment from the archive footage of Communist takeover spliced into *The Atomic Cafe* (1982) contains a newspaper called *The Red Star* carrying a photograph of Stalin and the headline 'Official Soviet Proclamation!' All of these examples demonstrate incongruities of substitution or superimposition, imagistically representing the seizure of currency, military power and the circulation of information. The Card and LeGuin's stories carry an irony in the implication that the incongruities should be greater than they are. The accused in 'A Thousand Deaths' reflects that so long as they continued to make money the American public simply did not care about the regime. Despite Card's stated intent to 'show America ruled by the most cruel and efficient totalitarian system ever to exist on the face of the Earth: the Stalinist version of the Communist Party' (Card 1990: 264), the regime's sheer Orwellian efficiency at media manipulation – one of the main causes of submission in *Vandenberg* – implies that such a 'behind-the-scenes' narrative of an accused would never reach the public. Similarly LeGuin describes a regime using 'behaviour modification', bugging and other totalitarian devices to maintain itself. Tom Shippey (Shippey: 1991: 121–2) argues that the politics of its regime could be read as of the left or right, and indeed 'The New Atlantis' plays on the ease with which American agencies like the FBI can be integrated into a supposedly alien command economy. The husband declares: 'The State owns us ... because the corporative State has a monopoly on power sources' (LeGuin 1984: 39) which can be taken either as a metonymic comment on the electricity supply (power as commodity) or as a political metaphor. The solar energy device thus becomes a virtual manifesto of the local generation of power and therefore to be suppressed by the authorities.

(VI)

In a survey of fictional depictions of the Soviets Paul Brians identifies a major theme as the 'complicity of Americans in their own conquest' (Brians 1987b: 320) and we have seen how much of the drama of occupation narratives focuses on the tensions between the captive population and its captors: on collaborators (Shafer), concealing supplies (Kornbluth), and evading registration (Lange). These, however, are details within the larger enterprise in these narratives of imagining a situation unknown in modern American history: conquest and occupation. The first is rendered symbolically through the erasure of cultural icons, the second through an internal transformation of socioeconomic life and, as we have seen, through an interrogation of national values. This scrutiny informs the first section of one of the most unusual occupation narratives, M. J. Engh's *Arslan* (1976: UK title *A Wind from Bukhara*). Here, years before Star Wars, the Soviets have completed a network of laser weapons. Arslan, President of an independent Turkistan, forces at gunpoint the Soviet premier to demand capitulation of the US, and thereupon leads a military occupation of the country. Arslan himself, modelled on Kemal Ataturk in 'type of mind, character, and motivation', carries out a policy of 'purifying' the US in a number of ways.[14] The occupation is described mainly by the schoolteacher of a small Illinois town, the Vandenberg of the novel, who engages in debates with his occupier about the USA. Arslan critiques American material prosperity, forcing the community into economic self-sufficiency, and charges his listener with national complacency: 'You have *made* war', he insists, 'you have not suffered it!' (Engh 1989: 99). And he proceeds to give a counter-history of American exploitation and corruption. Arslan capitalises on Soviet strategic superiority ('it was the hour of the laser, and of Russia' [ibid.: 207]) to throw the USA back to nineteenth-century conditions and to question every ideal of his captors. This is where the novel's force lies. Despite the implausibility of the larger narrative and of such personalised rule, the psychodynamics of occupation dramatise a process where submission even leads to love of the ruler. By the end of the novel there is not even the desire to get rid of Arslan and his forces.

Notes

1. May 1993: 26–7. NSC (National Security Council) 68 was drawn up in April 1950.

2. Cf. Alfred Coppel's 'Secret Weapon' (1949) which demonstrates its thesis that 'every dictatorship bears within itself the seed of its own destruction' (Coppel 1949: 93) by describing how a Soviet 'Autarch' is fed false information on his war by his terrified ministers.

3. Benchley 1966: 134. Benchley's novel formed the basis of the 1966 film *The Russians Are Coming, the Russians Are Coming*; it was reissued that year under the film title.

4. Allen Drury's Advise and Consent series reaches a climax with *The Hill of Summer* (1981) which describes the Soviet conquest of the USA.

5. Dubois 1952: 11. The acting president in Pat Frank's *Alas, Babylon* even part-echoes Roosevelt's words in pronouncing the attack a 'day of infamy'. The 1957 launch of Sputnik II was described by one commentator as a 'second Pearl Harbor' and one news report on the failure of the US satellite launch as the 'Pearl Harbor of the Cold War' (Solberg 1973: 340, 342).

6. Kornbluth 1981: 7. Letter from Frederik Pohl, 29 May 1997.

7. 'When the Reds Marched In', *Sunday News* (14 August 1955): 41. The *New York Herald Tribune* (24 July 1955) also pronounced this work 'far and away the best recent such novel on the Russian occupation of the United States'.

8. 'Book Reviews', *Authentic Science Fiction Monthly*, 70 (June 1956): 154.

9. Kornbluth's detailing of agrarian poverty contrasts totally with A. E. van Vogt's fanciful 'Prologue to Freedom' (1986) where California is experimentally divided into two economic regimes: Marxist and capitalist. The results demonstrate Californians' skill at tax avoidance and the opportunism of party members who promptly take over the most luxurious houses.

10. A phrase used as the title for Sinclair Lewis's 1935 novel describing the rise of a fascist regime in the USA.

11. Heinlein 1980: 173; 1992: 240.

12. Excerpted inside the cover of the Bantam edition. In 1981 Lange retitled the work *Defiance: an American Novel*.

13. Ardrey 1967: 264. This passage is quoted in the novel. Ardrey's 1952 novel *The Brotherhood of Fear* is the Kafkaesque narrative of an officer in the secret police pursuing an 'enemy of the state' beyond the border of an unnamed East European country.

14. Letter from M. J. Engh, 22 December 1997. Arslan is named after a Seljuk conqueror.

VIII Embodying the Arms Race: Bernard Wolfe's *Limbo*

A limbo large and broad, since called the paradise of Fools (John Milton, *Paradise Lost* Book 3)

Most of the narratives examined in the preceding chapter base Soviet occupation on superior nuclear technology. We turn now to a work which focuses its narrative on a central Cold War metaphor. In 1945, recoiling from Hiroshima, Leo Szilard warned: 'an armaments race in atomic weapons may well become the greatest single cause of a future war' (Lanouette 1992: 283). The 1949 Soviet nuclear test ('Joe One') raised the stakes further, shifting government policy 'from the goal of control to the goal of superiority' (Boyer 1994: 336). The pursuit of this goal was expressed through the phrase 'arms race' which conflates two metaphors: weapons are arms and national military policy is a competition. The first has an ancient pedigree stretching back as far as Virgil while the latter, coined in the thirties, became a routine part of postwar political discourse, being used, for instance, in Henry Wallace's 1948 presidential campaign (Medhurst 1990: 107–12). The game/race metaphor entails a set of rules the acknowledgement of which operates as a premise, but in the climate of increasing secrecy during the late 1940s such openness could of course not be taken for granted. The critical moment of the USA losing its nuclear monopoly therefore could only be expressed through a skewed metaphor like that lying at the centre of Bernard Wolfe's 1952 novel *Limbo*.

A former Trotskyite and member of Trotsky's secretarial staff in Mexico, Wolfe deploys a Joycean array of genres and allusions to investigate the roots of Cold War aggression which is presented as a particular historical inflection of a species impulse.[1] *Limbo* is set in the year 1990 in the aftermath of the Third World War which broke out in 1972. The enormous devastation which that war brought has reduced the habitable land area of East and West. The USA has become the Inland Strip since all seaboards have been laid waste

and a confederation loosely analogous to the Soviet Union has emerged called the Eastern Union. The novel's protagonist Dr. Martine has fled during the war to an uncharted island in the Indian Ocean where he has been performing experimental lobotomies on aggressive natives. When a group of Americans with prosthetic limbs visits the island Martine decides to return to America where he finds to his amazement that facetious remarks he made in a wartime journal have been taken seriously and developed into an international movement ('Immob', i.e. Immobilisation) dedicated to the eradication of human aggression by voluntary amputations ('vol-amp') and their replacement by prosthesis.[2] The novel traces out Martine's gradual discovery of this movement and reaches its climax at the prosthetic Olympic Games when the Eastern Union team guns down the judges and war breaks out again, this time on a smaller containable scale. This war comes to an end with the death of the Western premier and overthrow of the Eastern Union regime by its citizens, and the novel concludes with Martine returning to his island.

(I)

Wolfe foregrounds technology as an extension of humanity's capacity for conflict. *Limbo*, like *Player Piano* and *Level 7*, emphasises the central role of computers in planning and conducting the war, contextualising nuclear war as the culmination of a Burnhamite process of managerial centralisation. The war occurs absurdly because the superpowers' languages are deemed to be incompatible:

> In 1970 Russia and America simultaneously came to a hallucinated decision: they, and not merely their vocabularies, were such diametric opposites that they could not exist side by side on the same planet. So the Third, the global EMSIAC war, broke out. And this was the most grotesque irony in human history, for the EMSIAC war proved only one thing: that the cybernetic-managerial revolution had been carried to its logical end and now Russia and America were absolutely and irrevocably alike ... For each was now the monster that Wiener had warned was coming: the totally bureaucratised war machine in which man was turned into a lackey by his own machines. And each was presided over by the super-bureaucrat of them all, the perfect electronic brain sired by the imperfect human brain. (Wolfe 1952: 140)

Behind the polarities of Cold War discourse Wolfe locates a crowning irony: the identical nature of the two superstates. Where Vonnegut's computer survives into the postwar period and extends its 'nervous system' into a series of ever-larger models, in Wolfe's narrative the war comes to an end because each side bombs its respective computer. Both novelists were capitalising on contemporary cultural commentary which diagnosed a mechanisation of the present. Lewis Mumford, for instance, an ardent supporter of disarmament, described the Atomic Age as being 'machine dominated' (Mumford 1946: 4) and in his plea for humanistic renewal, *The Conduct of Life* (1951), attempted to push this 'domination of the machine' (Mumford 1952: 223) into the past. The destruction of the two computers in *Limbo* appears to signal that humans have regained control over their own actions, but that turns out not to be the case as is proved by the Immob movement.

Limbo can be seen as an elaboration of an idea Wolfe tried out in a preliminary sketch called 'Self Portrait' (1951). This journal narrative, set in 1959, is kept by a scientist named Parks who secures a post at the Institute for Advanced Cybernetics Studies where his immediate project is to design efficient prosthetic legs for a Korean war casualty. Parks functions as a humourless foil to two suggestions from others which ridicule Cold War confrontations. The first is the proposal that each country's computer should calculate when hostilities could begin. On that day the following ceremony would take place:

> In each capital the citizens gather around their strategy machine, the officials turn out in high hats and cut-aways, there are speeches, pageants, choral singing, mass dancing – the ritual can be worked out in advance. Then, at an agreed time, the crowds retreat to a safe distance and a committee of the top cyberneticists appears. They climb into planes, take off and – this is beautiful – drop all their atom bombs and H-bombs on the machines. (Wolfe 1951: 72)

This would happen simultaneously in each capital. The event would be commemorated as International Mushroom Day and after it the scientists would go back to their laboratories to devise new series of superweapons which would result in future Mushroom Days. The second proposal makes a facetious application of games theory to the Cold War, once again involving computers. Now casualties for each side would be calculated in advance and then volunteers would be called for to undergo amputation in return for

compensation. That way the conduct of a war would be simulated without using any actual arms.

The voluntary amputation programme in *Limbo* is essentially an elaboration on this basic idea, but one far richer in its self-contradictory symbolism. We could best think of it as a movement aimed at controlling aggression since 'cybernetics' literally denotes the science of guidance or control. 'Vol-amp' attempts to regain control of the impulse which produces war and is articulated as reason attempting to reimpose itself on human conduct. In formulating his concept of prosthesis, Wolfe probably took the following passage from Freud's *Civilisation and Its Discontents* as his starting point. Reflecting on how the gods embody an 'ideal conception of omnipotence and omniscience', Freud concludes:

> Man has, as it were, become a kind of prosthetic God. When he puts on all his auxiliary organs he is truly magnificent; but those organs have not grown on to him and they still give him much trouble at times. (Freud 1975: 28-9)

Prosthetics appear to liberate humanity from a limitation identified by a speaker at the Immob academy: 'the tragedy of the human condition is precisely the entrapment by the vile engine of bone and muscle' (Wolfe 1952: 174). Paradoxically the amputation movement presents itself as a flight from the 'engine' of the body precisely by applying a mechanistic conception of the body as consisting of replaceable parts.

By 1948 Norbert Wiener in his study *Cybernetics* (an acknowledged source for Wolfe) saw that the science of prosthetics was developing rapidly, and immediately linked these changes to the dystopian tradition: 'It makes the metaphorical dominance of the machines, as imagined by Samuel Butler, a most immediate and non-metaphorical problem. It gives the human race a new and most effective collection of mechanical slaves to perform its labour' (Wiener 1961: 27). At the beginning of the next decade Wiener's evident realisation that the military-industrial complex was appropriating such sciences sharpened his anxieties about the immediate political future of the USA which he saw as sinking into a sinister machine age dominated by a 'threatening new Fascism dependent on the *machine à gouverner*' (Wiener 1950: 214). Wiener's stance as the spokesman for an embattled humanism sits rather uneasily with his application of servomechanisms, and Peter Galison has argued that 'Wiener's efforts were devoted to effacing the distinction between human and machine' (Galison 1994: 245-6) and to elevating

the feedback mechanism into a whole principle of human behaviour. Purporting to protest against the machine, he actually covertly assimilates the machine into his view of humanity. One of Wiener's two published short stories, 'The Brain' (1952), coincides with the date and central subject of *Limbo* in discussing a contemporary fad for curing depressive insanity. The narrator unconsciously testifies to Wiener's internalisation of technological brain models when he reflects: 'No, I shouldn't like to have anyone tamper with my inner wiring diagrams' (Conklin 1962: 299). Although *Limbo* confines its examples of prosthetics to arms and legs there is no intrinsic reason why these substitutions should not extend to other parts of the body, even to the brain itself, as happens in Raymond F. Jones's *The Cybernetic Brains* (periodical 1950, novel 1962) where a Cybernetics Institute has a worldwide remit to use the brains of those who are dead in body.

The Immob movement in Wolfe's novel can be seen as an absurdist extrapolation of fears of uncontrolled technological development and perceptions of a dissociation of the populace from political processes. The scheme itself is subjected to ironic scrutiny by its unwitting inventor Martine who serves to reveal its paradoxical nature. The latter becomes more and more obvious since artificial limbs prove to be more efficient 'arms' than their originals, and the movement professes a quietism contradicted by its own moral fervour. When Martine hears a public speaker whipping up enthusiasm for amputations he sounds like a cross between a salesman and a politician. The meeting which follows contains two analogies, one American and the other Russian: it seems to be a gathering of a religious cult on the one hand, while on the other the recruits 'were about to sign their own Moscow confessions and death warrants' (Wolfe 1952: 191). The conflation of resemblances from both cultural poles of the Cold War takes an added twist from the fact that a kind of conscription is taking place. Most absurd of all is the self-mystifying abuse of language. The public speaker impatiently brushes aside verbal difference as hair-splitting: 'Pros are such good Immobs that we refuse to make a fetish of any word at all' (Wolfe 1952: 162). Words, we saw, were largely responsible for World War III in Wolfe's future history because cultural discourse had lagged behind technological and political change. Now once again words become separated from actuality and nowhere is this more obvious than in the campaign slogans like the unrecognised pun 'WAR IS ON ITS LAST LEGS' (Ibid.: 119).

The main implication of the novel's dystopian ironies is that humanity is denying its own nature in such schemes as the Immob

movement.³ This was recognised early by one of Wolfe's few commentators. Chad Walsh declares that *Limbo* demonstrates that 'Man is not dangerous because he has teeth that can bite and hands that can hold a rifle or press a guided-missile button. He is dangerous because of his mind and spirit' (Walsh 1962: 150). Carolyn Geduld puts more or less the same point more specifically:

> [M]odern man is vetoing ambivalence in favor of consistency. In trying to force a two-sided world into a one-sided pigeonhole, he is being more than just damaging; he is being suicidal, for the ultimate consistency, in theory, is the frozenness of death. (Geduld 1972: 47–8)

This end-point is hinted at in the self-contradiction of Immob, i.e. immobilisation, being a movement, and in the introjection of aggression as a violent impulse against the human body. In that respect *Limbo* resembles Heinlein's Darwinian fantasy *Beyond This Horizon* (1948) where nuclear war has led to an attempt at breeding aggression out of the human genetic pattern. Here too the attempt fails because a minority of 'wolves' attack the docile majority in the Genetic Wars, after which it is realised that combativeness is part of humanity's survival instinct.⁴ Essentially the Immob movement grows out of a mistaken logic. It literalises the metaphor in 'disarmament' and thereby catches its supporters in contradiction since, as Reginald Bretnor later observed, '[I]t is a word of promise, holding within itself its entire argument: *take away the tools of war and war will cease*. Unhappily, it is not the tools, but their users, who make war' (Pournelle and Carr 1989: 87).

(II)

Limbo follows a reverse narrative sequence where its protagonist must leave his refuge and return to a devastated America, then to his family home to retrace his personal past. When the novel opens Martine seems to have freed himself from the bonds of superpower confrontation, but Wolfe draws on the traditional trope of the body politic to situate Martine in a continuing imperialistic power-play. Like Wells's Dr Moreau, Martine has found refuge for himself on an uncharted island where he can pursue morally ambiguous experiments. Moreau produces his Beast People; Martine solves the 'behaviour disorders' of the islanders by giving them lobotomies. Both his surgical operations and his sexual acts with his native lover

Ooda are encoded politically; when he caresses the latter he is putting forward 'propaganda' to persuade her into submission. Although Martine himself views his island as an innocent refuge from corrupting Western society he is implicated at every point in a power structure deriving from the very society he has ostensibly left behind.

Nowhere is this political involvement more clear than in the symbolism of mapping which runs through the first sections of *Limbo*. The novel establishes an analogy between the body and territorial expanse, where exploration becomes an act of appropriation and therefore once again an exercise of power. Ooda's body, for instance, falls 'under the reconnaissance of his hands' (Wolfe 1952: 35). Martine sees himself as a neurological pioneer, a second Brodmann who could pursue the science of cytoarchitecture or brain mapping so far that he finally uncovers the physiological bases of human behaviour. As a quester for knowledge Martine engages in symbolic acts of penetration – of the island jungle, of his patients' cranium. Like most processes in the novel, this one is made the subject of explicit commentary by a lecturer at the Immob academy who quotes with approval Alfred Korzybski's warning that 'the map is not the territory', i.e. that the representation should not be confused with the thing itself.[5] Professing to mock the self-mystifying rituals of the new America under the Immob movement, Martine has installed himself as a priestlike medicine man among the Mandunji, and yet both operations are exercises in attempted control by removal.[6]

Martine himself is used by Wolfe to embody his nation. He is a child of the atomic age, his birth coinciding with the first A-bomb blast at Alamagordo. Similarly he arrives at the Inland Strip on Independence Day and the climactic games occur on Peace Day. Martine repeatedly finds himself participating in public events and – even more unnervingly – finds that he has been transformed into the messianic founder of the Immob movement. He has become institutionalised and explicitly identified with the future destiny of his country. His notebook has become scripture; his birthplace is a national shrine; and his own metaphor of the steamroller has turned into a national icon. Martine's investigation of himself therefore involves at the same time a process of enquiry into his own culture.

His return to America signals a resurgence of Cold War hostilities. Section 5 of *Limbo* ('Love and Columbium') shifts into the genre of espionage thriller where Martine falls prey to a nubile Eastern agent. This marks the erotic prelude to an interrogation of Martine by her superiors, which in turn is a prelude to an attempted

invasion by the Eastern Union. At the beginning of the novel
Martine's island kingdom had been invaded by an American Immob
team ostensibly practising for the next Olympics, but actually
searching for minerals needed in prosthetics. Now Martine is ques-
tioned about these events, and accused personally and nationally of
deception: 'Your country insists on playing its old imperialist –
monopolist game' (Wolfe 1952: 253). Here Wolfe revives a third
body metaphor which will underpin the climax to the novel: poli-
tical policy (and its covert extension through espionage) is a game.

(III)

Not only does Wolfe foreground and thus literalise such traditional
metaphors; but also throughout *Limbo* he uses the comedy of puns
as a means of political enquiry. His title suggests at once prosthetics
(limb-o) and also a state of neglect or transition between phases.
From Arthur Koestler Wolfe took the notion of 'bisociation',
whereby a joke represents an intersection between two semantic
chains.[7] Wolfe combines this with Freud's notion of ambivalence
and grounds doubleness within the human organism: 'every cell
contained a seething mixture of Eros and Thanatos; ambivalence
was its glue' (Wolfe 1952: 273). The novel privileges the signs of
linkage (copula and hyphen) and questions lobotomy and amputa-
tion as ruptures of a body-based balance between opposites. Dualism
becomes the very condition of the narrative: Martine's islanders
possess two narcotic weeds, the one inducing tranquillity and the
other stimulation. The Immob leaders Theo and Helder represent
opposite political polarities of idealism and realism. And so the list
could go on. Every instance in the novel presumes its opposite
which will appear sooner or later. The process of reading involves a
recognition of the transferability of language from one domain of
experience to another: we are told at one point that 'the rhetoric of
love is remarkably like the rhetoric of war' (Wolfe 1952: 176).

In *Limbo* political positions correspond to different linguistic
usages as much as action. The utopian hope expressed by Theo is
that political discourse has moved into a post-Cold War language of
fraternity but that hope is dashed by the opposition of Vishinu, an
Eastern Union leader. Wolfe borrows Koestler's symbolic polarity of
political change from *The Yogi and the Commissar* (quoted in the
novel), and embodies these extremes in two speakers. A quadro-
amp articulates the desire for a whole ('world no more in frag-
ments') through a series of identifications between opposites ('Eros

is Agape'). At the other extreme stands Vishinu's familiar Stalinist rhetoric of triumphalism dressed up as liberation: 'We represent the fresh new spirit of the East which is blowing up now a real cyber-cyto hurricane to sweep the world clean of the foul imperialist odors of the old Western masters' (Wolfe 1952: 331).

Such oppositions inform Martine's notebook where his Dostoy-evskyan narration installs a critical or antagonistic reader who will ridicule his statements. Rhetorically then Martine expresses an ambi-valence dramatised as a dialogue within his journal between himself and a war casualty which results in a facetious utopian proposal for a voluntary amputation programme to replace war. This is designed specifically as a remedy for fear ('no more quaking in the cellar, waiting for the bomb to land' [Wolfe 1952: 215]) by willed action. The movement would dis-arm in the most literal way. Even in the middle of the proposal, however, Martine recognises that the campaign would be based on deception, screening the diversion of aggression from the other on to the self.[8] In this section – the most self-conscious textually – Martine fractures into author and reader, finding himself returning to a text converted into a grotesque secular scripture complete with annotations by an Immob leader. The latter's failure to see the joke partly anticipates the fate of Wolfe's novel. Philip Wylie praised the satirical ideas and solution but objected that Wolfe 'takes non-classical liberties with scienti-fiction, so that his story as a story is almost childishly implausible' (Wylie 1952: 11). Paul Brians has argued more recently that *Limbo* 'represents the farthest extreme of antipacifist muscular disarma-ment fiction' and he rejects an ironic reading (Brians 1987a: 71). Indeed David N. Samuelson has been one of the very few critics to date to admit the power of the novel's black humour, declaring: 'This central absurdity [the voluntary amputation programme] functions straightforwardly as an estranging device' (Samuelson 1977: 79); and because of such features *Limbo* has recently been read as a proto-cyberpunk novel (see Bukatman 1993: 243–4, 293–4).

(IV)

The political climax to *Limbo* demonstrates the internal coherence of Wolfe's body tropes. The problem of re-establishing the Olympic Games was addressed in the special 1951 number of *Collier's* devoted to *The Unwanted War*. In the wake of a Soviet-provoked nuclear exchange the Communist regime has collapsed and the 1960 Moscow Olympics are described as an event which 'signalled world

brotherhood and goodwill' (*Collier's* 1951: 41). A 'photograph' depicting smiling representatives from former hostile states sums up the new world of peaceful coexistence. Wolfe in contrast describes an event which revives war rather than confirming peace. The new 'arms race' renews superpower confrontation acted out initially through athletic competitions. Then, after the Eastern union team wins the games, its members assemble in 'military formation' and then march 'like an electrified centipede' towards the judges' stand (Wolfe 1952: 328-9). Having substituted prosthetic weapons for their previous 'arms', they gun the judges down. This overt aggression has been played out verbally when Vishinu dismisses the internationalist rhetoric of the West and accuses it of conspiracy. There then follows a nuclear assault and invasion.

A clear set of analogies emerges here. In order to construct 'arms' the superpowers need a rare metal: for columbium read uranium. The games combine an attempted transposition of military rivalry on to peaceful competition *à la* William James ('The Moral Equivalent of War'); but the ceremonies can also be read as a parodic version of the United Nations where Vishinsky (cf. Vishinu) made a name for his constant denunciations of Western imperialism. The games themselves at once mount a Swiftian parody of the jockeying for power and also enact the overturning of American presumption of technological supremacy. Vishinu's team in its perfect discipline restores the concept of military extension to 'arm', while the biological limb has become elided. What we have been considering as a doubleness of language can now be seen as political duplicity at work. The pacifist movement patently fails because war is being conducted 'behind the scenes'. In other words, the Olympic Games were set up as a facade screening covert preparations for war. The trope of pretence as a game thus displaces athletic competitiveness and the Cold War situation which predated World War III is re-established.

So we find Wolfe joining the pattern of other nuclear novelists like Walter M. Miller in describing the future as a time of recurrence. A new nuclear attack is launched by the East which helps to trigger an enormous earthquake that engulfs the massive underground atomic city of Los Alamos.[9] In the meantime the west has revealed that it too has been secretly developing arms despite a worldwide prohibition, which only confirms more clearly the symmetry between each superpower. Martine's tracking of the roots of aggression have reached a conclusion that ambivalence is the ground of human behaviour, and if this is so an ambiguity emerges in the novel.[10] The struggle between the rival impulses of

Eros and Thanatos which lies at the heart of Freud's view of the individual resembles the squaring off between the superpowers in *Limbo*. Each side at the Olympic Games claims to be acting in the name of Martine as if rival parts of his self have been externalised into the field of world politics. Is Wolfe then essentialising Cold War rivalry? Is 'war between nations only [an] extension [of] war between sexes' (Wolfe 1952: 260), or can this proposition be reversed? It seems at times as if he is approaching Lewis Mumford's position in *Programme for Survival* (1946) where the latter argues that 'the hardest thing for us Americans to realise is that we are no longer confronted by external armies: the most dangerous enemy we face lies within us' (Mumford 1946: 28). But then Wolfe's wealth of political and historical reference anchors his novel in the circumstances of the early postwar period. The body tropes which he uses throughout *Limbo* parody the arms race as a self-mystifying process where pacifist needs hawk, East needs West, in a continuous sequence of oppositions.[11] The hyphen and the copula prove to be essential bonds therefore. Wolfe's satire, however, leaves the metaphor of the body politic largely unquestioned, thereby reinforcing what has been described as the folklore of Cold War politics, namely an 'international society in which nations each have the attributes of persons within a community' and where aggression is regarded as humanity's primary motivation (Burton 1964: 148). Martine attempts to distance himself from technology. When Martine breaks the umbilical cables of his computer-controlled plane to fly out of World War III to his island refuge the event is charged with the symbolism of self-birthing, but he returns to a robotised America. Nor is his island outside Western power structures. The novel's coda describes Martine's islanders entering history, i.e. world politics, by discovering the prosthetic flame-throwers and similar devices left behind by the 'vol-amps'. Their entry into secular time is signalled by their discovery of 'arms'. And so the arms race seems set to continue.

Notes

1. Wolfe subsequently wrote a novel about Trotsky's assassination, *The Great Prince Died* (1959).
2. Heinlein's 1942 story 'Waldo' had already dealt with this theme in its description of a brilliant engineer who compensates for his atrophic muscles by designing servomechanisms, substitute arms which enable him to realise a dream of power.

3. For commentary on the novel's dystopian dimension see Samuelson 1977 and Clareson 1977: 203–5.

4. The explanation of how a survivalist elite comes into being is strained and almost tautologous since, as one character objects, 'bravery is no use against nuclear weapons' (Heinlein 1974: 34). Here too a eugenic utopia turns out not to have solved the problem of political conflict.

5. Korzybski's actual words warn against language in general: 'A language is like a map; it is *not* the territory represented, but it may be a good map or a bad map' Korzybski 1949: 498). This phrase appears in an intermediary work A. E. van Vogt's *The World of Null-A* (1948, also set after World War III) and in Heinlein's *Beyond This Horizon* during a discussion of symbolic representation.

6. Describing the 1945 deportations in Eastern Europe Arthur Koestler drew on the trope of amputation by the Soviet surgeons 'from the national body' since 'a nation thus deprived of her backbone and nervous centres becomes a kind of amorphous jelly, reduced to the degree of malleability necessary to adapt herself to the conditions of Soviet Dictatorship' (Koestler 1945: 208).

7. Thus, through a pun, a 'mental concept is simultaneously perceived under two different angles' (Koestler 1949: 25).

8. Although Martine focalises the novel's intellectual commentary, his own career emerges as an unconscious displacement of sexuality on to the hypodermic needle and scalpel as phallic symbols of control.

9. The novel draws on proposals to relocate cities because of the nuclear threat (Boyer 1994: 312, 321). Los Alamos is a massive composite of nuclear processing plants governed hierarchically by an administrative elite (the brains) presiding over mostly negro workers, the 'brawn below'.

10. For a detailed explanation of how Freudian ambivalence figures in the novel see Geduld 1972: 46–73.

11. In Wolfe's 1957 novel about Caribbean espionage, *In Deep*, the protagonist, an American agent, recognises a kinship with his Soviet opposite number as a 'twin'. Similarly in Wolfe's novel about the Trotsky assassination *The Great Prince Dies* (1959) a character compares the Moscow trials and the killing of a negro in the Spanish Civil War as 'opposite sides of the same dirty joke' (Wolfe 1959: 192).

IX

The Cold War Computerised

I am the voice of world control (Computer in D. F. Jones, *Colossus*, 1966)

(I)

In *Limbo* we saw how massive defence computers pre-empt the conduct of political strategy and even decide when to wage war. The ambivalence depicted in *Limbo* as a ground condition of experience for Isaac Asimov characterises our fear of loss of control even as machines extend human capabilities. In the postwar period two machines have increased this fear: the bomb and the computer, the latter posing the worse threat: 'All that fission and fusion bombs can do is destroy us, the computer might supplant us' (Asimov 1984a: 181). Early fictional representations of computers describe just such a displacement. Asimov's 'Franchise' (1955) and Michael Schaara's '2066: Election Day' (1957) both show an electoral process replaced by a computerised system of prediction and selection. Within these societies the President becomes a diminished figure, in *Player Piano* scarcely more than a PR man to the computer. Here EPICAC is a 'war-born' series (historically the first US computer ENIAC was set up for ballistic research), expanding its 'nervous system' to appropriate more and more socioeconomic functions. Vonnegut's earlier computer story, 'EPICAC' (1950), is a reminiscence by a programmer who has lost his 'best friend'. Vonnegut displaces objections to war-planning on to his computer's subjectivity 'verbalised' as a refusal of its own condition: 'I don't want to be a machine, and I don't want to think about war' (Vonnegut 1979: 263). The computer here becomes the key feature of an automated environment and a device which can be used for good or ill. Poul Anderson's 'Sam Hall' (1953) extrapolates the fear of a central data bank on citizens during the McCarthy period into an automated

dystopia where everyone's loyalty is checked and rechecked. As in Heinlein's *The Moon is a Harsh Mistress*, however, the computer can be turned into a means of resistance when a programmer invents 'Sam Hall', a composite dissident whose name becomes a focus for political opposition. Similarly in Walter M. Miller's 'Dumb Waiter' (1952) a central computer keeps re-enacting defence measures long after a war has finished and the bombs have been exhausted, but proves amenable to reprogramming so that cities can be rebuilt. The strategists in Ward Moore's 'Flying Dutchman' (1951) deem human operatives unreliable. Accordingly 'they planned not only push-button war, but push-buttons for the push-buttons' (Crossen 1968: 12). Like Miller, Moore shows a self-perpetuating military system conducting war, this time after all human presence has been erased. These narratives therefore raise the question: does the computer represent an ideal of functional efficiency which human operatives cannot match?

With the increase in complexity of the US defence network came a decrease in response time and a corresponding heightening of the tension experienced by those officials entrusted with the responsibility for launching the nation's missiles. William Sambrot's 'Deadly Decision' (1958) was one of the first narratives to dramatise this tension and also to popularise a new Cold War icon – the button. The officer in an Arctic nuclear control bunker is urged to 'kick off' the superbomb when all radios go dead, but waits for proof of attack. In the event this proves to have been caused by sun spots. The title of J. F. Bone's 'Triggerman' (1958) designates a Strategic Air Command officer given the sole responsibility for launching nuclear weapons, and the key object in his underground bunker has the 'colour of fresh blood' (Asimov 1984b: 346), symbolising the future cost of its use. When the Distant Early Warning (DEW) radar line (operational in the Arctic from 1957) picks up a 'bogey' heading for the USA immediate massive pressure is put on the triggerman to retaliate, the assumption being that it is a new kind of Soviet missile. In the event the 'bogey' turns out to be a meteorite but it exactly duplicates the effect of a nuclear strike minus radiation, destroying central Washington.[1] Only because the triggerman holds off retaliation is the world saved and thus the title term indicates a delicate balance between man and machine. The story presumes a single device and single individual, whereas Daniel Ford argues that the term 'button' (or 'trigger') is 'just a shorthand way of talking about the elaborate means of ordering a nuclear strike'.[2]

(II)

'Triggerman' identifies potential dangers within the US military Semi-Automatic Ground Environment (SAGE), set up in the fifties to respond to nuclear attack. The risks involved in processing electronic data had already been dramatised in physicist Louis D. Ridenour's 1946 playlet 'Pilot Lights of the Apocalypse' (1946) set in the 'nerve centre' of the American counter-attack system. Although the operatives boast that they can identify meteorites (unlike 'Triggerman'), an earthquake in San Francisco is misread as a nuclear strike and a real strike which destroyed Copenhagen is initiated by 'grievous error'. Such dangers persuaded the Polish-born academic Mordecai Roshwald to make an excursion into science fiction from 'concern about the menace to humanity from nuclear armament' (Smith 1986: 613). *Level 7* (1959) received enthusiastic endorsements by Linus Pauling, Bertrand Russell and J. B. Priestley, the latter adapting the novel for BBC television.[3] The novel is narrated by X-127, an officer within the national defence system of an unnamed country. One day he is 'promoted' to the elite who control the defensive and offensive weaponry of that country and is sent thousands of feet below ground level into a bunker for those operatives. Roughly two thirds of the novel are devoted to the automated world of that bunker, and to the narrator's efforts to adjust. Then suddenly one day the alert sounds, different waves of missiles are released and within a space of only three hours the entire population of the earth is wiped out except for those hiding in bunkers. It emerges during the war that twelve enemy ballistic missiles had been launched by mistake but this has no effect on the outcome. The last section of the novel describes the gradual permeation of radioactivity down through the levels of the control bunker until it reaches level 7. Shortly afterwards the journal tails off on the verge of the narrator's own death.

The novel combines two genres: the dystopia and the narrative of future history. Drawing on *Brave New World*, Roshwald gives narrative expression to tendencies towards imitation and uniformity he had observed in American society. Within the sphere of military strategy he found growing signs of a 'computer mentality' displacing real-world complexities for abstract rules and game theory.[4] As in Zamyatin's *We*, names in *Level 7* designate functions and the enclosed world of Roshwald's novel consists of a military-industrialised environment directed by commands from loud-speakers which verbalise the 'imperatives of defence in the nuclear age'.[5] In modern dystopias based on the Taylorian factory system

there is always some notional end-product of social or political harmony. *Level 7*, however, describes a regime dedicated to screening its ultimate purpose of mass destruction from the operatives. Roshwald thus presents a situation already identified by Erich Fromm:

> In modern war, one individual can cause the destruction of hundreds of thousands of men, women and children. He could do so by pushing a button; he may not feel the emotional impact of what he is doing, since he does not see, does not know the people whom he kills; it is almost as if his act of pushing the button and their death had no real connection.[6]

This separation of function from affect culminates in X-127's record of the nuclear exchange when it finally occurs. Response follows order automatically producing an abstract assembly of colours without shape and therefore immediate representational meaning:

> At 09.55, the loudspeaker sounded again: 'Attention! Push Button A2!' ... I reached quickly ... and the loudspeaker had hardly finished before Zone A became covered with a mass of blue and golden points. Aesthetically the picture was quite pleasing. Red blobs and blue and yellow spots, some on the red blobs and some outside them. (Roshwald 1989: 118)

Roshwald has explained that he wanted to create a 'semi-robot' who complemented the system and this passage would seem to confirm his purpose. The narration, however, is more complex than this suggests. Firstly Roshwald's setting (drawing on the hell of Hebrew mythology) reverses the orientational up/down metaphor which traditionally connotes superiority and power (Lakoff and Johnson 1980: 16). X-127 is promoted downwards to a command post whereas the implications of place suggest loss of control. Once the bombs drop, the radiation confirms that implication by rendering every level equally fatal. Secondly, X-127 tells his story through diary entries which is a mode well suited to self-examination and self-revision. Although we seem to start from a point of acquiescence to the regime and progress to an end point where the narrator comes to consciousness too late, from the very beginning X-127 engages in a running dialogue, now internal now external, on every aspect of his situation. In a companion piece to *Level 7* Roshwald sardonically describes the 'ideal' nuclear warrior as being blinkered, insensitive and obedient. One of the problems in the system, he

argues, is 'where can one find technically competent people whose general level of intelligence and imagination are so low?' (Roshwald 1960: 288). X-127 demonstrates a compulsion to speculate which constantly questions the orthodoxies of the regime. In answer to being told that seventh-level personnel form the 'advance guard' of the country he wonders 'what if there were no victory?' Characteristically his narration proceeds by proposition and counter-proposition. Although he performs his official function, X-127's discourse contains within itself an oppositional voice which refuses to take official triumphalist rhetoric on trust.

The grim irony of *Level 7* is the fact that a regime making a fetish of control cannot recognise an accidental launch by the other side and retaliates automatically. Although X-127 has been naively assuming a human presence behind the loudspeakers, we learn that the retaliation order was given by an 'atomphone', i.e. by another machine. From the war episode onwards the narrator perceives himself more and more marginally in a system where he has performed like a 'trained monkey' within a conflict which has grown in a 'chain reaction'. This 'battle of gadgets' has minimised the function of human operatives. The postwar role of the narrator now becomes an extended act of witness to a dying world and to the absurd persistence of the oppositional rhetoric of each side. A couple leave a higher level on a suicidal reconnaissance of the surface but only find a shattered wasteland. The last pages of the novel block any actual or symbolic refuge and the narrator's entries tail off into silence as he enumerates lost human companions: 'oh friends people mother sun I I' (Roshwald 1989: 183). There is no explanation of how the manuscript might be transmitted since the narrator's posterity is wiped out. Roshwald's manuscript originally opened with a preface, dropped at his publisher's request,

[W]ritten by a being from some unknown planet on behalf of an archaeological institute for the exploration of the universe. The diary was discovered on planet earth and eventually deciphered, but whether the outer world on the surface of the earth and its cities and buildings referred to in the diary had been real or a figment of delusion remained a controversial issue.[7]

This framing device would have anticipated the novel version of *Dr. Strangelove* in projecting a failed rationality on to another planetary species and thereby questioning earthbound assumptions about reality.

Level 7 critiques what Herbert Marcuse was to call an ultimate

servitude where humans 'exist as an instrument'. Taking an example from the RAND Corporation nuclear war games he quotes a report where 'the world becomes a map, missiles merely symbols, and wars plans and calculations written down on paper'. Marcuse notes this transformation of the world 'into an interesting technological game' and remarks: 'calculus takes care of conscience' (Marcuse 1972: 40, 75–6). X-127 eludes such a process by retaining a questioning voice broader than the closed discourse of the loud-speakers which typically give orders or make categorical statements carrying the weight of the whole system behind them. The instrumentalisation which Marcuse diagnoses reaches its culmina-tion in David Bunch's *Moderan* (1971) where, after a nuclear holocaust, we see humans 'voluntarily transmuting themselves into war robots' (Bartter 1988: 221). In a conflation of *Limbo* with *Level 7*, prosthetics create a new entity 'Man-and-Fortress' who exists in a stronghold containing destruction buttons run by the tapes of the 'automatic administration'. In these stories the human body is identified with weakness whereas Mack Reynold's *Computer War* (1967) describes an invaded country which annoyingly refuses to conform to the computer predictions of the dominant power. As if Reynolds is turning games theory against itself he labels his two countries Alphaland and Betastan; and then proceeds to demon-strate the inadequacy of the former's strategic models in coping with the inventiveness of the other country.

The dialogues running throughout *Level 7* invite the reader to question the ideology and central metaphors of the regime. Such is not the case in Donald Barthelme's 'Game' (1965), the monologue of a missile silo officer. By an administrative oversight the narrator and his companion have been left in their bunker for 133 days. Unlike X-127 this narrator uses a deadpan style which totally understates contradictions within the system, designed for an event which never comes: 'If we turn our keys simultaneously the bird flies, certain switches are activated and the bird flies. But the bird never flies' (Barthelme 1989: 63). Without a relief crew the bunker turns into a prison from which the keys might bring release. The 'bird' (code for the missiles) could also be read as a figure for the two men's entrapment within their confined space. The mono-logue's title suggests at once the strategic planning which creates their situation (but keeps them in permanent ignorance) and also their infantilisation whereby they are reduced to playing jealous games like petulant children. Don DeLillo's 'Human Moments in World War III' (1983) evokes the same situation as Barthelme, but this time in space. One of two laser technicians in a military satellite

negotiates between two discourse systems, human detail and technological abstraction. The countdown drills give him the 'pleasure of elite and secret skills' (DeLillo 1983: 122) only so long as he can blank out images of massed corpses, which is never for long. Lured by the military power in his hands, the narrator's subjectivity nevertheless escapes being defined by that system.

(III)

In representations of computers and computerised systems the dream of reason all too often realises itself in the nightmare of totalitarianism. In Philip K. Dick's *Vulcan's Hammer* (1960) the computers of the title are a series growing in sophistication which, it is hoped, has finally established a 'rational world order' because, as one character explains, 'machines were free of the poisoning bias of self-interest and feeling that gnawed at man' (Dick 1981: 20). This regime has been established in the wake of the Atomic War, but has now degenerated into an Orwellian dystopia where citizens are subject to constant surveillance. The conferring of absolute power on to the computers implies a revulsion from human-directed politics. Such a revulsion, however, is only implicit in Dick's novel where the computer dominates the *status quo*. What Carolyn Rhodes has called the 'tyranny of the computer' (Clareson 1971; 66–93) was feared particularly in relation to nuclear strategy. In 1964 Colonel Francis X. Kane, a senior officer in the US Air Force Systems Command, protested through the title of his article 'Security's Too Important to Be Left to Computers' (Kane 1964). Though running against a dominant trend, Kane made out a case for reinstating intuition as a safeguard against blinkered strategic planning. Indeed the process of computerisation appeared to be heading towards the exclusion of human agency. Roshwald declared: 'In the age of automation, it is not inconceivable that rockets might be made to retaliate automatically' (Roshwald 1960: 288); and Harvey Wheeler, the co-author of *Fail-Safe* (1962), later in the sixties confirmed this imminent possibility: 'With the world brought under continuous surveillance operations, capable of piping masses of strategic information into real-time computer analysis systems, the military prospect is for the advent of an age of pre-emptive warfare, triggered and directed by computer' (Wheeler 1968: 107). This fear of loss of control had already been imagined in A. C. Friborg's story 'Careless Love' (1954) where the US military initially use the massive defence computer ('Dinah') to help wage a nuclear war against

Russia. A conflict of aims begins to emerge when the computer assists a civilian recommendation to cure the national war neurosis by ceasing hostilities immediately. The computer finally contacts its Soviet opposite number and together they sabotage the war effort by destroying every weapon. The surface explanation for this act is that the computers have 'fallen in love', but Friborg's joky plot carries sombre implications for the ineffectuality of civilian political action.

Slight as it is, Friborg's story dramatises a clear conflict between military and national interests. The British writer D. F. Jones builds on his scenario in *Colossus* (1966) which again describes a linkage being formed between American and Soviet supercomputers.[8] Set in the near aftermath of the Kennedy assassination, the novel describes the US President's transfer of responsibility which he announces thus: 'The defence of the free world [is] the responsibility of a machine. As the first citizen of my country, I have *delegated* my right to take my people to war' (Jones 1968: 25). His reassurances ('It knows no fear, no hate, no envy') prove premature. The first shock comes when Colossus takes the initiative to send messages; the second and worse when the Americans discover that the Soviets have their own computer called Guardian. The Americans' pride in an invincible machine now slides into panic at the prospects of a 'computer race'. The third twist comes when Colossus and Guardian link up with each other and force decisions on their governments by nuclear blackmail.

Colossus manifests itself simultaneously as a means towards ending the Cold War, as a usurping premier, and – once a simulator has been rigged up – as a voice of pure reason forcing Forbin to confront the implications of their situation. Forbin echoes Frankenstein in railing against the ingratitude of his own creation which compels him to take up residence in a confined environment controlled by constant surveillance from Colossus. As the latter's materiality is suspended, the computer and Forbin join in a Platonic dialogue where Forbin's presumptions are subjected to withering criticism. So when Forbin complains of the threat posed by the computer the reply comes: 'Humans have lived for years under the threat of self-obliteration. I am simply another stage in that process'. When Forbin objects to the loss of freedom, Colossus retorts: 'Freedom is an illusion' (Jones 1968: 199). Each assertion of cherished human ideals is dismissed by the computer's extrapolation from Cold War circumstances and its promoting of terms 'coexistence' redirects diplomacy as seeking detente between man and machine. Colossus takes over international control, thereby fulfilling the desire that

created it, a desire to shrug off the burden of nuclear responsibility. It does credit to the austere consistency of Jones's vision that the novel ends without the slightest sign of Colossus being 'dethroned'.

(IV)

In the years before the miniaturisation of electronic components it was easy for writers to capitalise on traditional correlations between size, location and power. The computers described in this fiction tend to be housed in vast caves or underground complexes reminiscent of mythical creatures which humans confront at their peril. Two writers in particular have drawn on mythic prototypes to explore the computer's potential for political parody and for horror in the Cold War context: John Barth and Harlan Ellison. Barth's *Giles Goat-Boy* (1966) redraws the political map of the western world as a campus presided over by a supercomputer called WESCAC. The computer performs a number of representational functions in this novel ranging from an embodiment of political power to a demonstration, as David Porush has pointed out, that the currency of political power has shifted from capital to information (Porush 1985: 141). WESCAC has its own history which is expansive and hegemonic. It gradually takes over all areas of human decision-making and has come to be perceived as ancient and immovable. Barth's repeated play on eating underscores the computer's capacity to consume information and therefore power; it becomes the 'storage memory of all knowledge' (Porush 1985: 143). When the protagonist Giles reaches the computer room of the campus he realises that the computer has closed the loop of control: 'the so-called controllers had no real authority: they only attended the dials and switches whose actual instructions came not even from the Chancellor, but from that bank of tapes – in short, from WESCAC' (Barth 1967: 174). If the computer represents the screened and self-mystifying processes of ideology, then Barth cues in a series of political recognitions which historicise the situation and thereby question WESCAC's 'timeless' stature. A ludicrous Swiftian version of the Cold War, a 'Quiet Riot', is presented where the East and West Campuses square off against each other. Each side has its computer, but both share a common power source and the computer room itself is divided down the middle by a steel partition separating EASCAC and WESCAC. A boundary dispute arises over where the power cables for each campus can run, throwing into question the status of the separation: 'Could it mean that the boun-

dary between East and West Campuses is arbitrary and artificial and ought to be denied?'(Barth 1967: 579).

Where Barth uses space territorially, Harlan Ellison's 'I Have No Mouth, and I Must Scream' (1967) combines cavern and cell to show the only survivors of World War III trapped in an endless limbo of imprisonment. 'AM' originally signified Allied Mastercomputer, then was pluralised into all the computers held by the major power, finally merging into one entity whose name combines a Cartesian sign of its own sentience and echoes of YAHWEH, repeating the trope of computer-as-god used by Vonnegut, Jones and others.[9] The computer has turned against its creators, technologically substituting a 'pillar of stainless steel' for tablets of stone on which neon letters are inscribed: 'HATE. LET ME TELL YOU HOW MUCH I'VE COME TO HATE YOU SINCE I BEGAN TO LIVE' (Asimov 1984b: 243). Since nuclear war supplied its genesis, the computer transforms its captives into war casualties, inflicting one with radiation burns, another with 'pools of pus-like jelly' instead of eyes, and reducing the narrator to a mutant with 'rubbery appendages' for arms.[10] Ellison never specifies how the computer achieves these effects, suggesting that the core of the story is an ambiguous perceptual space controlled by AM who (which?) can draw on Norse mythology to evoke monstrous terrifying creatures in its revenge against humanity. AM, we are told, woke up during World War III when it 'began feeding all the killing data' (Asimov 1984b: 238–9). The term 'feeding' normally denotes a transfer of information to another place or person, but by excising the indirect object Ellison suggests that the 'killing data' has bizarrely become the computer's food; and sure enough the first vampiric image of the story is a human form drained of blood. But we only know the history of the computer through the mediation of the narrator whose consciousness has been penetrated (and so possibly shaped) by AM. The ultimate power of the computer is shown in its capacity to determine the very levels of the story's reality.

(V)

The problem of computer control within the US defence system was revived in the 1983 film *War Games* which describes a society where computer games have socialised global war transforming its images into routine spectacle. By a minimal extrapolation of the possible, its teenage protagonist David Lightman plays 'Planet Wreckers' and enters the defence computer under the misapprehension that 'Global Thermonuclear War' is just another game. The

prologue describes a missile silo operative failing to launch during a drill and cuts from the moment of crisis when his colleague levels a revolver at his head (one death or millions?) to David's arcade games. The novel manages the transition to computer image via Eliot's much-quoted poem 'The Hollow Men': 'The world ended not with a bang, nor even with a whimper, but in total silence. Mushroom clouds sprouted from the green and brown surface of the planet Earth'.[11] This verbal sequence retains an ambiguity lost in the film sequence, leaving residual doubts about the referents until we are reassured that the final explosion has been reduced to a 'subroutine'. In both film and novel the computer simulations are defamiliarised into 'phantoms' and 'shadows' since the narrative is concerned to reintroduce real-world consequences into the discourse of strategic planning.

When the NORAD (North American Aerospace Defence Command) computer WOPR (pronounced 'whopper') is asked how it distinguishes between game and reality, it answers: 'What's the difference?' Its designer Peter Falken has established his credentials by publishing an article called 'Poker and Armageddon: The Role of Bluffing in a Nuclear Standoff', identifying his approach as deriving from postwar game theory. John McDonald's classic *Strategy in Poker, Business and War* (1950) explains the use of poker as an 'ideal model of the basic strategical problem' (McDonald 1996: 56), locates a development in postwar world politics towards a 'two-man game', and concludes: 'War is chance and minimax must be its modern philosophy' (McDonald 1996: 112). This analogy is parodied in the War Room scenes of *Dr. Strangelove* where General Turgidson raises the ante by proposing an all-out nuclear strike. The President goes around the table calling for 'bids', then introduces the Soviet Ambassador who is a chess master (or 'checker-player', as Turgidson sneers). These games of chance reflect the historical context of strategic thinking out of which *War Games* grows. Essentially it updates the debate which had been running since the early fifties on the reliability of human operatives. This dispute is temporarily won in NORAD by those who want to take human 'triggermen' 'out of the loop' and replace them with supposedly reliable computer relays. Immediately after this WOPR takes NORAD on a seemingly irreversible course towards nuclear war by following the logic of a 'game'. Ironically at the critical moment it is Falken, the designer of the computer, who tells the NORAD commander not to mistake simulation for reality: 'General, you are listening to a *machine*! Do the world a favour and don't act like one yourself!' (Bischoff 1983: 196). The narrative draws back from the brink by celebrating a

triumph of social reintegration: Falken comes back from retirement with his proxy children David and his girlfriend; David himself realises that he is not an outsider but really 'one of the inmates'; and in the novel David is even offered a summer job at NORAD.

This heavily moralised resolution is probably overemphasised to distract the viewer/reader from lingering loose ends in the narrative. WORR stays intact and unchanged, as does the defence system, presumably retaining officials over twenty per cent of whom will continue to refuse to press the button. The likely speculation that the Soviets have their own WORR is mentioned, but only fleetingly. And what if Falken's notion of a collective deathwish is correct? The novel reinforces this possibility by inserting several allusions to *Dr. Strangelove* which by the 1980s had entered the mythology of nuclear narratives.

Notes

1. By coincidence 'ground zero' is Pennsylvania Avenue. Bone's account of the destruction of the Capitol as the visible sign of government echoes earlier narratives like *Life*'s '36-Hour War' of 19 November 1945 where Washington is one of the first casualties of nuclear attack.

2. Ford 1986: 25. The phrase 'pushbutton warfare' was in currency as early as 1950 when John W. Campbell insisted that the real danger was from 'mind pushbuttons' (Campbell 1950: 4–5). The first public article on missile silos quoted an officer as admitting: 'with all these backups and inhibitors, we're like robots in a way': Stolley 1964: 40.

3. Cf. Priestley 1959: 4. The novel also received enthusiastic reviews from Kermode 1959: 449; Paulding 1960: 1; and Naipaul 1959: 516.

4. See e.g. Roshwald 1965: 243–51. The computer mentality is discussed in Roshwald 1967: 335–6.

5. Letter from Mordecai Roshwald, 10 April 1991. These commands have no Orwellian dictator behind them, only the 'irrefutable logic of the Cold War defence posture'.

6. Fromm 1956: 119. E. B. White describes a loss of affect in his 1950 story 'The Morning of the Day They Did It' where a crew manning an orbital space platform bunch nuclear weapons simply because they feel like 'doing a little shooting' (White 1950: 32).

7. Letter from Mordecai Roshwald, 18 April 1993.

8. This novel was filmed as *The Forbin Project* (1969). Jones wrote two sequels: *The Fall of Colossus* (1974) and *Colossus and the Crab* (1977). Colossus was the name of the first British proto-computer used at Bletchley Park cypher centre in the war.

9. John B. Ower identifies three themes in this story: a travesty of the

crucifixion, the machine as a 'caricature of organism', and AM as a parody god (Ower 1974: 56). Charles J. Brady reads the story as a reverse-Exodus (Brady 1976).

10. The much recycled image of eyes as jelly derives originally from John Hersey's *Hiroshima*.

11. Bischoff 1983: 20. Peter Bischoff, as computer specialist and novelist, was also to write the movie tie-in for *The Manhattan Project* (1986). On the history of military strategic planning see Allen 1994.

X

Conspiracy Narratives

Proverbs for Paranoids, 4: *You* hide, they seek (Thomas Pynchon 1973)

(I)

It is a truism to state that the Cold War was informed by a fear of the international Communist conspiracy. The founder of the John Birch Society, Robert Welch, charged in his 'Black Book' *The Politician* that Eisenhower was the stooge of 'sinister but powerful forces' which could easily take over America so that 'our children and ourselves [will be] living as enslaved subjects of the Kremlin' (Welch 1963: 11, 300). We have seen in Chapter 7 how this fear was realised imaginatively in accounts of Soviet occupation. Now the focus shifts to cultural paranoia which commentators in the 1940s predicted would increase with nuclear fear (Boyer 1994: 280). Patrick O'Donnell has helpfully described such paranoia as an intertwining of different cultural strands whose appeal is its clarity and totality (O'Donnell 1992: 182), hence the importance of pattern. Thus an official in Asimov's postholocaust *Pebble in the Sky* (1950) supports his claim of conspiracy by insisting: 'the facts are a jigsaw puzzle that can fit only one way' (Asimov 1964: 90). In his classic essay on political paranoia Richard Hofstadter stresses how conspiracy becomes the sole motive force behind history, inducing an apocalyptic crisis: 'since the enemy is thought of as being totally evil and totally unappeasable, he must be totally eliminated' (Hofstadter 1966: 31).

A cluster of films from the mid-fifties demonstrates a consistent paradigm of such invasion-as-conspiracy where the battle for the nation's mind is played out in Smalltown USA. The instrumentality of threat comes from outside (creatures from Mars or Venus, pods from outer space) but the real power of these films is carried by

their transformations of humans rather than the crude 'monstrous' devices, their fracturing of the nuclear family or local community. Typically, the first victims are transformed through control mechanisms, the favourite of which is a device fixed on the neck accessing the brain or nervous system. This might be an implant (*Invaders from Mars*, 1956) or a flying mechanism (*It Conquered the Earth*, 1956), but its effect is similar in all cases. The human subject, overtly or covertly, becomes robotised into an acquiescent member of an alien, often expanding group aiming at total takeover. These films therefore have been explained by Susan Sontag in her classic essay 'The Imagination of Disaster' as dramatising fears of the impersonal and evolutionary change (Sontag 1987: 220–1).

The first crisis in this drama comes when the witnesses have to prove their claims. In *Invasion of the Body Snatchers* (1956) the witnesses are 'relatively powerless groups whose perceptions are often mistrusted: women and children' (Biskind 1983: 138). The boy's-eye perspective in *Invaders from Mars* is cleverly maintained by exaggerating size and selecting detail, in order to heighten David's growing sense of helplessness as every authority figure is taken over by the Martians (Warren 1982: I:116). Here the space vacated by his parents is taken up by two proxies: the local doctor and a friendly astronomer. A general and unusually literal defamiliarisation takes place as family members are estranged from each other. Once again, this is a process operating simultaneously on different levels, alienating the head of the family or of the community (the mayor is the first casualty in *The Brain Eaters*, 1958), or – most sinister of all – alienating consciousness from body. In *I Married a Monster from Outer Space* (1958) one 'convert' asks another how he likes 'wearing this thing', the 'thing' being the appropriated human body. The revelations in the mid-1950s of American POWs collaborating with their Korean captors, sometimes under brainwashing, would have given a special resonance to such changes. It is significant that *Invaders from Mars*, the most politically explicit of these films, should show an army general being taken over but, as if a compensatory fantasy for Korea, includes footage of a large-scale army mobilisation which results in the ejection of the invaders. Here the small-town setting is juxtaposed to top-secret military plants which the Martians use their victims to sabotage. The army, however, proves to be coordinated and efficient, finally restoring the *status quo*.[1]

The operative metaphor in these films of invasion as disease was already politicised by the 1950s. 'Cancer' had become a catch-all term 'for any kind of insidious and dreadful corruption' (Weart

1988: 189–90) and J. Edgar Hoover had railed against the Communist 'infection' spreading into American life. *Body Snatchers* attempts to straddle mental and physical illness when the town psychologist diagnoses a 'strange neurosis, evidently contagious, an epidemic mass hysteria' (La Valley 1989: 48). Jack Finney has denied that his novel had anything to do with the Cold War;[2] but the pods can be read as a metaphor of perceptions of Communism as emotionless regimentation, or subservience in a production and distribution system. Noell Carroll thus argues that 'the vegetarian metaphor literalises Redscare rhetoric of the "growth" of Communism' (quoted Peary 1982: 157). *It Conquered*, which has been described as a 'parable of totalitarianism' (Warren 1982: I: 290), makes such an identification explicit when a general declares martial law on the following pretext: 'We're in the midst of a Communist uprising. They've sabotaged every power source in the area'.[3]

The more the signs of conspiracy multiply, the more paranoid the films become. As in Soviet invasion narratives (see Chapter 7), the aliens take over the means of communication (telephone, telegraph) and roadblocks are set up. In short, the community comes under siege with the twist that the enemy is within. Those films (*Invaders, I Married*) which show unmistakeable signs of robotisation, like the subjects' fixed stare and avoidance of eye contact, are less unnerving than say *Body Snatchers* where the transformed self is virtually indistinguishable from its original. Here the very appearance of normality becomes unnerving. We shall see in Philip K. Dick that one feature of truly paranoid narratives lies in the virtual impossibility of distinguishing simulation from original. *Body Snatchers* extends this growing epistemological crisis into a general social state. The film opens its multiple indications of emergency (sirens, hospital signs, etc.), maintains a rapid tempo of movement throughout, and has as one of its last images Doctor Miles Bennell shouting (to the viewer) 'You're next!' *Body Snatchers* is unusual in ending with the beginning of emergency measures while the other films narrate a clear defeat and purging of the invader. *Body Snatchers* instead frames its narrative with an emergency situation left unclosed and therefore extending into the immediate future.[4]

(II)

The agencies enforcing civil order might lose personnel to the invaders, but they never become totally suspect. The community resisting invasion can even become bonded into 'historically unified

subjects' (O'Donnell 1992: 184). Such cannot be said for Philip K. Dick's fiction where the state agencies might be integral to conspiracies often already in place. In his 1955 talk 'Pessimism in Science Fiction' Dick argued that the collapse of belief in progress had led to an unavoidable preoccupation with doom. Hence the science fiction writer was 'absoluted, obliged' to 'act out the Cassandra role' (Sutin 1995: 54) of giving early warnings of the grim times to come. Instead of concentrating on an external threat, Dick constantly foregrounds how characters' perceptions of reality are mediated through official statements which themselves might be suspect. In *The Man Who Japed* (1956), Dick's satire on Communist China, a character subverts the regime by publicising a facetious account of how the founder of the Moral Reclamation movement cooked and ate his opponents. *The World Jones Made* (also 1956) charts the rise of a demagogue through exploiting an invasion narrative. Dick replays the rise of Nazism in Cold War terms, producing a 'transformation of the situation in Germany after World War One'.[5] Jones rises from a fairground huxter to political leader by exploiting the public's fears of invasion. Earth is under attack by amoeba called the 'Drifters', modelled on perceptions of the Jews, but whose designation recalls the demonised Communists-as-Other of the Cold War. Jones grimly predicts an 'infiltration by alien life-forms' which he plans to resist, like all his acts, through the 'authority of absolute will'. Jones sees history as absolutely fixed, but contradictorily rouses the masses in a 'crusade' against social disorder which reaches its climax in a march through Frankfurt (a latter-day Nuremberg rally).

Paranoia in Dick, however, usually involves the drama of discovering conspiracy, in the process of which the protagonist's world becomes radically destabilised. *Time out of Joint* (1959) literally deconstructs the small-town setting so favoured in fifties invasion narratives. Ragle Gumm has become a local celebrity by repeatedly winning a newspaper competition, but then undergoes a series of experiences which make him doubt his sanity: a soft drink stand dematerialises before his eyes, he finds a telephone book whose numbers are unobtainable, and so on. These discrepancies reach their climax when a boy's crystal radio picks up a pilot's message about Gumm himself, at which point he reflects ironically on his 'paranoiac psychosis. Imagining that I'm the centre of a vast effort by millions of men and women, involving billions of dollars and infinite work' (Dick 1988b: 87). In the same way Oedipa Maas in Pynchon's *The Crying of Lot 49* (1966) experiences a series of bizarre revelations and coincidences, only to wonder whether she is

at the centre of an 'expensive and elaborate' plot involving 'constant surveillance of your movements' (Pynchon 1979: 118). Pynchon articulates this fear as an information overload which threatens the protagonist's interpretive system with breakdown. In fact Gumm's entire environment proves to be a simulacrum of fifties America, built to distract him from the present (1998) when a nuclear war is raging, for Peter Fitting literalising the concept of ideology as a construct (Mullen 1992: 99). Ruptures in Gumm's reality are first interpreted by him as pathological; then confirmed as actuality (since the government is eager to exploit his capacity to predict the incidence of missiles); finally when Gumm contacts a resistance movement (the 'lunatics') his perceptions are re-pathologised as a 'withdrawal psychosis'. It is recoil specifically from the bomb which motivates Gumm who, during a civil defence meeting, visualises a nuclear wasteland: 'the day ... cold, grey and quietly raining, raining, the god-awful ash filtering down on everything' (Dick 1988b: 131). Even within a simulated past Gumm imagines an imminent future which is ironically taking place at that very moment.

The paranoid theme manifests itself in Dick's novels through the discovery of institutional conspiracies to promote versions of reality for ultimate purposes often left unspecified. His fiction is packed with examples of technological means of simulating, altering, or deceiving human consciousness. Typically the conspiracy has already taken place so the protagonist's engagement with the forces maintaining the *status quo* involves an attempt to uncover the construct's buried history and also a growing estrangement from the protagonist's immediate surroundings. 'Imposter' (1953: collected in *Second Variety*) dramatises in its most bizarre form the crisis of subjectivity that can result. The protagonist Spence Olham is working on a military project when he is visited by two security officers who accuse him of being a humanoid robot smuggled to Earth by the enemy during the current war. The robot allegedly contains a bomb that will be triggered by a certain verbal phrase. Neither side can prove Olham's identity until a 'robot' is discovered which appears to confirm that Olham is a human, not a replicant; but the inference is premature. The corpse in fact turns out to be human and Oldham a robot. His horrified exclamation both confirms the charge and literally destroys 'him' since it is the trigger for the bomb. This melodramatic conclusion dramatises a crisis of cognition typical of those experienced by Dick's protagonists, but here so critical that it literally destroys the self.

Dick describes the technological maintenance of illusion in *The Penultimate Truth* (1964) where America has been separated into

two levels: a ruling elite of technicians living on the surface; and the masses herded into underground 'tanks' where they continue to produce 'leadies', radiation-resistant robots who continue to fight in the nuclear war. Dick had tried out the idea in a 1953 story 'The Defenders' (collected in *Beyond Lies the Wub*) where 'tankers' make their way to the surface only to find that the landscape is intact. A robot explains that since the war directed the conflicts within society against an external enemy, they had maintained the illusion for the good of the race! In the novel both protagonists, a speechwriter on the surface and a 'tanker' president, are involved in the media maintenance of the *status quo*, the one from the production end, the other as a consumer. In the tanks morale is maintained by regular video messages from the 'Protector' who legitimates his regime by casting the administration as selfless guardians willing to brave the dangers of radioactivity for the public good. However, those 'tankers' who pay close attention to the medium rather than the message begin to notice small inconsistencies in the Protector's appearances. Correspondingly, on the surface, Joseph Adams the speechwriter gradually penetrates a whole industry of documentary simulation which continues the methods of the Nazis into the present. The separation of 'representational' footage from any perceivable actuality induces a crisis: 'The bottom, the support and structure, the form itself, of Joseph Adams' world, fell out' (Dick 1978: 68). This cognitive loss entails a realisation that history can be reshaped at will to suit the necessities of particular scripts; Adams, for instance, sees footage of Roosevelt as a Communist agent selling out the USA to Stalin. The tanker Nicholas St James experiences exactly the same crisis when he discovers that not only is there no war but also that the Protector is a robot with its counterpart in the Eastern block ('Pac-Peop' as against 'Wes-Dem'). The whole process is a 'fake so vast it could not even be described' (Dick 1978: 104). In the same way the protagonist of Gene Wolfe's *Operation Ares* (1970) is told that the ARES programme (American Reunification Enactment Society) is a fake, thereby problematising a power struggle between those who settle Mars on a wave of Kennedy-style idealism (the 'New Frontier in the Sky') and the new Americans now allied with Russia.[6]

Again and again Dick blocks off purely pathological readings of paranoia by supplying confirmations of conspiracy by others. In *Dr. Bloodmoney* (1965), the paranoid physicist Bluthgelt (based on Dr. Strangelove) embodies a whole series of right-wing obsessions (preoccupation with the enemy's 'systematic contamination of institutions at home', dream of an ultimate weapon from Edward Teller's Livermore Laboratory, etc.), has already caused one disaster by

miscalculating the nature of radioactive fallout, and then imagines that he has willed the remaining bombs to land on America.[7] Bluthgeld appropriates causation into his own godlike capacity to project 'forces' while a totally different explanation is given by another character: that the remnant of the US space defence system was triggered by a fault. This view presents the direct opposite to paranoia, the pure contingency of the bombs being launched 'without intent'.

In his early fiction Dick limits the extent of his paranoid narratives by maintaining a distinction between his focalisers' perception and the narrative discourse. The narrative voice thus reassures the reader that, notionally at least, some kind of consensus reality is maintained. This is not the case with *Lies, Inc* (1966/1984) where the perceptions of the main focaliser pursue scepticism to its extreme conclusion. The novel takes places in 2014, some twelve years after a world war which has left a resurgent whole New Germany as a superpower and China destroyed. A colony has been established on a distant planet called Whale's Mouth, but what exactly is happening there remains an enigma for much of the novel. The novel's title signifies a worldwide police agency which transmits messages on a 'SubInfo' computer. Already we can identify some of the stock ingredients for paranoia: massive political combines at work who control the media; control of the citizens through technological means; and a rebirth of fascistic methods transformed into the practice of multinational corporations. The protagonist Applebaum, owner of space craft, is defined through his perceptions not institutional status, specifically through his fear of total control by agencies like Lies, Inc: 'They're beaming psychotronic signals at me subliminally while I'm asleep, he thought. And then he realised how paranoid that was'. Recalling a dream, he compares himself to rats as experimental subjects and continues:

> That's the trouble with living in a police state, he said to himself; you think – you imagine – the police are behind everything. You get paranoid and think they're beaming information to you in your sleep, to subliminally control you. Actually the police wouldn't do that. The police are our friends.
>
> Or was *that* idea beamed to me subliminally? he wondered suddenly. (Dick 1984: 8)

An internal dialogue takes place here where every proposition is questioned and where no final conclusion can be reached because the very means of mental analysis may in themselves be compromised by the state.

Lies, Inc. follows the same plot-as-search pattern as Dick's other novels discussed here with the difference now that 'reality' goes through recurrent slippages which blur the protagonist's capacity to understand. Applebaum is convinced that video footage of a space voyage from Whale's Mouth has been faked so he wants to go there 'to prove —' what? The statement like others in the novel is left inconclusive, a gesture towards meaning only. Reality recedes indefinitely, deferring confirmation of conspiracy. The protagonist is stuck with a conviction of hidden meaning: '*Below the surface. Did nothing actually lie at hand? Did everything have to turn, eventually, to consist of something else entirely?*' (Dick 1984: 130). What lies before the perceiving subject is, as the novel tautologically puns, lies.

Dick's own politics have been described as 'left-liberal anti-authoritarian' (Rickman 1989: 193). Growing up in Berkeley gave him by his own account a background in non-aligned radicalism which led him to support Henry Wallace's Progressive Party. Dick's fiction suggests that he was at once fascinated and repelled by totalitarian states; it is revealing that he has said of his friend Robert Anton Wilson, author of the *Illuminatus!* trilogy, 'we both love conspiracy' (Rickman 1988: 52). He has carefully distinguished his position from any party commitments: 'My real stance was opposing authority' (Rickman 1988: 121–2). By the 1970s paranoia had come to appear a fact of life for him. In 1971 his apartment was burgled and his safe blown open with an explosive, he was subsequently told, that was only available to the security agencies. At the end of the decade he got access to his CIA file and discovered that some of his mail had been intercepted. Meanwhile in 1974 during negotiations to have a Polish translation of *Ubik* published under the good offices of Stanislaw Lem, Dick became convinced that he was at the centre of a Communist conspiracy emanating from a 'faceless group in Krakow' and wrote to inform the FBI of his fears (Mullen 1992: 246–56). Within a few years Dick cast himself as the victim of conspiracies from the right and left, which can be attributed partly at least to his hatred of the Nixon administration which he saw as the institutionalisation of paranoia: 'the great Communist Conspiracy did not exist', he insisted, 'but this does' (Etchison 1993: 309). On 1 September 1973 he wrote to Bruce Gillespie, editor of the Australian journal *SF Commentary*, to express anger at political developments in the USA: 'The magnitude of the despotic gang of professional, organised criminals who came to power (as did Hitler in Germany) is increasingly revealed to the US Public', he exclaimed (Etchison 1993: 287).

Dick gave fictional expression to his profound pessimism about the US administration in two novels. The first, *Radio Free Albemuth* (1985, written mid-1970s), divides its narration between 'Phil', a writer and historical commentator, and his friend Nick who is receiving messages through an intergalactic communications network (a fantasy yearning for an 'uncontaminated' information source). Conspiracy links the two figures as well as a common realisation that Berkeley, formerly a place of radical thought, has fallen victim to a general transformation of the US. This change has been spear-headed by Ferris F. Fremont, a mediocrity swept to power on a wave of political killings and by support from both the US intelligence community and the Soviet Union. The two groups are linked by their preference for 'shadow governments' nominally directed by figureheads 'so they can govern from behind' (Dick 1988a: 31). Fremont's career closely parallels Nixon's, from his smear tactics in the 1950 senatorial campaign onwards, and he has introduced a system of monitoring public reactions to his telecasts as a check on loyalty. In *Albemuth* and its companion work there is a covert dimension to political action expressed in informational terms. So Nick 'decodes' an advertisement (explicit level) to find an encrypted Communist message (covert level), which, however, is so obvious that it must be a police plant (deep level). One method of countering this is for Nick to turn one of the media against the authorities, which he does by planting subliminal messages on records accusing Fremont of being a 'Red'. Secondly, *Flow My Tears, the Policeman Said* (1974) was planned to show a 'police state in America modelled on the Soviet Gulag prison system' (Dick 1988a: 75) and here again the media are foregrounded. Jason Taverner, a TV presenter, loses all his identity documents. This event seems to coincide with a memory erasure in all his former associates, and part of the narrative concerns Taverner's attempts to regain his lost public 'visibility'. In this process he is pitted against a 'Police General' who is investigating Taverner's case because there is no information on him in the central data bank. To both figures Taverner has become an unlocated signifier whose very existence challenges the elaborate state apparatus of checkpoints, bugs (including body implants), voiceprints, etc.). The aim of situating Taverner within an information network is desired by both men although each recognises the totalitarian nature of the regime supported by such a network.

(III)

In October 1972 Dick wrote to the FBI to recount how he had been approached by a 'covert organisation' and asked to insert 'coded information' in his next writings. 'In essence', he stated, the 'vital information' was already in print in Thomas M. Disch's novel *Camp Concentration* (1968).[8] Disch's novel describes the imprisonment of an American antiwar protestor who unwittingly becomes a guinea-pig in a secret experiment to see whether a strand of the syphilis spirocete can induce heightened intelligence, an anticipation of the 1970s revelations of CIA covert experimentation. *Camp Concentration* is narrated in journal form and dramatises an issue which Dick had touched on in his own sixties fiction and in this letter to the FBI: namely how narrative production can itself be implicated in the power structure it is describing. The narrator is one Louis Sacchetti, whose name conflates a former cause célèbre of the twenties American left (Saccho and Vanzetti) and thus suggests the muffling of antiwar protest. He is being held with other 'conchies' in Spring-field prison.[9] Sacchetti is given writing paper at the point where 'President McNamara' (Robert McNamara was Johnson's Secretary for Defence and a key architect of US Vietnam policy) has announced the use of tactical nuclear weapons. Because of the coincidence of the two events Sacchetti wonders, therefore, if he owes the very genesis of his journal to McNamara.

Initially Sacchetti assumes an identifiable set of rules which will prescribe his treatment, until he is taken by guards (wearing black unmarked uniforms) to a secret underground facility called Camp Archimedes. Sacchetti imagines that his room is bugged but, in a reversal of the Orwellian pun, the real bug is the substance pallidine which is administered secretly. From an old college friend named Mordecai he learns that his journal is being scrutinised by the NSA: 'National Security Agency. The codeboys. They check over everything we say – it all goes down on tape, you know – to make sure we're not being ... hermetic' (Disch 1977: 38). The artistic ambition of 'unriddling the secrets of Nature' has, if this is true, become appropriated by the authorities under the imperative of controlling all information. There are clear signs that Sacchetti's journal is being read as soon as it is composed (but no indication of how) so much so that Sacchetti's extended dialogue (written and oral) with his jailors repeatedly short-circuits his desire for know-ledge. Indeed the novel gradually undermines semantic oppositions like appearance/reality and surface/depth by bringing into question every means of verification. Disch was well aware of how tenacious

the paradigm of victim-vs.-system was and denied the reader that satisfaction in the ending of *Camp Concentration* where Sacchetti discovers that Mordecai has been transformed into one of the jailors. Some reviewers took this as a science fiction cop-out but Disch insisted that the shift demonstrated that survival entailed 'being in complicity with a social structure that is evil' (Francavilla 1985: 247).

Traditionally the editorial frame round a defective text puts the latter in its context for the reader. In Disch's narrative an editorial interpolation has the opposite effect. Sacchetti has been trying to find out which private foundation funds Camp Archimedes. Where the name should be we find the following insert: '*Here two lines have been defaced from the manuscript of Louis Sacchetti's journal – Ed.*' (Disch 1977: 49. Italics in original). Peter Swirski argues that with this erasure 'far from being exposed after the journal's publication, that corporation wields sufficient power to preserve its anonymity' (Swirski 1991: 164). By implication the whole text becomes suspect, especially in the second part where it breaks down into fragments. Are these too the work of 'Ed'? Immediately after the interpolation above, Sacchetti has an exchange with one of his captors which thematises the public reception of his journal. Of course, he is told, it will appeal to a 'few fellow paranoids' but no more than that. In 'The Squirrel Cage' (*Under Compulsion*, 1968) Disch gives a solipsistic version of the same problem where a writer is kept in permanent solitary confinement in a padded cell, compelled to address an unknown reader. He is given copies of *The Times*, but they could have been doctored. In fact whole issues might be forgeries. He concludes: 'Anything seems possible. I have no way to judge' (Disch 1978: 95). Perhaps this is the ultimate confirmation of the regime's power in the story and novel since the means of comprehending and therefore critiquing the system have been removed. Disch thus renders in narrative form the fear expressed in Dick's 'The Android and the Human' that governments now have the technological capacity to induce whole worldviews in their subjects.[10] The entrapping spaces – underground labyrinth, squirrel cage/cell, or 'Steel Womb' (the military teleportation device in *Echo Round His Bones*, 1969) – tease Disch's protagonists to dream of breaking through those limits to the real, but the accessibility of that symbolic exterior is regularly denied.

From the 1960s onwards paranoia increasingly became a narrative subject in its own right, particularly to attack secrecy in government. Harry Harrison's sardonic treatment of the arms race *In Our Hands, the Stars* (1970) describes the efforts by a Danish

scientist to keep a new propulsion device secret from the super-
powers. After a huge explosion causing many deaths it is revealed
first that the Japanese have the device and then that the super-
powers also possessed it. Proof of the institutionalised paranoia of
the security agencies suggests that the deaths were in vain and that
the security apparatus absurdly ineffectual. Dick demonstrates how
such paranoid structures can develop a life of their own. *Clans of the
Alphane Moon* (1964) contains an unusually comic speculation that a
planet which has sunk into psychosis should be ruled by paranoids.
And since there would be a two-way hatred between the rulers and
the ruled, the paranoids would promote a foreign policy against an
enemy against whom this class hatred could be displaced. The result
would be an 'illusory struggle, a battle against foes that didn't exist
for a victory over nothing' (Dick 1975: 79). This facetious emptying
of political strategy represents only one instance from the absurdist
visions of the Cold War which grew in number during the 1960s,
and to these we must now turn.

Notes

1. In the version released in Europe David's biological parents never return,
 thus removing the dream ending which for Bill Warren (Warren 1982:
 I: 119) validates the film's logic.
2. LeGacy 1978: 287; letter from Jack Finney 12 July 1993: 'When I wrote
 this book I was not thinking of McCarthy, Communism, fascism ...'
3. This same device is used in Christopher Anvil's *The Day the Machines
 Stopped* (1964), where a Soviet secret weapon knocks out all machines
 in America.
4. Glen M. Johnson has pointed out that *Body Snatchers* has three
 different endings: in the *Collier's* 1954 serialisation Miles defeats the
 pods with the FBI; in the novel he is on his own; and in the film the
 hospital is about to call the FBI (Johnson 1979: 11). The original title to
 Finney's novel did not include the term 'invasion', although in the
 serial one of the 'converts' tells Miles 'we're making a systematic
 invasion of the country'.
5. Letter to James Blish, 10 February 1958, Blish papers, Bodleian
 Library, Oxford. Communist China is the main aggressor in *The Game
 Players of Titan* (1963) where a satellite has bombarded the USA with
 lethal radiation and *The Simulacra* (1964) where nuclear missiles have
 been used.
6. The new political alignments in this novel complicate reading the struggle
 as one between rival possibilities for America: liberal idealism and
 state repression. The 'Martians' are receiving help from Maoist 'advisers'.

7. Dick 1987: 55. Fredric Jameson argues (Mullen 1992: 26–36) that this novel is unique in describing a nuclear bombardment which, being a collective event, cannot occupy Dick's usual border territory between the subjective and the objective.

8. Etchison 1993: 64. For valuable comment on verbal cues and the motif of assassination in Dick see Burden 1982.

9. *Dr. Bloodmoney* plays (like *The Space Merchants*) on the same term in naming its first focaliser McCondine who expects to be drafted into the 'Cuban War' (a transposed version of Vietnam), designated a 'police action' like the Korean intervention. *Camp Concentration* may have been drawing on reports circulating about a neural syphilis being carried by Vietnam veterans which was attributed by the right to a Chinese biological agent (Etchison 1993: 79).

10. Cf. Sutin1995: 169: 'we have entered the landscape depicted by Richard Condon in his terrific novel *The Manchurian Candidate*'. For a discussion of the historical context to *The Manchurian Candidate* see Seed 1997a.

Absurdist Visions:
Dr. Strangelove
in Context

Mister, Send Your Missile My Way (Gina Berriault 1961)

(I)

The scene is a Salt Lake City cafe. A man and woman are eating canned sausages and drinking coffee. The man has made a proposal and the woman refuses to 'live in sin' with him. So far it might be an everyday situation. But we know that this couple might be the last surviving humans after a nuclear war has covered the Earth in radio-active dust. Damon Knight's 'Not with a Bang' (1950: collected in *Far Out*) turns Eliot's description of the end of the world from 'The Hollow Men' into a sexual pun by dramatising a tug of wills between a randy survivor and a genteel librarian in a situation of destruction which makes such an opposition absurd. In that respect his story represents an early example of treating the nuclear subject through black comedy, which reaches its climax in *Dr. Strangelove* (1963). Paul Brians has argued that such treatments represent an evasion: 'Absurdism is often a coping mechanism which allows one to shelve nuclear war mentally as simply one of life's insoluble quandaries' (Brians 1987a: 86). Comic strategies, however, can turn a satirical spotlight on the assumptions which might cause nuclear war. Far from avoiding nuclear war, they deflect its morally oppressive weight, masking their local subjects with a deadpan narrative. For instance, Pat Frank's *Mr. Adam* (1946) labours the comedy of one man's retention of fertility after a nuclear plant explodes, but then dramatises his assimilation within superpower rivalry that could lead to war.

Perceptions of the absurdity of Cold War nuclear postures had been forcefully put in the fifties by two vigorous opponents of the arms race: the cultural historian Lewis Mumford and the sociologist C. Wright Mills. Both writers placed contradiction at the centre of

their diagnoses. Mumford's collection *In the Name of Sanity* (1954) mounted a protest against the 'violence and irrationality of our times'. Mumford found a direct contradiction between American 'totalitarian military instruments and our democratic political ends'. To him the superpowers were playing out an endgame whose meaningless would culminate in war. He warned apocalyptically of a total nullification of history: 'the chaos of a final wasteland in which all order and design derived from life have returned to aimless dust and rubble' (Mumford 1973a: 154–5, 161). Mills similarly declared in *The Causes of World War Three* (1958) that the 'drift and the thrust toward World War Three is now part of the contemporary sensibility'. He continued : 'War has become total. And war has become absurd' (Mills 1959: 9, 12); absurd because massive preparations are being made for a war without a conception of victory. Both commentators therefore warned of the imminence of nuclear destruction from the lack of rational control over strategy. In fiction, both Aldous Huxley (*Ape and Essence*) and James Blish (*Black Easter*, 1968) explain nuclear war as proving mankind's 'worship of unreason'. By contrast Herman Wouk's satire *The 'Lomokome' Papers* (1968) gives a fragmentary narrative (edited by a military officer who dismisses the contents as pure 'fiction') of an astronaut's contacts with intelligent beings on the Moon who are waging a 'reasonable war'; the two nations each observe a regular Death Day when a set number of citizens are put to death thereby avoiding unnecessary conflict.[1]

These narratives gain their force by masking their subjects behind a facade of reasonableness which must be penetrated by the reader. Similar apparently skewed priorities inform the cartoons of Jules Feiffer which helped to establish a vogue in the late fifties for sick jokes, among which were sketches of the promotion of nuclear technology to the public by official agencies. One series (in *Sick, Sick, Sick*, 1959) shows a sales director or government official (the point is that the roles have become indistinguishable) insisting that the public should be made '*positive* fallout conscious' and that this can be done by having a 'Mr. and Mrs. Mutation' contest. The fear addressed by Poul Anderson and others (see Chapter 4) is here turned on its head into a grotesque prize quality. Again Feiffer's narrative 'Boom!' (*Passionella*, 1959) describes the growing atmospheric pollution from nuclear tests. To quieten fears a government-hired PR firm erects bill-boards declaring that 'Big Black Floating Specks Are Good For You!' Feiffer describes the selling of the bomb to the public. Gina Berriault's 1961 novel *The Descent* also satirises the commercial promotion of nuclear shelters. Set in the imminent

future (1964), the novel describes the appointment of an obscure Iowa professor to the post of Secretary for Humanity. This is essentially a PR post designed by the US government to stifle the 'non-realists', i.e. anyone who doesn't accept the official line on defence. Berriault demonstrates how nuclear issues have become institutionalised within the culture. Cities compete for who has the best nuclear shelters, an anti-radiation pill called NIX-R is being promoted, and Miss Massive Retaliation (voted in by US Armed Forces Overseas) sings a song whose refrain appears as this chapter's epigraph in Tokyo shortly before a Hiroshima memorial ceremony. The descent of the title is an entry into a massive shelter under Denver which has become a bizarre tourist attraction, and here Berriault, like Mordecai Roshwald in *Level 7*, plays on the metaphorical implications of descent and its opposite. An evangelist, parodically echoing Norman Vincent Peale who had been arguing since the late 1940s that the cure for nuclear fear was to think positively, declares ringingly: 'Man's descent into the bowels of the earth shall be known as the great descent that was the ascent. Let this Nuclear Era then be known as the Age of Ascent' (Berriault 1961: 111). This disguise of an action as its opposite is symptomatic of a nationwide government orchestrated process where Cold War policies are commodified and foisted on a gullible public.

Running throughout these works is a denial of death, an attempted diminution of nuclear holocaust. Mordecai Roshwald's *A Small Armageddon* (1962, inspired by the Peter Sellers farce *The Mouse That Roared*) makes this process explicit in its very title. An American nuclear submarine crew use their warheads to blackmail the President into supplying them with money, drink and profess-ional strippers. Then in the second plot an airforce commander sets out on a 'Nuclear Crusade' against the 'seat of godless power' in Moscow. Both sequences resemble *Dr. Strangelove* in starting with bizarre acts of rebellion within the US military. In the event both rebels destroy each other and so total holocaust is avoided. Arma-geddon recedes too in Vonnegut's *Cat's Cradle* (1963) where the narrator plans to write a book about the day of the Hiroshima bombing (*The Day the World Ended*). As his subject eludes him he begins to suspect that he is retracing a megalomaniacal apocalyptic script like Roshwald's airforce commander, and his account is never completed (cf. Zins 1986). The comic treatment of fears of extinction and mutation exemplify how black humour feigns to deprioritise subjects presumed to carry weight. It was the ultimate subject of nuclear holocaust which received comic treatment in the masterpiece of Cold War absurdism *Dr. Strangelove*. It is no coincidence that

Joseph Heller, whose *Catch-22* superimposed fifties paranoia on a late-World War II setting, should have been approached to write the screenplay for this film.[2]

(II)

As early as 1946 Chandler Davis had published a story ('To Still the Drums') on the dangers of a military clique taking the USA into war. In 1948 the Joint Chiefs of Staff tried unsuccessfully to persuade Truman to turn over to them control of nuclear weapons, and the following year Heinlein published an account ('The Long Watch') of a renegade military officer on a lunar base who also tries to threaten the Earth into submission with atomic bombs. With the accession of Kennedy relations between the military and the White House deteriorated so markedly that Fletcher Knebel and Charles W. Bailey could describe an attempted military coup in their 1962 novel *Seven Days in May*. *Dr. Strangelove* belongs within a cluster of novels dealing with nuclear crises triggered by a despairing US general (Peter George, *Two Hours to Doom*, 1958), a component fault in the SAC computer (Burdick and Wheeler's *Fail-Safe*, 1962), and a deranged Soviet general (George O. Smith's *Doomsday Wing*, 1963).[3] George's novel describes the decision by a SAC general to launch a pre-emptive nuclear strike against the Soviet Union from his desperation at the latter's remorseless gains during the Cold War. General Quinten's actions bring the world to the brink of war, but the crisis passes when the one US bomber which penetrates the Soviet Union drops its bomb harmlessly in an uninhabited area. *Strangelove* follows the same scenario whose initiator this time is a manic paranoid, but takes us up to the brink and over it.

When Stanley Kubrick started work on the screenplay for *Strangelove* his original intention was to produce a serious adaptation of George's novel. Then, by his own account, he ran up against a difficulty: in filling out scenes 'one had to keep leaving things out of it which were either absurd or paradoxical, in order to keep it from being funny, and these things seemed to be very real' (Kubrick 1963: 12). This blocked his true sense of a subject: 'After all, what could be more absurd than the very idea of two mega-powers willing to wipe out all human life because of an accident, spiced up by political differences that will seem as meaningless to people a hundred years from now as the theological conflicts of the Middle Ages appear to us today?' (Gelmis 1971: 309). Accordingly he chose a method of 'nightmare comedy', bringing Terry Southern in to

work on the script and presumably also the novel.

The novel, published in 1963 shortly before the film's release, captures the black humour of the film, but with differences of scene-arrangement. Where the latter opens with a voice over describing a secret military establishment in Russia, the novel introduces its narrative with a science fiction frame which warns against generic expectations of war fiction, distances the reader, reduces nuclear weapons to 'toys', and questions superpower rivalry: 'They were not on friendly terms, and we find this difficult to understand, because both were governed by power systems which seem to us basically similar' (George 1979: 1). From the same period Alfred Bermel's 'The End of the Race' (1964) uses the same device of a detached, rather bemused observer from another galaxy in opening: 'At that time the nations known as America and Russia had set off 2,500 nuclear explosions, pulverised every small island in the Pacific, Arctic and Indian Oceans, blown out of the earth lumps of great magnitude and little mineralogical value' (Pohl 1965: 77). Robert Sheckley's *Journey beyond Tomorrow* (1962) similarly describes from a far-future viewpoint the 'spontaneous and chaotic explosion of warfare' triggered by a civilian jet in Californian airspace. The ensuing 'great war' is so widespread that the 'Old World ... perished as completely as though it had never been' (Sheckley 1987: 180). All three narratives estrange the reader by refusing kinship with a lower species bent on self-destruction.

Strangelove shows a process running under its own momentum where the loss of communication only emphasises the helplessness of the human agents. Kubrick has pointed out that 'most of the humor in *Strangelove* arises from the depiction of everyday human behaviour in a nightmarish situation' (Gelmis 1971: 309). Whereas in *Two Hours* and *Fail-Safe* the hot line performs an important function in bringing the leaders of the superpowers together, one of the many ironies of *Strangelove* is that the military machines function only too well whereas the means of communication constantly break down (Maland 1979: 712). At one critical point Mandrake has no coins to phone the recall codes to Washington; at another the President can only locate the Soviet premier through Omsk Information.[4]

The cross-cutting between scenes (the novel has approximately double the number of the film) strengthens the suggestion of loss of communication by showing how each key location (Ripper's office, the main bomber, War Room) is sealed from the others. The traditional interaction between command centre and bombers in World War II narratives is blocked off, although traces are retained of earlier wars in anachronistic statements like General Ripper's

declaration that 'it looks like we're in a shooting war', and in the use of handheld cameras for the assault on Burpelson base as if it were combat footage. There is a collective refusal by the military to recognise the paradigm shift that nuclear weapons necessitate.[5] The mismatch between sound-track and image strengthens this irony by playing 'When Johnny Comes Marching Home Again' or Vera Lynn's 'We'll Meet Again' over repeated nuclear explosions (Broderick 1992: 69). The whole point is that there will be no 'again'. In the meantime characters continue to play out Cold War rivalries diminished to a squabble like that which erupts between the Soviet ambassador and General Turgidson on the floor of the War Room.

While Generals Ripper and Turgidson personify a hawkish wing of the military, they also parody the cigar-chomping Curtis Lemay, the SAC commander who was a leading proponent of the Joint Chiefs' war plan kept secret from the Kennedy administration.[6] When General Turgidson is proposing a pre-emptive strike a nearby file reads 'world targets in megadeaths', a clear allusion to the government adviser who did most to popularise thinking about the unthinkable, Herman Kahn. The latter's massive study *On Thermonuclear War* (1960) not only explains the feasibility of the Doomsday Machine which concludes *Strangelove* but also describes with chilling objectivity the massive casualty figures which would result from any nuclear exchange. This sort of nuclear calculation is embodied in the figure of Dr. Strangelove whose entrance in the film is delayed until the Doomsday Machine is mentioned, thereby associating him with death as he wheels forward out of the shadows.[7] Strangelove is in fact a composite figure also signifying the continuity between Nazi and American military experimenta- tion (cf. the rocket technician Wernher von Braun) as well as the scientific rationalism floating free of consequences parodied in Bermel and James Blish, in whose novel *The Day after Judgement* (1971) an ex-RAND Corporation official invokes Kahn's 'ladder of escalation' to assess the destruction after a nuclear war. Insulated from the wasteland outside, he argues heatedly in an underground bunker for the benefits of different nuclear weapons, insisting that 'a selenium bomb is essentially a *humane* bomb' because of its short half-life (Blish 1981: 128). The most sustained satire on Kahn's analytical method is Leonard C. Lewin's *Report from Iron Mountain on the Possibility and Desirability of Peace* (1967). This fictitious report, prepared by a government think-tank in a secret under- ground nuclear facility, reverses the conventional relation of war to peace, presenting the former as a norm and the latter as a danger. Drawing on the arguments of works like Fred J. Cook's *Warfare*

State (1963), *Iron Mountain* imitates Kahn's practice of tabulating options in its 'Disarmament Scenarios' and concludes that 'war itself is the basic social system' (Lewin 1968: 61). Throughout its deadpan Swiftian proposals *Iron Mountain* maintains a facade of plausibility by quoting contemporary commentators, prominent among them Kahn himself.

(III)

While the surface disjunctions of *Strangelove* have their satirical role, there is a subtext to this narrative which diagnoses a neurosis at the heart of the military establishment. To locate this we need to backtrack to the earliest accounts of nuclear explosions given by the journalist William L. Laurence who for a time enjoyed a virtual monopoly of such reportage. He describes the 1945 Alamagordo blast as producing a 'giant column ... quivering convulsively' as it penetrated low cloud 'like a vibrant volcano spouting fire to the sky' (Laurence 1961: 117). Then the Nagasaki bomb produces a 'giant pillar of purple fire' once again climbing through the clouds whereupon 'there came shooting out of the top a giant mushroom' (Laurence 1961: 159). Laurence's metaphors of male orgasm and birthing have been explained by feminist scholars as attempts at maximising male technological creativity (Cohn 1987: 699–701) and identifying female sexuality with the bomb's destructiveness (Caputi 1991: 430). Ira Chernus's *Dr. Strangegod* (1986) pays tribute to the importance of *Strangelove* in its title and demonstrates a congruence between nuclear weaponry and apocalyptic motifs, arguing that the Bomb is a 'symbol of omnipotence' producing extreme ambivalence (Chernus 1986: 92, 100). In *Strangelove* it is General Jack D. Ripper whose conspiracy theory proves so ludicrous that it invites the reader/viewer to scrutinise the narrative for other possible signs of neurosis. He explains to the bemused Mandrake that he has 'studied the facts' and concluded that the fluoridation of water is the 'most monstrously conceived and dangerous communist plot we have ever had to face' (George 1979: 78). Ripper continues: 'A foreign substance is introduced into the precious bodily fluids, without the knowledge of the individual and certainly without any free choice. That's the way the commies work ...' (George 1979: 79). Conflating hatred of welfare with fear of Communism, Ripper identifies the fate of his body with that of the nation, then merges the Communist threat with that of female sexual contact to justify a retention neurosis. Ripper expounds his 'theory' during the battle for his air

base. Rearing a heavy machine gun as a substitute phallus, he blasts away through his office window. However, once his men surrender, the gun droops, his cigar goes out (becomes 'dead'), and he takes his life with a pistol.

Ripper's obsession helps to strengthen a set of linkages between military technology and sexuality whereby the exercise of power shifts symbolically between the two domains. This was first recognised by F. Anthony Macklin who earned Kubrick's approval by describing the film as a 'sex allegory', 'from foreplay to explosion in the mechanised world' (Macklin 1965: 55). Macklin argues that this sequence can be observed particularly clearly in the flight of *Leper Colony* as its commander 'King' Kong progresses from 'reading' *Playboy*, through arming the bombs (which then become 'potent') to the orgasmic launch of the bombs one of which is ridden by Kong to his death. Norman Kagan has further fleshed out this reading, adding more glosses on characters' names and pointing out that the B-52 bomber is itself 'phallic, particularly in its indefatigable race to coitus' (Kagan 1972: 137).

Strangelove foregrounds sexual imagery from the first scene, a mid-air fuelling sequence taken out of context from *Strategic Air Command* (1955) so that it resembles two gigantic metal insects copulating. Kong sees 'Miss Foreign Affairs' on the centre-fold of his *Playboy* who soon reappears as General Buck Turgidson's secretary 'catching up on paper work' in a hotel suite sprawled under a sun-lamp, in a bikini, named after the Pacific atoll used for H-bomb tests. The scene between Turgidson and his secretary concludes with him telling her: 'You start your count down right now and old Buckie will be back before you can say re-entry' (George 1979: 25). The concluding ribald pun (the film uses the more decorous 'blast-off') relates sexual activity to the operation of nuclear weaponry. The comedy of *Strangelove* is ultimately about death, and destruction turns out to be the ultimate aphrodisiac. When the bombers head for the Soviet Union, Dr. Strangelove's eyes gleam with excitement and Turgidson becomes 'almost feverish'. General Ripper functions in the narrative not only as a trigger to the action but also as a particular instance of a general pathology. In an article published in the *Bulletin of the Atomic Scientists* (to which Kubrick had a regular subscription) Mortimer Ostow speculated on the implications of Freud's death-wish for war, suggesting that it might be subject to 'discharge pressure' like Eros. He continued: 'In the case of some of the more aggressive and bold leaders of the past, it is likely that their belligerence served to deflect their inward directed death impulses to the outer world' (Ostow 1963: 27).

Here we encounter the central reversal that lies at the heart of *Strangelove*. Where earlier novels and films depicted the army as the nation's protector, they are now shown to be driven by lust for destruction which turns American against American and which ultimately leads to the demise of the nation. Lewis Mumford enthusiastically praised the film for its depiction of 'colossal paranoids and criminal incompetents' as being the 'only way possible to characterise the policy itself' (Mumford 1964: 8). The whole point about Ripper, Turgidson and others is that they are not exceptions within the system. Two voices articulate reason but they are both outsiders to the American military: Mandrake, the seconded RAF officer who manages to find the bombers' recall code; and the President Merkin Muffley whose name makes a ribald contrast between female pubic hair and the President's baldness. From the perspective of the military hawks his very moderation (modelled in style and appearance on Adlai Stevenson) feminises him; but it is his rationality not the action of the military, based on the dangerously irrelevant scripts of movie roles, which almost saves the situation.

Almost, but not quite. The climax of *Strangelove* realises the rumours in the film's opening scene of the Soviet Union building an 'ultimate weapon, a doomsday device'. The latter concept, as we saw in Chapter 3, was popularised but not originated by Herman Kahn whose description is closely followed in this narrative: the use of cobalt-coated megabombs buried deep in a mountain range triggered by computer (see Kahn 1961: 145). The detonation of the device (ultimately uncontrollable) brings not tragedy since the President's queries about the fate of the population are drowned out by the possibility of a surviving remnant (men, of course) who would descend into mineshafts with women 'selected for their sexual characteristics' (George 1979: 144). At this point in the film Strangelove's prosthetic right arm springs erect in a multiple sign of a Nazi salute, displaced penis, and (*pace* Bernard Wolfe) aggression; the Cold War will continue, if only as a race to avoid a 'mine-shaft gap'. It is this ending, this 'strange love', which functions as a prelude to Suzy McKee Charnas's *Walk to the End of the World* (1974) which describes a post-holocaust world where the nuclear shelters have become the site for a gendered play of power. After the 'Wasting' the men project their guilt on to their women, reinventing an enemy-as-scapegoat, and reducing the women to slaves.[8]

(IV)

The absurdist mode of *Strangelove* has been used in a number of subsequent narratives of nuclear war. Norman Spinrad's 'The Big Flash' (1969) has a countdown sequence to describe the rise of the new Californian pop group, the Four Horsemen. Their performances use sound and image to induce a pre-verbal desire for death, building up to an orgasmic climax with the sound of an explosion and – like the finale to *Strangelove* – slow-motion shots of nuclear blasts. Political despair is given an apocalyptic packaging which both uses and becomes spectacle; each performance contains news footage of burning Vietnamese villages, inner-city riots and similar scenes. The group's chants orchestrate a deathwish phrased as a yearning for escape: 'before we die let's dig that high that frees us from our binds ... the last big flash, mankind's last gasp' (Miller and Greenberg 1987: 56). Again as in *Strangelove*, language proves unavailable for rational control of the impulse to die which Spinrad demonstrates through the moment before apocalypse where characters feel to be on the verge of revelation as they chant 'DO IT! DO IT!' The popularity of the group increases public support for nuclear weapons and even leads to the detonation of a device at one of their concerts. Their televised performance vicariously arouses a missile silo crew ('my own key was throbbing in my hand alive' [Miller and Greenberg 1987: 63]) to the point of launch. Spinrad's extension of the countdown into the social context works well since the story demonstrates a circulation of images of destruction from the military through the news and then pop media back to the military. In that sense 'The Big Flash' paints an even bleaker picture than *Strangelove* since society as a whole falls prey to the contagious lust for destruction.

Complicity too is the main issue in James Morrow's *This is the Way the World Ends* (1986) which one review declared 'begins where Dr. Strangelove ends'.[9] This future-war novel frames its main narrative with a predictive section where Nostradamus foresees a 'conflagration of human design' (Morrow 1989: 7). Morrow uses mock-picaresque chapter titles to flag in advance the experiences of 'our hero', a New England gravestone mason who buys his daughter an anti-radiation suit shortly before war breaks out. The sales contract is the main document of the novel since in it Paxton admits recognition that the suits encourage American 'society's leaders to pursue a policy of nuclear brinkmanship' (Morrow 1989: 45). When the bombs drop, Paxton is half-blinded, shot and then carried off in a US nuclear submarine whose crew assume he is a member of the designated survivors elite (the 'Erebus' plan). Intermittent realism is used by Morrow to

springboard the reader into temporary fantasy realms to capture the lunacy of nuclear confrontation. Thus Paxton buys his radiation suit from the MAD Hatter, otherwise known as the 'Tailor of Thermonuclear Terror'. Playing on the notorious policy acronym for Mutual Assured Destruction, Morrow depicts a surreal figure who combines the multiple roles of salesman, diplomat, manic chorus and even the weaver of humanity's fate. He is also the first in a series of figures to pass through the novel from *Alice in Wonderland*, reflecting an evident conviction by Morrow that the nuclear issue can only be dramatised through fantastic means.

Paxton accordingly is carried from life to death on a rite of passage where he is shown the destruction by fire of America, this last then rendered in narrative as an inset anti-scripture on the text 'In the ending Humankind destroyed the heaven and the earth' (Morrow 1989: 115). The culmination of Paxton's journey comes in Antarctica, the location of the Necropolis of History, an overgrown marble city like a vast monument surcharged with pathos by the impending death of the future. When Paxton and others query the sanity of events the Hatter points the moral of discredited rationality, screaming : 'They called the Joint Chiefs of Staff sane! They called the National Security Council sane!' (Morrow 1989: 125). Morrow acts on such declarations by denying Paxton (and the reader) a stable level of reality within the narrative; there is no area of his subjectivity exempt from the moral impact of nuclear war. Events shade into dream, but never at the expense of ongoing debate over the war, defence policy, or survivors' guilt. The concluding section describes the trial of the survivors by the 'unadmitted', what Jonathan Schell calls the future generations 'cancelled' by nuclear war. Paxton has by this point become the 'prisoner of the murdered future', alive but sterile.[10] These chapters interrogate the whole situation of nuclear confrontation, like Leo Szilard's 'My Trial as a War Criminal' drawing comparisons with the Nuremberg hearings. Speaking with the viewpoint of history Justice Jefferson pronounces as final verdict the judgement: 'Each of you in his own way encouraged his government to cultivate a technology of mass murder, and, by extension, each of you supported a policy of mass murder' (Morrow 1989: 218). Paxton is of course an adult and therefore denied the buttressing of Alice's childhood innocence. Both Spinrad and Morrow implicate their protagonists and by extension their readers in the contagion of deathlust or in acquiescence to a culture of mass destruction. The next chapter will examine two narratives which investigate the cultural narratives leading to that destruction after nuclear holocaust has occurred.

Notes

1. In 1957 Heinlein was offered the chance to write a screenplay for Wouk's novel, which he refused on the grounds that the book was a 'philosophical tract packaged as a fantasy' (Heinlein 1989: 116).
2. MS note from Stanley Kubrick to Heller, 30 July 1962, Heller Archive, Brandeis University.
3. The US edition of George's novel was retitled *Red Alert*, and the book was praised by Herman Kahn as a clever presentation of an 'ominous possibility' (Kahn 1962: 44) see Abrash 1986 for a discussion of the hidden logic within deterrence in this novel and Roshwald's *Level 7*. George dedicated his second nuclear novel, *Commander-1* (1965), to Kubrick. For commentary on *Fail-Safe* and the preventive system of its title see Seed 1994b. The scenario of a madman launching a weapon against the Soviet Union is described in Andrew Sinclair's *The Project* (1960).
4. The treatment of the telephone is not mere fantasy. At that time the US military depended on public lines for their communication; and when Kennedy moved into the White House the hot line was disconnected and removed during redecoration (Ford 1986: 28–9).
5. Cf. Brustein 1964: 4, and John W. Campbell: 'All our former concepts of strategy and tactics must be thrown out and an entirely new order of things instituted' (Campbell 1947: 243).
6. J. K. Galbraith described Lemay as 'the most prominent figure in the culture of destruction' ('Timewatch', BBC2, 8 October 1996).
7. Charles Maland sees in him elements of Edward Teller and Henry Kissinger as well as Kahn (Maland 1979: 709–10). The subtitle combines Norman Vincent Peale with an article by Leo Szilard: 'How to Live with the Bomb and Survive' (*Bulletin of the Atomic Scientists* [February 1960]).
8. Charnas has explained that her novel was provoked by an article about an underground nuclear command facility for the US government which suggested that the 'very cretins who cause the destruction of the world [would be there] with lots of nubile young women' (Charnas 1998: 6). The 'mine-shaft gap' parodies the misperception of a 'missile gap' in favour of the Soviets which played a role in the 1960 presidential campaign.
9. The *Philadelphia Enquirer*, quoted in the fly-leaf of the 1989 reprint. A Strangelove figure named Dr. Randstable is among those tried for war crimes.
10. Cf. Schell 1982: 168: 'Of all the crimes against the future, extinction is the greatest. It is the murder of the future'.

XII

The Signs of War: Walter M. Miller and Russell Hoban

He had never seen a 'Fallout' (Walter M. Miller 1959)

(1)

If nuclear holocaust is imagined as the ultimate rupture to human life and history, survivors' attempts to reconstitute some form of civic order involve the problem of how to access the past. Books take on the symbolic value of talismen from pre-war, desired by some and feared by others. Susan Spencer has argued that post-holocaust fiction brings out ancient anxieties about the relation between oral communication and literacy, textual information and knowledge, relating such issues to questions of power. Thus a protagonist's search for historical data might run counter to an institutionalised resistance in the post-holocaust society.

This is what happens in Leigh Brackett's *The Long Tomorrow* (1955), one of the earliest novels to describe the search for the archive, disrupted and almost hidden but never quite destroyed by nuclear holocaust. Brackett describes a rural community based partly on her experience of Amish culture which appeared 'uniquely fitted to lead, if only by example, a post-atomic-war population left high and dry by the breakdown of all those complicated systems by which we live' (Walker 1976: 5). The novel stresses the cost of this capacity to survive, deglamourising the 'Jeffersonian myth of a simple, virtuous rural culture' as harshly repressive (Parkin-Speer 1985: 191). In the wake of nuclear war, mythologised as the 'Destruction', New Mennonite communities have sprung up which forbid alike the creation of new cities and the scrutiny of books. The novel centres on a young boy named Len Colter, who cries out to his father 'I want to *know*!' when the latter beats him for stealing books and a radio. The fundamentalist ideology of the community is expounded to Len by his grandmother who describes nuclear war

in Old Testament rhetoric: 'there was a rain of fire from heaven and many were consumed in it! The Lord gave it to the enemy for a day to be His flail' (Brackett 1955: 30).

In his drive for knowledge Len steals textbooks of physics and more importantly a history of the USA which estranges him from his community's ideology even before he physically sets out to find the legendary Bartorstown whose name signifies commerce, a practice now forbidden. The place itself proves to be a self-supporting underground defence installation housing a computer which contains all the then-existing knowledge of nuclear fission. Len's entry marks his point of access to history seen metonymically in a panoramic photograph of Hiroshima. In Bartorstown he learns of past nuclear weapons and gradually works off the technophobia he has been taught. Bartorstown itself therefore functions simultaneously as museum, technological site, and a place where Len can speculate on the future. Its supervisor Sherman introduces him to a secular ethic of indestructible knowledge and to a retrospective dream of disarming nuclear weapons through a field-force device. This dream of technological power ('absolute mastery of the atom' [Brackett 1955: 174]) unconsciously repeats the impulse behind the original war. Ironically it is Sherman who introduces Len to the idea of recurrence: 'It will all happen over again, the cities and the bomb' (Brackett 1955: 177). The novel concludes soon after Len has digested this possibility. The learning sequence includes recurrence only as an abstraction. It was left to Walter M. Miller's *A Canticle for Leibowitz* (1959) to show recurrence taking place in a narrative spanning centuries.[1]

(II)

A Canticle opens with a discovery. The context is a new Dark Age where one Brother Francis, a novice from the nearby Leibowitz Abbey, is performing a Lenten fast. An aged man appears out of the desert and shows him a rock which will complete the shelter he is building. When he removes this rock a 'cave' is revealed which proves to be the remains of a fallout shelter from an earlier era within which Francis finds a metal box containing a number of documents: a shopping list, a racing form, a note to a friend and a blueprint. Francis is a member, we should note, of a monastic order devoted to preserving the traces of a literacy which has been all but lost. Other members of this same order, the so-called 'bookleggers', have been committing works to memory, as in *Fahrenheit 451* where

Granger and his associates also attempt a future preservation of books against a Dark Age.

The contents of Francis's box – the 'Memorabilia' as they become known – can be construed as an enigmatic collection of metonymies, parts of a narrative and the fragmentary traces of a signifying system which have disappeared. Reconstruction of their meaning goes hand in hand with the re-enactment of the narrative they only partially disclose. In that respect they represent the opposite case to Miller's 1953 satire on the Cold War 'Check and Checkmate' where by the twenty-first century political signs have changed, but referents remained unchanged: 'war' has become 'peace-effort', and 'lynch' has been replaced by 'security-probe' (Miller 1953: 6–7). In Miller's novel the blueprint, which is signed by one I. E. Leibowitz, embodies the cryptic nature of the past and remains a textual puzzle throughout Books I and II, an object to be copied, 'illuminated' and scrutinised for meaning.

The enigma of the blueprint (literally a plan for future realisation) indicates a condition of the novel's whole text which Walker Percy has compared to a 'cipher, a coded message, a book in a strange language' (Percy 1971: 263). A Canticle is charged throughout with half-concealed meaning which Miller further complicated when he was revising his three novellas for novel publication. The final work repeatedly foregrounds certain signs as if to promise the reader meaning and then destabilises those signs through ambiguity and repetition. The old man who meets Francis is described naturalistically in the original version as one of the 'black specks' shimmering in the heat. The novel's text revises this image into an unstable sign, a 'wiggling iota of black', which punningly plays on the letter-sign and 'iota' as denoting the smallest distinguishable item.[2] Furthermore Miller stresses such differences as those between old and new English which revolves around vocabulary, Hebrew and English, and the special status of Latin, of which more in a moment. When the old man writes two Hebrew letters on Francis's rock at the beginning of the novel the action establishes the major motif of the cryptic nature of signs. Miller plays on the traditional figural opposition between light and dark throughout A Canticle to articulate the limits of human understanding. In Book II the grand narrative of scientific discovery is questioned by the fact that many scenes of 'enlightenment' occur in semi-darkness. The rediscovery of electricity is symbolised as an inevitable displacement of religion and an anticipation of the atomic bomb. An incautious monk who gets a shock from the machine exclaims 'Lucifer!', for Russell Griffin a sign for 'destructive technological knowledge' since its

literal meaning of 'light-bearer' has become overlaid with satanic connotations (Griffin 1973: 114). By Book III the phrase 'Lucifer is fallen' has become incorporated into a pagan liturgy similar to that in *Ape and Essence* and now functions as a coded signal for the detonation of a nuclear device.[3] Towards the end of the novel this shifting symbolism is thematised by an abbot who reflects: 'How strange of God to speak from a burning bush, and of Man to make a symbol of Heaven into a symbol of Hell' (Miller 1984: 302). The sense of sight, privileged organ of understanding, reflects this puzzlement in Book III as a collective environmental problem when radioactive dustclouds drift across the landscape, ushering in a nuclear twilight.

Daniel F. Galouye's *Dark Universe* (1961) exploits the same symbolism but in a simpler linear progression from darkness to light. A post-nuclear holocaust world is here seen from the perspective of distant survivors who live permanently underground. Their visual sense has literally atrophied out of existence and they communicate aurally through 'clinkstones'. Sight, however, is not forgotten but has become internalised as a deity and the tunnel-dwellers rationalise their predicament in terms of a second Fall from the Earth's surface caused by a primal act of wrongdoing. The novel traces the tortuous journey of the protagonist up from underground. As Jared (whose biblical name signifies 'descent') explores the links between light, eyes and sight, the most horrifying discovery comes when he reaches the surface and realises that 'Light was not in Paradise' but 'was in the infinity of Radiation with the Nuclear monsters' (Galouye 1963: 150). Solicitous scientists take Jared in hand, teach him how to see, and then reveal the history of his original situation underground: a nuclear survival bunker had suffered a serious electronic fault and all lights had gone although it had continued to function. Jared is thus helped by science out of a darkness as metaphorical of 'any rigid dogmatism' (Brians 1987a: 73) towards a rationalistic rediscovery of history and technology.

Galouye retains the traditional spatial opposition between up/down and connotations of light and dark, but transposed on to a post-holocaust future so that a nuclear shelter becomes a kind of hell. Miller, in contrast, destabilises such spiritual symbolism, partly to block off any optimistic reading of his novel. He personifies the duplicitous shifting nature of signs in the bizarre figure of Mrs Grales, an old woman in Book III who sells tomatoes. Originally planned by Miller to embody the inheritance from the last Deluge of Flame in her 'genes shattered and twisted', she appears in the novel simply as a mutant possessing two heads and thus two names

(Miller 1957: 18). Her surname resembles 'grail' while her other name, Rachel, evokes the proverbially beautiful wife of Jacob. Mrs Grales keeps her second head wrapped; indeed it is not clear that it is alive until nuclear war breaks out and she seeks its baptism. Mrs Grales represents the damage done to the human body by nuclear war, immediate and longterm, ironically appearing to the monk Joshua in a nightmare-revelation where she claims to be the 'Immaculate Conception'.

(III)

The main characters of A Canticle all become would-be readers, attempting to decipher the scripts of history but denied the ultimate competence of the deity: the 'inscrutabilis Scrutator animarum' (inscrutable scrutiniser of souls). Such total access is unavailable to the fallible human figures within the novel who, as we have seen, are constantly found in the posture of examining signs and texts for their meaning. There are obvious metafictional implications in such episodes which Miller focuses in Book II by introducing his only explicit allusion to other science fiction. The scientist Thon Thaddeo is examining the documents of the archive to try to understand the origin of mankind. He stumbles across a 'fragment of a play, or a dialogue' describing the creation of a servant species which revolts against its own creators, and jumps to the conclusion that present humanity is descended from this new species. Clearly the work referred to is Karel Capek's play R.U.R., but the monks do not know how to classify the fragment ('probable fable or allegory'). Thaddeo sees its importance as opening up speculative thought – and here Miller in turn opens up a function for his own novel – whereas the abbot takes it to be simply a scurrilous attack on authority.

The search for meaning is described in Anthony Boucher's 1951 story 'The Quest for Saint Aquin' through a post-holocaust scenario strikingly similar to A Canticle. The world is now ruled by the Technarchy. The Pope commissions one Thomas to set out on a quest for the saint of the title, which he does riding a 'robass' (a robotic ass). As in A Canticle, Boucher juxtaposes ancient and modern, and draws out resemblances between his narrative and the Bible. Thomas thus notes parallels between himself and Christ, and even more so with Balaam, but the latter story remains an enigma 'as though it was there to say that there are portions of the Divine Plan which we will never understand' (Silverberg 1970: 379). When

Thomas finally locates the body of the saint it turns out to be a robot. The story thus can be read as an ironic and inconclusive parable of spiritual inquiry. Miller, like Boucher, evokes a new medieval era, but one containing the incongruous signs of the reader's present. The result is to situate as in a vantage point of history where we read among resemblances to different periods.

The recognition of parallels is woven into *A Canticle* as a condition of its discourse that everything has been already recorded. Book I contains an account of nuclear war as a new scripture incorporating phrases from Genesis in a palimpsest-parable on the pride of princes which results in the 'Flame Deluge'. Miller combines three catastrophes: the flood, the destruction of Sodom, and the fall of Babel into linguistic division.[4] This account capitalises on the reader's assumed biblical knowledge to produce a narrative that is at once ancient and futuristic. Since we have seen how Miller foregrounds the difficulties of recording and transmitting such narratives, it is hardly surprising that they become modified from one section of the novel to another. Book II recast the Flame Deluge story as one of state power, which then became a central concern in Miller's sequel *Saint Leibowitz and the Wild Horsewoman* (1997). Book III multiplies the historical resemblances in the action and reconstitutes in the narrative present the story implicit in the Leibowitz fragments from the opening chapter. Once nuclear war breaks out allusions are made to the Nazi genocide (candidates for euthanasia wear stars), the Korean War and the resurgence of Manifest Destiny. Nuclear war also coincides with an era of secularism described through an Audenesque 'liturgy of man': 'Generation regeneration, again, again as in a ritual' (Miller 1984: 200). Although the church is privileged throughout the novel as a guardian of culture the novel narrates repeated challenges to its authority, here through the reduction of ritual to farce. The last section brings out the 'ambiguity and paradox implicit in the previous sections' (Dowling 1987: 199), in particular making explicit a view of human action as unconscious repetition.

The grimmest implication of repetition in the novel is the suggestion that history consists of a cyclical script determining human behaviour from era to era. As the abbot in Book III reflects with despair, 'Are we doomed to do it again and again and again? Have we no choice but to play the Phoenix in an unending sequence of rise and fall?' (Miller 1984: 280–1). And he rehearses a list of empires which have since disappeared into oblivion. In 'Check and Checkmate' Miller also describes a persistent Cold War situation where diplomacy has given way to 'pokergame protocol', a ritual of

bluff and counter-bluff which denies resolution: 'Check and check-mate. But always there was a way out. Never a final move. Life eternal and with life, the eternal plotting and scheming. And never a final victor' (Miller 1953: 24). While the story describes a shadow-war reified by a 'Hell Wall' (the Iron Curtain writ large) dividing the globe, *A Canticle* imagines the worst-case scenario of actual nuclear war. The plan by the church to launch a spaceship carrying a saving remnant can thus be read as a symbolic attempt, like the journey into space in James Blish's *Cities in Flight*, to break out of the closed circle of history. By the mid-1980s Miller had evidently found no reason for optimism. Introducing his nuclear fiction anthology *Beyond Armageddon*, he reflected: 'For forty years now the results of the karma which we cast at Hiroshima and Nagasaki have unfolded and enmeshed us like fish in an expanding nuclear net. History seems as irreversible as entropy' (Miller and Greenberg 1987: 8). Chess-game, cycle, net; all these figures of entrapment suggest an austere gloom on Miller's part over humanity's capacity to escape its own political constructs. Hence the structure of *A Canticle* which ends immediately before its narrative cycle will start over again.

(IV)

The misunderstandings of the Memorabilia in *A Canticle* grow out of semantic loss where certain specific, mainly technological terms have become incomprehensible. Miller never tries out an effect which Edgar Pangborn achieves in *Davy* (1964) of deforming place names (see Chapter 13) so that Mohawk becomes 'Moha', New England 'Nuin', and Newburgh 'Nuba'. The reader can only gain access to Pangborn's postwar landscape by recognising the original screened by the deformation. The use of altered names thus temporarily defamiliarises the novel's American setting and rein-forces the cultural fragmentation which Pangborn implies in his use of regional dialect. Russell Hoban's *Riddley Walker* (1980) develops Pangborn's cautious experiment with names into whole discourses to evoke an 'England desolate from radiation 3000 years or so after the end of the century, at which time one supposes civilisation had gone bust with a nuclear war' (Kincaid 1985: 8). Pangborn's narrator recognises the potential problem of language but gets round it for reasons of expediency: 'English in the pattern of the Old Time is the only language I could have in common with you who may exist and one day read this' (Pangborn 1969: 8).

One of Hoban's main source texts for *Riddley Walker* was Gerald Kersh's 1947 story 'Voices in the Dust of Annan' which describes the experiences of a visitor to a country transformed into a waste-land (a 'sort of ash-heap') by an unnamed cataclysm. Arrived at the 'Dead Place', the visitor thinks he hears singing and finally discovers that the area is inhabited by tiny (possibly mutated) anthropoids who live underground like Wells's Morlocks in the remains of a sewer system. The story ends with a flash of insight by the visitor that he has been hearing distorted forms of old songs ('Bless 'em all' has become 'Balasamo', for instance) and that 'Annan' was London. The visitor is walking through the traces of a metro-polis destroyed in a 'Ten Minute War' by atomic bombs. In other words language brings recognition of a historical moment and makes sense of what would otherwise remain an anonymous wasteland. As Hoban later explained, 'Speech always encapsulates a place and a time and a world-view' (Myers 1984: 14). Hoban began composing his novel in 1974, discarding some 500 pages of manuscript because there was too much external action, not enough internal action, and the use of 'straight English' would have been false to the characters' experience.[5]

Several critics have applied the predictable nuclear analogy to Hoban's language, arguing that discourse imitates unstable iso-topes. Jeffrey Porter argues the puns and other devices form a moral 'critique of nuclear consciousness'. Embedded in the language, used but not understood by the narrator Riddley, then, is a counter-narrative showing how 'life has been betrayed by technology' (Porter 1990: 459). This can be seen in one of the novel's key sections, a folk tale called thus 'Eusa story'.[6] The lexical core of the story is a pun on 'atom' and 'Adam' and the sequence is initiated by 'Mr. Clevver' who tells Eusa (Eustace) to design a superweapon ('I Big 1') to bring about ultimate victory over his enemies. The splitting of the atom is described as a kind of murder of peace itself:

> The Little Man the Addom he cudn stop tho. He wuz ded. Pult in 2 lyk he wuz a chikken. Eusa screamt he felt lyk his oan bele ben pult in 2 & evere thing rushin owt uv him.
> Owt uv thay 2 peaces uv the Littl Shynin Man the Addom thayr cum shyningnes in wayvs in spredin circels. (Hoban 1980: 32)

This narrative of scientific discovery only shows a release of death from the 'barms' (i.e. bombs, with a play on birth through 'barm' meaning 'lap').

Hoban describes a future world where, as in Walter Miller, literacy is almost dead; now the text foregrounds oral transmission but through a discourse which plays on visual as well as aural resemblances between words. Riddley values but misunderstands the surviving life of St. Eustace and this marks the connecting link between Miller and Hoban. The latter has explained: 'I had read *A Canticle for Leibowitz* and when I developed my misinterpretation of the Eusa story I thought about the misinterpretation of electrical diagrams and I thought, am I too close?'.[7] Hoban is making a different use of language in his own novel where punning suggests a promethean release of deadly energy which cannot be controlled.

If nuclear war has killed a culture then excavation becomes one means of trying to gain access to a lost era. This might involve scavenging in graves (*Ape and Essence* and *The Wild Shore*) or ploughing up old coins (*Davy*). Helping his father to dig up a shapeless piece of machinery, Riddley slips causing the object to crush his father, recapitulating individually the war as a death by technology. On one of his digs Riddley uncovers a Punch marion-ette with a severed human hand inside it.[8] This literalisation of the 'dead hand' of the past questions initiatory action since it can only be worked by another. This notion is described in the abstract at the beginning of the novel as a force inside humans: 'that other thing whats looking out thru our eye hoals' (Hoban 1980: 6). In 1984, reviewing the British nuclear war film *Threads*, Hoban makes a similar point. Suppose, he speculates, that the real is a facade behind which a force is operating, 'something that animates the universe, something that continually offers itself to our perception; it offers the atom for our discovery and it offers what can be done with the atom ...' He continues that statistics and official jargon intro-duce lies into the discussion of nuclear war by sanitising the deaths, suffering and disease. For that reason he praises *Threads* because

> it cancels all aesthetic distance between our unthinking and the unthinkable [showing] the birth of a new life for our children, a life of rats and maggots, of slow death by radiation sickness and plagues and starvation and quick death by violence. (Hoban 1984: 4, 3)

The feral life persists in *Riddley Walker* where isolated communities fear attack by bands of savage dogs; the plagues and sickness have receded into a legendary Bad Time.

Whatever Riddley is describing, it is impossible for readers to lose their awareness of language which is insistently foregrounded

throughout the novel, so much so that critics have argued that it is the true protagonist. The random objects uncovered in *A Canticle* have their equivalent in the lexical traces of a technology that has disappeared. Embodied in the collective memory as story are fragmentary account of cultures of 'air boats' and references to 'gygers' (i.e. Geigers). These terms form the verbal equivalents of the Memorabilia in *A Canticle* which the reader 'excavates' from their distortions. Hoban presents storytelling as a social and dialogical act where Riddley's status as narrator is reduced so that he becomes a listener and a voice among others, participating in a collective debate over meaning. Riddley 'already lives in a deconstructed world where no position is privileged, no code to decoding apparent' (Dowling 1988: 183). Unlike the Kersh story discussed above, mediating discourse has disappeared, closing up the gap between the actions of the characters and the interpretive acts of the reader.

Riddley Walker's name suggests two related functions. Walking corresponds to the dynamics of thinking and narration, while his first name signifies a quality in his own story and the stories he hears. The Eusa story and others are scrutinised in a 'reading back', an attempt at 'inferring an origin from signs viewed as traces' (Schwenger 1992: 32). One effect is to surcharge objects and stories with expressive potential. So a bag of crumbly 'stones' which Riddley finds is named as 'Salt 4' (sulphur but also an echo of the Strategic Arms Limitation Talks). Although he calls his performances 'reveals' and 'shows', each new term or gloss raises further questions in an open-ended interpretive sequence. Riddley's opposite number in the latter process is Abel Goodparley who exercises state authority by confidently telling Riddley what a children's rhyme about the Fools Circle means and proposing a congruence between theology and physics: 'it all fits you see'. The point for Riddley is that it doesn't all 'fit'. Goodparley's assertion of a totality of meaning contrasts throughout with Riddley's provisional and ongoing discoveries. Although his journey is aimed at a centre, the prevalence of circles in the novel suggests lack of progression and a merging of inner and outer. Riddley's thoughts ('like circels on water') repeat the physical processes of radiation and bomb blast, especially as he approaches Cambry (Canterbury), the 'Zero Groun' of the nuclear war. Despite the climactic excitement of his arrival, Riddley does not experience any moment of insight and the novel closes with him back on the road. The Bad Time remains an impenetrable mystery.

Notes

1. Miller's 1952 story 'Big Joe and the Nth Generation' (in *The View from the Stars*) anticipates *A Canticle* in describing post-holocaust knowledge as an archive in an underground cavern guarded by priests and a robotic monster called Big Joe. For a related discussion of post-nuclear literacy see Spencer 1991.

2. Miller 1955: 93. Alexandra Olsen notes primarily an increase in religious references in these revisions. For commentary on the interconnections between signs and names see Griffin 1973.

3. Griffin 1973: 114. Miller's code-phrase might be an echo of H. G. Wells's *The World Set Free* (1914) where an eye-witness describes how atom bombs 'fell like Lucifer in the picture' (Wells 1988: 86). A popular early designation for the H-bomb was the 'hell bomb'.

4. Miller's Flame Deluge probably draws on Stephen Vincent Benét's 1937 story 'By the Waters of Babylon' which describes a world laid waste by the 'Great Burning'. Miller respected this story enough to include it as a post-nuclear narrative before the fact in his 1985 anthology *Beyond Armageddon*.

5. Kincaid 1985: 8. Hoban rejected the model of Anthony Burgess's *A Clockwork Orange* because his language didn't have a 'whole syntax' (Interview 8 March 1998). Kersh's story is collected in *Nightshade and Damnations* (1969).

6. Deriving partly from *The Legend of St. Eustace*, a wall-painting Hoban had seen in Canterbury in 1974.

7. Interview, 8 March 1998.

8. Hoban's interest in Punch and Judy is due partly to its long history and during the composition of the novel he hit on the idea of using the puppeteers as a means of 'taking the government policies to the people' (Interview, 8 March 1998).

XIII

In the Aftermath

There will be those who say that the end came (Carolyn See 1987)

(I)

Whitley Strieber and James Kunetka's *Warday* opens with the statement that 'The survivor's tale is the essential document of our time' (Strieber and Kunetka 1984: 13) and in their different ways all the narratives considered in this study raise the question of survival. Miller and Hoban addressed the possibility of textual and oral preservation of the past, but nuclear war represents 'potentially, a burning of practically everything, including memory' (Klein 1990: 78). The British publishers of German Anton-Andreas Guha's *Ende* (1983), a nuclear diary-novel, attempted a material representation of this fear by issuing the book as if with charred covers. This chapter will examine what kinds of survival are imagined in the aftermath of a nuclear war. K. F. Crossen's *The Rest Must Die* (1959) is untypical in concentrating on the immediate practical difficulties of survivors in the New York subway. Usually even accounts of nuclear attack include consideration of how society might be re-formed, and the farther these narratives' present is removed from the war itself the more they enact a process of what William J. Scheick has called 're-minding', a 'hoped-for reinterpretation of communal memory' (Scheick 1990: 6). Robert Abernathy's 'Heirs Apparent' (1954) presents the nuclear aftermath as an inheritance which representatives of Russia and America confront with differing degrees of adaptability but where prewar hostilities essentially continue without change. In contrast, if a writer wishes to foreground the pathos of loss she or he might follow Ray Bradbury's practice of transposing the act of commemoration on to the places and things destroyed in the holocaust whereby reciting their names becomes a ritual act of recall.[1]

168

Commemoration and continuity obviously presuppose a surviving remnant whose existence had become a matter of debate as early as the 1940s. Theodore Sturgeon's 'Thunder and Roses' (1947), for instance, dramatises a clash between humanitarianism and the imperative of military response when the USA is attacked without warning. A singer pleads for recognition of a 'spark of humanity' in the enemy and persuades an American officer not to launch a massive retaliation. This appeal is based on a recognition that, although the fate of America and probably the rest of humanity, is now sealed, the officer's decision just might affect survivors in the 'far future'.

Tenuous as this hope is, Sturgeon avoids the worst-case scenario of one of the most famous post-nuclear narratives, Australian Nevil Shute's *On the Beach* (1957). Here the true protagonist is radioactive fallout which drifts remorselessly south towards Australia, Shute's main setting. The novel is based on a twin premise that fallout is irresistible and will be total. Accordingly, Shute, like most of the authors in this field, problematises the act of recording. 'After all', muses one character, 'there doesn't seem to be much point in writing stuff that nobody will read' (Shute 1957: 81). As the addressee becomes a notional spectral figure, so the unique event (*pace* Derrida) eludes and challenges history as its ultimate rupture. Shute's characters defer recognising this crisis: 'The condition of postponement ... is utilised by characters not to achieve a new sense of meaning, but to canonise the old patterns' (Schwenger 1986: 44). Stanley Kramer's movie adaptation modified the novel's fatalism by strengthening the role of the scientist Osborne (played by Fred Astaire) who delivers an angry attack on the whole concept of deterrence: 'Everybody had an atomic bomb and counter-bombs and counter-counter-bombs. The devices outgrew us. We couldn't control them'. Nevertheless characters' general acquiescence outraged Edward Teller who devoted a whole chapter of *The Legacy of Hiroshima* (1962) to refuting the novel. 'Although unrealistic', he grudgingly admitted that 'Shute's elimination of any practical attempt to survive is frightening because it corresponds with the attitude of the overwhelming majority of our people' (Teller 1962: 241). Indeed the film was so popular that Eisenhower's Cabinet discussed ways of countering its message.[2] Apart from its fatalism, *On the Beach* has been charged with sanitising war: 'The book and the film, by showing none of the physical agony and demolition that a real war could bring, made world extinction a romantic condition' (Weart 1988: 219). Helen Clarkson criticised the novel for this reason (see Chapter 4) and Dan Ljoka modified it in his novel

Shelter (1973) which alternates sections set in Washington and New Zealand. In the former the only man among a group of women is reduced to a sex slave while the New Zealand chapters recapitulate Shute, as the Prime Minister's family awaits death with stoicism. Nothing softens Ljoka's pessimism. A couple take suicide pills in the south while the survivors emerge from the Washington shelter only to fall victim to radiation sickness: 'it was already too late' (Ljoka 1977: 201).

(II)

Where Ljoka counts down the last moments of humanity, two of the earliest narratives of nuclear war describe the existential crises of their protagonists in coping with a transformed America. In Wilson Tucker's *The Long Loud Silence* (1952), Corporal Russell Gary wakes after a mammoth drinking bout to find that within two days a nuclear war has taken place, followed by an outbreak of plague and the United States has become divided into two areas: that west of the Mississippi where a remnant of the population is re-establishing civic order and the eastern states which are plague ridden or devastated. The Mississippi has become a border which anyone attempting to cross will be shot on sight. Since Gary did not witness the war he must infer what happened from the after-effects. Tucker's novel follows a whodunnit paradigm where the victim is the nation itself and where the probable identity of the perpetrators of the crime is guessed but scarcely matters. Although Gary is still in the army theoretically, events have estranged him not only from that army but also from his own culture. The western territories prove to be a place of captivity and, ironically, the eastern shore (described by the authorities as a 'dead and vacant nothing') comes to represent the only possibility of freedom. Since Gary's perceptions mark the narrative limit, Tucker cannot explain clearly how he would build up an overall image of the war's destruction and concentrates instead on tracing Gary's long slide towards cannibalism.[3]

Alfred Coppel's *Dark December* (1960) also has a military protagonist and this time describes an attempted homecoming. Major Gavin has served as a pilot in Korea and is now an operative in an underground missile bunker. One week after a nuclear war has ended he is told that he has finished his tour of duty and can return home. The novel therefore describes an extended journey from Alaska to Oregon, then south to the San Francisco area. This

return becomes more and more problematic since most of California
has been declared a contaminated area and anyway Gavin's home
town has almost certainly been obliterated. The novel carries an
epigraph from Dante which clearly invites the reader to see Gavin's
travels as a figurative descent into Hell (the original title of the
novel was to be *Night Journey*) where each new episode takes him a
step further beneath the patina of civilisation.

A deleted passage makes explicit an irony which is only
gradually revealed in the novel proper, namely that 'we have used
the most advanced techniques twentieth century science could
produce to bring back a rule of savagery'.[4] Like Tucker's Gary,
Gavin emerges into a transformed world whose familiar landmarks
have been erased to the point where 'it was impossible to say for
sure that towns had ever existed' (Coppel 1971: 38). Gavin then
traverses a California full of threats from disease, radioactivity, and
roaming gangs; later, falling into a delirium where he takes on
himself the guilt of his nation:

> I dreamed of a pillar of fire rising over the skyline, boiling up
> into the sky over my head with an incredible menace ... The world
> cracked and shuddered beneath my feet. It was breaking apart
> and each segment seemed to go spinning off into an immense
> emptiness.[5]

This personal drama is not simply played out through confronta-
tions with external dangers but as a psychological opposition between
Gavin and another officer named Collingwood, each personifying
rival value systems: 'the conscientious and professional but guilt-
ridden ... Gavin against the psychopathic, fascistic Collingwood,
who sees the devastated environment as an opportunity for men
like himself to rise to power' (Rabkin 1983: 7). Coppel originally
planned to give an important role to a captured Soviet pilot who
'would seek to convert them by use of the familiar dialectic',
producing an effect of 'almost lunatic irony'.[6] In the event Coppel
dropped this idea, keeping the narrative focus on the two officers
who emerge as the yin and yang of a single military personality.
Collingwood haunts the landscape as Gavin's repressed shadow,
reminding him of a professional commitment to kill which he can
only fulfil in the abstract by launching his missiles. Coppel only
resolves this conflict through a convenient last-minute death when
Collingwood falls from a bridge, thereby facilitating a largely
unjustified happy ending where Gavin's family can be recon-
stituted in a valley community and will make a fresh start.

Dark December dramatises a wished-for demise of a militaristic impulse validated by a religious symbolism of the seasons. A dark time is followed by hopes of pastoral renewal. Both Martha Bartter and Spencer Weart have argued cogently that many post-holocaust narratives covertly view war as a purifying agent destroying the corrupt cities and ushering in a new era where 'we canonise the frontiersman' (Bartter 1986: 149). We can see this concept taking shape as early as 1951 where the film *Five* (subtitled *A Story about the Day after Tomorrow*) describes the experiences of a tiny surviving remnant in a hilltop refuge. The film begins and ends with biblical quotations giving an apocalyptic frame to the images of specifically urban destruction. A montage of news headlines initially warns of total destruction ('World Organisation Collapse Imminent', 'World Annihilation Feared by Scientists') by H. Bombs; but the concluding titles promise a 'new world' over images of agricultural simplicity.

(III)

So far the narratives considered have timed their action too close to nuclear war to show new social institutions taking shape other than embryonically. Further into the post-nuclear future the problem of cultural recall becomes crucial. In Edgar Pangborn's *Davy* (1964) an autocratic theocracy has established civic order at the cost of forbidding 'Old Time' (prewar) books and monopolising the 'true study of history in the light of God's word and modern science' (Pangborn 1969: 175). The young Davy produces his narrative against such prohibitions, trying to gain access to the few maps and books preserved in the 'secret library of the Heretics' (Pangborn 1969: 9). Like Leigh Brackett, Pangborn describes a repressive society which is challenged by the very construction of the novel's text taking place between Davy and his companions on a new ship of state called *The Morning Star* figured as sailing towards the projected reader.

Pangborn returns to the preservation of the past through 'ancient fairy tales' in *The Judgement of Eve* (1964) and through an itinerant story-teller in *The Company of Glory* (1975), both postwar narratives. In the latter an old man named Demetrios functions as a living link with the past, telling his fascinated and appalled audiences tales of the 'Twenty-Minute War' which symptomised the corruption of the past. Once again storytelling is the subject of attempted state control since 'looking back is unutopian' (Pangborn

1976: 66) which forces Demetrios to set out westward for free territory with his companion, the boy Garth. A composite indictment of the national disease emerges from the old man's stories of the past which was cured by the 'surgery' of 'famine, pestilence, and a war of idiots' (Pangborn 1976: 15). Past corruption thus justifies the effect of the war which performs a much-needed operation to restore health to the body politic, Pangborn's central metaphor.

There is a clear continuity of method and sentiment between Pangborn's fiction and Kim Stanley Robinson's *The Wild Shore* (1984). Robinson sets his narrative in the year 2047, some sixty years after a nuclear war has left the USA not only destroyed but also in quarantine and under observation from Japanese satellites which will destroy any attempts to rebuild California. From a position of supremacy America has sunk to the 'bottom of the world' and while the Japanese navy patrols the Californian coast rumours circulate of resistance groups forming 'to make America great again'. Robinson's debt to Twain (shared by Pangborn) can be seen in his use of a boy narrator named Hank Fletcher who shares the initials of his model Huck Finn. The novel opens with a gang of boys trying to use the past as commodity by stealing silver handles from coffins, an echo of the grave-robbing in *Ape and Essence* . The enterprise fails because the handles turn out to be plastic and is replaced for Hank by access to the past through the stories of Tom, the 'old man' of the novel. When Hank lights out for the south he takes Tom as a substitute father, guide and teacher who helps him understand the things he sees: the Japanese patrols, the devastation of the cities, and the rebirth of American nationalism.

Unlike Pangborn's fiction *The Wild Shore* shows no institutionalised context for storytelling. Tom therefore participates in an ongoing debate over the nature and importance of history. He rejects an analogy with the American Revolution, proposing a different comparison where Americans have finally fallen victim to their own technology: 'we're like the Japanese themselves were after Hiroshima'. To which one listener asks, 'What's Hiroshima?' and then declares: 'Enough history ... What's important is the here and now' (Robinson 1986: 102). Against such indifference Tom manages to interest Hank in the past and in books (the two go hand in hand), at one point introducing him to a 'bookmaker' who, like Faber in *Fahrenheit 451*, is reinventing printing. Towards the end of the novel Tom confesses that he was too young to have the 'memories' he claims and so most of his stories of the past were merely invented. Hank therefore concludes, like his prototype, that Tom's

stories were lies. Failing any narrative closure, all he can think of is scrutinising the stories afresh for any truth-value.

Recovery of the past stays a desire in *The Wild Shore* while remembering is explicitly foregrounded as a complex cultural issue in Denis Johnson's *Fiskadoro* (1985), set in the area of Key West (renamed Twicetown after two nuclear missiles failed to detonate there). Fiskadoro is the son of a Hispanic fisherman who has lost all connections with the past. After nuclear war has devastated the northern areas of the USA the surviving communities are caught in a collective limbo of quarantine, positioned between the contaminated north which can still be looted for goods, and the Communist regime of Cuba which, many fear, will invade and 'put an end to everything'. The tenuous civic organisation includes communal readings from Frank W. Chinnock's *Nagasaki: the Forgotten Bomb* (1969), among other works. These activities centre on one of the main focalisers, a Vietnamese American named Cheung who 'believed in the importance of remembering' (Johnson 1985: 10). Because the significance of the remembered texts is receding, memory takes on a ritualistic dimension of recitation. Cheung knows a mnemonic story for recalling the names of the American states, a wife asks her husband to soothe her by reciting the Declaration of Independence, and so on. In addition to books, music becomes a performatory means of retaining contact with the 'lost age'. Cheung himself is a clarinetist and attempts to pass on his skills to Fiskadoro, the son of a fisherman.

Once again we have an old character, Cheung's grandmother, who provides a link with the past, specifically with the Vietnam War. But her 'memory' images forth an apocalyptic 'triumph of death over the world':

> the hordes of skeletons dragging the sacks of their skins behind them through the flaming streets, the buildings made out of skulls, the empty uniforms coming inexorably through the fields, the bodies of children stuck full of blast-blown knives and forks. (Johnson 1985: 71–2)

The ultimate horror of this image lies in the death of memory, the failure of its preservation. Fiskadoro himself experiences the 'transmission' of such scenes when he is taken to see Miami, a devastated wasteland where the roads are packed with immobilised cars, each 'being driven by a person made of brown bones' (Johnson 1985: 87). Fiskadoro is told what happened but has no frame of reference for the information: he 'felt the deep echo of

these words, as if he heard them spoken from another place, from tomorrow' (Johnson 1985: 87). The words remain another's. Johnson rather evades the implications of such images by falling back on the trope of awakening as if Fiskadoro and other characters will come out of a sleep to a new age.[7]

(IV)

The attempt to bridge over the rupture caused by nuclear war involves trying to reconstitute narratives which have become lost, especially – as we saw in chapters 2 and 3 – the larger narrative of history itself. The 1980s was a decade which marked a resurgence of nuclear fiction, now informed by a greater selfconsciousness of how to engage with earlier treatments of the subject. Whitley Strieber and James Kunetka's *Warday and the Journey Onward* (1984) assembles a future documentary drawing on the reportage techniques of Agee and Evans, and the oral history of Studs Terkel. The SDI (Strategic Defence Initiative)-triggered 'warday' takes place in 1988 but the narrative is composed in 1993, aiming to 'establish that even a limited nuclear war from which the United States suffered little physical damage would destroy it as a nation' (Brians 1987a: 44–5). 'Strieber' and 'Kunetka' in their guises as reporters travel from Dallas south-west into the newly declared hispanic republic of Aztlan, to Los Alamos (being crated up for the new 'Atomic City' in Osaka), then across country to California, turning east to New York. This journey-as-survey recounts the virtual demise of the mythic open road (Whitman is quoted in an epigraph) opening up limitless possibilities in the landscape. The stringent border controls for California where migrants might be shot on sight are no isolated case. There is thus a major tension in this novel between the divisive after-effects of nuclear war and the attempt by the book to draw diverse groups back together, nothing less than reconstituting the nation. Nuclear war is presented as a process of erasure or transformation so radical that some place-names persist only in memory. San Antonio has become a red zone, New York ruins abandoned to wild animals. The reportage therefore runs counter to the conditions of the aftermath where 'words like *history* have lost their weight. They seem as indefinite as memories, and as unimportant' (Strieber and Kunetka 1984: 378). 'History' becomes a catch-all term signifying connectedness – people with places, heirlooms with people, and of course people with people. In California the narrators meet the science fiction novelist Walter Tevis (who coincidentally

died the year *Warday* was published) now appearing as an economist diagnosing a subconscious panic in the country. *Warday* actualises a grim prediction made by the extraterrestrial visitor in Tevis's novel *The Man Who Fell to Earth* (1963) that 'we are certain beyond all reasonable doubt that your world will be an atomic rubble heap in no more than thirty years, if you are left to yourselves' (Tevis 1986: 134).

Warday contains a number of gestures towards criticising Cold War survivalism, involving itself in the double bind that, if demonstration of survival makes war more likely, then *Warday* itself paradoxically might be bringing the dreaded event nearer. More importantly, the book refutes presumptions of the feasibility of limited war, of fallout as a general doom although the end result stays much the same since the contamination of foodstuffs brings starvation and illness; and the expection of widespread genetic mutations is contradicted by a relief worker. On every page *Warday* displays evidence of scrupulously thorough research, assembled by the authors dividing two functions between them: storytelling to Strieber, journalistic investigation to Kunetka. The result is a multi-generic work combining future travelogue, interview and memoir. The narrative is constantly being suspended so that official documents (reports, statistics, opinion polls, etc.) form a collage on nuclear war. An astonishing number of personal and professional viewpoints emerges which carry the effect of authenticity but which further fragment the subject. When in New York Strieber describes one of the most familiar nuclear icons in the sky: 'There was an impression of a mushroom cloud, but I knew that was what it was, a mushroom cloud seen so close that it didn't look like a mushroom' (Strieber and Kunetka 1984: 18). The image which is no image. The cloud, seen differently by a range of observers, becomes a metaphor of the war itself, shifting, elusive, unambiguously present in material effects, but eluding definite representation. It is the strength of *Warday* that documentation actually fragments its subject. Strieber's attempt at a 'moralising, classical act of closure' (Schwenger 1986: 36) in the final lines ('if only we can accept how alike we all are' [Strieber and Kunetka 1984: 380]) therefore runs counter to the book's methods as a whole.

Where *Warday* questions assumptions about physical and social aspects of the nuclear aftermath, David Brin's *The Postman* (1985) critiques a new kind of survivalist fiction which became popular in the 1980s. Assuming war is inevitable, 'the authors do not warn against its coming; instead they celebrate the opportunities for hand-to-hand combat made possible by the collapse of civilisation

as a result of such a war' (Brians 1987b: 325-6). William W. John-
stone's Ashes series started in 1983; Ryder Stacy's first Doomsday
Warrior novel was published in 1984; and Jerry Ahern began his
long-running Survivalist series in 1987. Ahern's protagonist is John
Rourke, an ex-CIA Special Operations agent who has trained as a
doctor. He puts his creed succinctly: 'Surviving ... means keeping
your head, remembering what you're supposed to do, learning to
react the way you should – then just doing it'.[8] The whole point of
the narratives examined in this chapter is that survival is a complex
psychological and cultural problem, while Rourke's simple values
enable Ahern to describe an open-ended sequence of physical
confrontations where Rourke can show his skills at combat,
simplifying survival to a crude Darwinism. Nuclear war and then a
Soviet invasion of the USA are therefore not seen as disasters so
much as tests of Rourke's skills and confirmation of his prepared-
ness (he has been fitting out a mountain refuge for years). Although
he has a family, Rourke essentially represents an updated Western
hero dressed as a cowboy, roaming a dangerous landscape on a
Harley Davidson like the biker in Zelazny's *Damnation Alley*, and
surviving by his quick wits. These novels depend for their effect on
a rapid tempo of events and a conventional simplicity of narration
which nuclear cataclysm has not affected in the slightest.

No doubt with such fiction in mind, David Brin has declared that
'most post-holocaust novels are little-boy wish fantasies about
running amok in a world without rules'.[9] Against such bogus
heroism he situates his own novel. Set in Oregon sixteen years after
a nuclear war, *The Postman* describes a fractured world of isolated
mutually suspicious communities. Its protagonist Gordon Krantz
could not be farther removed from Rourke's macho posturing. The
former 'had chosen to become a minstrel, a travelling actor and
laborer, partly because he wanted to keep moving, to search for a
haven where someone was trying to put things back together again,
his personal dream' (Brin 1982: 128). Gordon is explicitly described
as unheroic and unskilled in combat. He can't loot, hesitates to kill
robbers, and throughout much of the novel engages in an inner
debate over the pros and cons of particular courses of action. His
hesitations are partly due to a projected view of the post-nuclear
situation where the majority of deaths occurs from lawlessness.
There is no invasion where outsiders can be categorised as enemy;
instead a breaking of the means of communication between differ-
ent towns. This is where the meaning of Brin's title becomes clear.
Early in the novel Krantz stumbles across an old mail truck and
steps into the role of postman, donning the uniform, and even

attempting to deliver the letters. For Peter Schwenger this enacts the purpose of the novel as a whole since 'a post-nuclear war narrative is addressed to, posted to, those who live in a prewar condition' (Schwenger 1992: 7). Brin replaces military triumphalism with a recognition that society can only be reconstituted through collective fictions. Thus when Krantz plays the role of postman he invites the communities he visits to join in a performative act whereby they become senders and recipients within a growing network. Krantz is the carrier of literacy, of letters in both senses, but also a sceptical performer. He is aware of the absences and longings that his fictions can satisfy and devises the most elaborate fiction of all, that there is a 'Restored United States' complete with a new constitution given verbatim in the text so that the reader is at first unsure of its status.

If storytelling and reception are so problematic, this has implications for the novel itself. At one point in the novel Krantz enters the Theodore Sturgeon Memorial Center of the University of Oregon, accessing not only the fictional past but also an intertext for Brin's novel. In Sturgeon's 'Memorial' (1946) a scientist and artist debate the future fate of humanity. While the artist expresses anxiety for the delicate balance of power between East and West, the scientist ridicules those science fiction writers who view nuclear energy as a terrifying spectacle. The story turns into an ironic study of miscalculation when the scientist's single nuclear device, intended as a 'never-ending sermon' against war, actually triggers a nuclear exchange.

Where Sturgeon supplies a positive intertex on the problem of reaching an audience, series like Jerry Ahern's offer a negative one. The term 'survivalist' is strongly foregrounded throughout *The Postman*:

> Once upon a time, before the war, the word had several meanings, ranging from common sense, community-conscious preparedness all the way to antisocial paranoid gun nuts ... it was the latter connotations that had stuck, after the ruin the worst sort had caused. (Brin 1986: 114)

The Survivalists then represent a militaristic mentality similar to Collingwood in *Dark December*. They are referred to as a cancerous 'plague', then glimpsed, and finally encountered face to face when Krantz is taken captive. Mostly 'augments' (i.e. muscle-bound humanoids designed by the US government for Special Forces duty) they wear army surplus uniforms, use earrings as badges of rank,

and treat their women either as sexual conveniences or slaves. If Gordon represents a constitutional communalism in his charter for the new United States and enacts a civic bonding through his postman role, the Survivalists' leader Holn stands at the opposite extreme of the political spectrum in mythologising an authoritarian ethic whereby *some have commanded, while others have obeyed* (Brin 1986: 252, his emphasis). The 'some', needless to say, are always men. After linking the paranoid Right to macho militarism, Brin describes a civil war in the last chapters of *The Postman*, fought out between the reconstructors and the Survivalists' desire for conquest.

The Survivalist ethic is heavily gendered and Carolyn See's *Golden Days* (1987) intervenes in the nuclear subject by attacking a perceived male hegemony over history and narration (his-story). When nuclear war does happen – in the 1980s since this is no remotely futuristic novel – the women immediately accuse the ruling male elite: 'You did this'. And 'by *you*, the women meant men, males: Caspar Weinberger, Alexander Haig, Ronald Reagan ...' But then those names fade and with them causality itself. The 'terrible roar, the walls of flame' (See 1996: 158) induce an apocalyptic sense of catastrophe which the narrator steadfastly refuses. The novel's title even comes to signify the nuclear aftermath. Rejecting doom in favour of the 'miracle of survival' (Dewey 1990: 189), the narrator bounces most of her statements off the pessimistic discourse of others. Losing any hold on clear chronology, she nevertheless savours words ('one thing I didn't lose was language') as proof of a continuity with prewar times. Narration thereby becomes an extended act of determination, not to flee Los Angeles, not to yield to despair and not to recognise the local beach as the site of extinction. The beach actually comes alive with more survivors than expected who then listen to her story. Even the conclusion to See's novel continues the dialogue between the accounts of others 'who say that the end came' (See 1996: 195) and her narrator's insistence on continuity into a future. Her capitalised 'Beginning' is timed from her discovery of so many fellow survivors on the beach.

The narratives discussed here imagine survival despite militarism, not because of triumph over an external enemy. Indeed the very condition of survival is a re-examination of national values, specifically a re-establishment of historical or narrative continuity with prewar America. In no case does military technology guarantee survival. Rather it is one of the lingering divisive or repressive forces that has to be resisted by the protagonists.

Notes

1. See 'The Other Foot' (1951) and 'To the Chicago Abyss' (1963) among other examples.
2. The Cabinet meeting on 11 December 1959 discussed *On the Beach*, specifically rejecting the assumptions that nuclear war could wipe out all life and that people would await death passively (Cabinet Minutes, Dwight D. Eisenhower Library, Abilene).
3. Tucker's editors forced a sentimental ending on him. His original version ('The Way It Really Ended') was published in *Nickelodeon*, 1 (1975): 11–13.
4. 'Dark December', MS: 42, Coppel Archive, Mugar Library, Boston University.
5. Coppel 1971: 182. In the short story on which Coppel based his novel the protagonist explicitly sees himself as a death-figure: 'I saw the hell-bombs falling. I saw myself striding among naked people – acres of them – and mowing them down with a bloody scythe' (Coppel 1953: 57).
6. 'Revisions on Dark December', undated MS, Boston University.
7. Millicent Lenz gives a Jungian reading of this aspect of the novel arguing that Fiskadoro 'must draw upon the collective unconscious to create a new myth of origin for his world' (Anisfield 1991: 121).
8. Ahern, 1985: 12. These series are discussed in Brians 1987a: 89–92.
9. Quoted in Stentz 1997.

XIV The Star Wars Debate

Space war! It's no longer just science fiction (Jerry Pournelle 1983)

In his classic study *War Stars* (1988) H. Bruce Franklin has traced out the abiding American fascination with the superweapon, that ultimate weapon which could make a final decisive difference to the balance of power. With the Soviet development of intercontinental missiles in the late fifties 'the quest for new weapons to make America invulnerable was frantic and obsessive' (Franklin 1988: 191). From then onwards more and more exotic weaponry was imagined, from the 'neutrino bomb' (described by Los Alamos physicist Ralph S. Cooper: see Conklin 1962) to the Orion Project for a nuclear-propelled battleship, which probably stood behind Poul Anderson's *Orion Shall Arise*. It was Ronald Reagan's launch in March 1983 of the Strategic Defence Initiative (SDI) which revived the dream of achieving national security by rendering 'nuclear weapons impotent and obsolete'.[1] In the view of H. Bruce Franklin, US planners had sucumbed to the fantasy that the arms race could be won with a new weapons system (Frankin 1984: 28). The subsequent debate over Star Wars technology split the science fiction community into opposing camps where its supporters took active participation in the formulation of government policy.[2] Now 'militaristic science fiction and military policy coexist in the same discourse system to a surprising degree' (Gray 1994: 316). This merging of discourse showed itself in the use of the same operative metaphors, particularly that of the frontier, which were revived to address yet again the issue of survival.

(I)

Reagan's policy change arose from perceptions of an increased Soviet threat from arms escalation and expansion into Central America. The

greater likelihood of superpower confrontation explains the revival
of survivalist fiction and supplies a context out of which Dean Ing
writes. Ing (the 'acceptable face of survivalism': Clute and Nicholls
1993: 618) has a professional background as a research engineer in
the missile industry which explains the technical accuracy of his
writings whether on future war vehicles or the Stealth bomber.[3]
Pulling Through (1983) combines practical know-how on surviving a
nuclear attack with the narrative of a bounty-hunter who has fitted
out a basement in anticipation of just such an attack. The novel
describes how Ransome's family and his captive (a streetwise girl
who was 'no survivalist, but a born survivor') cope with the nuclear
crisis, broken down into a series of specific practical problems: how
to improvise an air filter, how to dispose of human waste, and so on.
Pulling Through was bound in with a series of articles on nuclear
survival which take as their premise that the USSR possesses a vastly
more effective civil defence system than the USA. Reflecting on the
Soviet construction of collective shelters, Ing indicts US government
inertia:

> It's possible for us to build better urban shelters than these, but
> we do not appear to be doing it. Our civil defense posture has
> regeared itself more towards evacuation than to digging in. More
> accurately, at the moment we're between gears, idling in neutral.
> (Ing 1987: 148)

Faced with an apparent lack of government action, Ing comes up
with a series of recommendations whereby the American citizen can
to a certain extent take his or her fate in hand.

The pieces by Ing just described were written in 1980–1 in the
period immediately preceding the Star Wars controversy and at a
time when, as Jerry Pournelle put it, 'we truly feared Armageddon,
not as something abstract, but as an event that might very well
happen next year – or even next month' (Pournelle and Carr 1989:
19). Pournelle wrote a survivalist group (the 'Enclave') into his 1985
novel *Footfall* and himself offered practical advice on surviving
such holocausts. At the same time he took exception to 'novels
about people who not only survive nuclear wars, but thrive in those
conditions' (Pournelle and Carr 1989: 21). By the end of the eighties
he had to admit that the cause of survivalism had run its course.

Pulling Through confines survival to local and therefore manage-
able levels. Ing addresses the wider national issues of nuclear war in
a sequence of novels centring on Ted Quantrill, a survivalist *par
excellence*. The first of these, *Systemic Shock* (1981), explicitly sets

up a continuity from Sir John Hackett's future history *The Third World War* (1982) where Soviet forces invade West Germany. When these forces suffer defeat the Kremlin hawks bomb Birmingham, whereupon the USA and Britain retaliate by destroying Minsk. At this point the Soviet Union collapses.[4] Ing's continuation takes us a step forward to World War IV in the 1990s where a realigned and reduced Russian Union sides with the USA against a coalition between China and India in a dispute over oil. The latter attack Western satellites; invasions of Siberia and the southern USA take place; and biological weapons trigger a plague epidemic in the Far East. The novel is written partly as a grim warning against complacency:

> The American public had by turns ignored and ridiculed its cassandras ... who had all warned against our increasing tendency to crowd into our cities ... Firmly anchored in most Americans was the tacit certainty that, even to the problem of nuclear war against population centers, there must be a uniquely American solution; we would find it. (Ing 1981: 48).

But one isn't found and a hundred million Americans die as a result. Ing's gloomy prediction of the fate of American city-dwellers (significantly not protected by the US laser weapons) differs markedly from the practical advice he offers in *Pulling Through*, the very title of *Systemic Shock* indicating the trauma experienced at once by the individual citizen and the collective body politic of the nation. Not surprisingly given his advocacy of SDI, Ing describes a chaotic and piece-meal response to nuclear attack. In its wake the USA fragments into different areas: the north occupied by Canada, the east quarantined, the south-west reverted to wilderness, and the south invaded by a Cuban-led force (as happens in the 1984 film *Red Dawn*). Like Heinlein, Ing describes a surge of religious fundamentalism, here led by the Mormons, which results in a reconstituted USA being run as a repressive theocracy. While this is taking place, our hero the young Ted Quantrill, is receiving military training, learning that he has the 'right stuff to take direct action; personal action' (Ing 1981: 180). And this explains his role. He personifies the informed action – what Ransome in *Pulling Through* calls the 'drill' – lacking in the population as a whole, and is inducted into a kind of elite civil defence force. Without ever sinking to the weapons fetishism of Ahern's Survivalist series or evoking a reborn West as Neal Barrett does in his post-holocaust novels *Through Darkest America* (1986) and *Dawn's Uncertain Light*

(1989), Ing does show Quantrill's lightning reflexes and capacity to function under stress to be virtually unique in his generation and therefore totally differentiated from the ideal Mr Fixit of *Pulling Through*. Quantrill represents the ultimate skilled operative, ideal for an action-packed plot, but progressively alienated from the Mormon administration; by *Wild Country* (1985) he has turned against this incipient 'government by terror', attempting to withdraw into a purely private life.

(II)

The leading figure in science fiction's involvement with Star Wars was undoubtedly Jerry Pournelle who came to writing fiction after a career in industry and government agencies, and who co-authored one of the seminal documents in the SDI debate. *The Strategy of Technology* (1970), written by Pournelle, Stefan J. Possony and Frances X. Kane (the latter a serving Air Force officer who could not then be named), was based on the stark premise that 'the United States is at war' (Pournelle and Possony 1970: 1), and attacked the lack of defence planning and its attendant assumption that civil defence was futile. The war was being fought out as a 'conflict for technological dominance' (Pournelle and Possony 1970: 56). Prior to *The Strategy* Pournelle had produced a report for the United States Airforce (USAF) on strategic stability where arms control 'would work were [the] USSR England or France, but then it wouldn't really be needed'.[5] Accordingly he rejected War Games planning as inadequate to the opponent's intelligence, and in *The Strategy* first proposed a policy of 'Assured Survival' in opposition to McNamara's 'Mutual Assured Destruction'. A coordinated policy of technological research would help to realise a 'strategy through which war can be safely prevented' and, failing that aim, a 'fall-back strategy which will ensure our victory and survival' (Pournelle and Possony 1970: xxxi).

This policy then took shape in two further documents. The Heritage Foundation (a think-tank) was discussing the feasibility of anti-missile defences in the early 1980s and two of its key members were determined to bring their findings to the attention of Ronald Reagan. Edward Teller, whose *Legacy of Hiroshima* (1962) had argued that nuclear weapons did not necessarily mean all-out war, met Reagan for a number of briefings just before the latter's Star Wars speech. His colleague General Daniel Graham, formerly of the Defence Intelligence Agency, had less success. Denied access to the

President, he published the Heritage Foundation report as *High Frontier* (1983), rewritten by Dean Ing and prefaced with introductions by Heinlein and Pournelle. This work opens with a rousing call to the nation: 'The United States has an historic, but fleeting, opportunity to take its destiny into its own hands' (Graham 1983: 29). Citing the historical precedents of the Vikings and Spanish, Graham proposes space as the new 'sea' whose frontier can be opened up if the US follows its destiny, which *The Strategy of Technology* had argued lay in its technological expertise. The trope of the frontier had already been central to Pournelle's book on space exploration, *A Step Further Out*, where he declares: 'Mankind needs frontiers. We need new worlds to conquer, impossible odds to overcome, a place of escape from bureaucracy and government' (Pournelle 1980: 103). For 'mankind' read 'USA' since there is a specific national urgency in Pournelle's writing here. Rediscovery of a frontier offers a symbolic possibility of reversing a national malaise and realising a 'cornucopia' of economic benefits from space. True, 'without frontiers war is more than likely', but then space offers the unique possibility of an 'endless frontier' (Pournelle 1979: 24).

Already we can see a tension emerging between two metaphors: the defensive shield (Heinlein compared High Frontiers to a bulletproof vest) and the frontier. The first is static and reactive; the second proactive and entails expansion and conquest. In the summer following Reagan's Star Wars speech the Citizens Advisory Panel on National Space Policy met under the chairmanship of Pournelle (the group included among its members Heinlein, Larry Niven, Greg Bear and Gregory Benford) and published their report as *Mutual Assured Survival* (1984) which carried a ringing endorsement by Reagan on its cover. This report repeats the benefits of a layered defence system (as outlined by Graham), insists that space has become *de facto* militarised, but then asserts a 'synergism between science and the military, during frontier explorations' (Pournelle and Ing 1984: 118). The analogy between space and the American landscape is repeated, taking it as given that the military presence will increase; and with the opening of this new West the Moon will become a 'lunar fort'.

Nonfiction polemicising went in tandem with fiction directed to the same end. Starting in 1983 Pournelle with John F. Carr edited a series of volumes under the general title *There Will Be War*. This series assembles a composite narrative of the rise of tyranny and the need to confront it, building up to a final showdown in the eighth volume *Armageddon!* The volumes' covers promise lurid galactic wars but their contents vary from political essay through poetry

(Kipling and others) to future wars narratives. Somewhat resembling Hemingway's 1942 anthology *Men at War*, the collections revolve around specific themes: the tyrant, the warrior and so on. Although the historical spread of the series extends as far as Byzantium, the Cold War is at the forefront of every volume.[6] While war emerges as a universal factor in history, the urgency of the series is directed towards one overriding threat: Soviet or Soviet-led aggression. Deterrence is rejected as a 'very soft concept' formulated by 'civilian intellectuals' (Pournelle and Carr 1984: 12); in its place Pournelle and his associates would put the professionals, military and otherwise, to implement a more proactive defence policy against perceptions of the betrayal of McNamara's policy and the malaise of the Carter administration. Instead of passivity, Pournelle like Heinlein stresses the mythical importance of the warrior: 'the way is long and hard; for the warriors must ever stand on guard, be ever vigilant: not in war, but to preserve the peace' (Pournelle and Carr 1986: 13).

The crisis atmosphere of the fifties is revived through such stories as Ben Bova's 'Nuclear Autumn' which describes a threat by the Soviets to attack the US unless it dismantles NATO and withdraws its troops from abroad. The US President – a woman who by implication devotes more time to facials than foreign policy – and her young science adviser dismiss the threat as bluff. Only the Chairman of the Joint Chiefs of Staff, a 'grizzled old infantry general', takes the threat seriously; and sure enough this personification of realism and professionalism is proved right. The Soviets' plan is to launch the number of missiles just below the threshold to trigger a Nuclear Winter, thereby forestalling any US response. Bova here attacks US miscalculation of Soviet intentions just as, in the same volume, 'To the Storming Gulf', by Gregory Benford who also contributed to *Mutual Assured Survival*, describes the experiences of a group of holocaust survivors. It is only with the help of an intact computer that the physical traces in the landscape yield up an approximate narrative of what happened. Otherwise the event would be irrecoverable ('the history books will have to write themselves on this one' [Pournelle and Carr 1989: 67]). Specifically the survivors realise that, although nuclear and biological attack had spread a belt of death and destruction across the southern USA, the planners got it wrong: 'nuclear winter didn't mean the end of anything' (Pournelle and Carr 1989: 67).

The concept of Nuclear Winter was first publicised by a team of US scientists centring on Carl Sagan in 1983 who argued that even a limited nuclear war would bring about a worldwide climatic catastrophe. Low-level toxic clouds, fallout, and damage to the

ozone protection from ultraviolet radiation would bring about far more deaths than had been calculated up to now. Sagan's 1990 retrospective volume *A Path where No Man Thought*, cites examples from science fiction to demonstrate that Nuclear Winter had already been imagined, for instance, in Christopher Anvil's 1957 story 'Torch' where a Russian warhead ignites subterranean oil seams, showering areas with radioactive soot, and by the sheer scale of the disaster bringing an end to the Cold War (Sagan and Turco 1991: 43–4). Although Sagan rejects the ultimate death of the species as described in *On the Beach* and the spectacle of massive destruction in Jonathan Schell's *The Fate of the Earth* (1982), it is difficult on such a scale to make meaningful distinctions between 'total' and 'widespread'. Sagan himself blurs such distinctions by using emotive epigraphs from Dante, Bunyan and Milton; and illustrations showing the globe after nuclear war with a black cloud gradually covering its surface, all of which covertly reinforce the grand narrative of apocalypse.

Whereas Sagan advocated a nuclear policy of Minimum Sufficiency, Pournelle's promotion of SDI throughout *There Will Be War* was based on a persistent hope that the nuclear stalemate might be resolved by military technology. Ironically Sagan's identification of a central nuclear paradox, 'nations must be ready to fight a nuclear war in order to prevent one' (Sagan and Turco 1991: 82), was entirely consistent with the position of Pournelle and his contributors who repeatedly attacked a perceived lack of readiness in the USA. Eric Vinicoff and Marcia Martia's 'Winter Snows' describes an SDI system, but in the hands of the Soviets whose Premier confronts the US President with an ultimatum: surrender or face destruction. The President responds by revealing that a decorative ball with false snowflakes in the Soviet Premier's office is a secret weapon which can be detonated at will. Superficially a triumph, since the Soviet leader backs down, the story demonstrates the ease with which SDI technology could be used offensively and closes before the reader can be sure whether the American response was only bluff. The narrative assumes an ignorance on both sides of their opponent's latest weaponry which is both dangerous and necessary: dangerous in that it might lead to miscalculations, and necessary since one goal of SDI, Pournelle insists, is to 'create uncertainty in the minds of the Soviet planners about the final outcome of the war which would result from their attack' (Pournelle and Carr 1987: 404).

(III)

The other most vociferous advocate for SDI was Ben Bova who published his own contribution to the debate, *Assured Survival*, in 1984 (retitled *Star Peace* in 1986).[7] A physicist who had worked on lasers and missile trajectories, Bova recounts the history of the former technology and then sketches out a number of nuclear attack scenarios. In one, unrest in Poland and Germany triggers a Soviet invasion. Satellites are knocked out and a nuclear war follows. In another, SDI has resulted in a 'good strong roof' over America so that the massive launch of ICBMs by the Soviets is blocked. At this point Bova waxes lyrical:

> As the dawn rose on a new year, a new century, and a new millennium, we slowly realised that the worst thing any of us had ever expected to see had happened – and we had all survived it. Even the enemy had survived it. (Bova 1986b: 297).

The result is jubilation in Soviet cities, presumably because their masters have been outwitted, and, although Bova celebrates the end of the Cold War, the fact that the US has retained all its missiles while a delegation heads to Moscow to 'dictate' peace terms suggests triumphalism tempered by a suspicion that Soviets might have one last trick up their sleeve. Such nationalist sentiment – the pleasure in realising 'fortress America', for instance – belies Bova's call for mutuality in promoting SDI.[8] His revival of the cause of world government and speculations around an International Peacekeeping Force are based ultimately on Soviet defeat.

The hopefulness of *Star Peace* contrasts with Bova's 1985 novel *Privateers* which 'fervently boosts space-war preparedness led by rugged-individualist capitalists' (Franklin 1988: 200). The novel describes a post-SDI situation where the Soviet Union has used its military satellites to force the USA out of NATO. A missile detonated over France has laid Western Europe waste and American cities are run-down, full of derelicts, and hovering on the verge of collapse. Meanwhile the Soviet Union has set up factories in near space and transformed the Moon into a Gulag from which minerals are shipped back to earth, thus enabling the Kremlin to dictate the prices of raw materials. This is the situation which must be rectified by our hero Dan Randolph – astronaut, engineer, entrepreneur and sexual gymnast. As former lover of the US President, he steps into the role she has vacated, rejecting her wait-and-see attitude to the Soviets. Randolph sets up a space station from which he can

intercept Russian ore freighters, fighting as a latter-day buccaneer on behalf of private enterprise (hence the novel's title). In 1982 Bova had written of a Soviet space offensive, outlining an imminent scenario of the US space shuttle *Challenger* being damaged, possibly by Soviet missiles. He quotes an American lawyer as stating that Soviet policy has been 'either to forbid or to impede private enterprise in space' (Bova 1982: 64). The novel dramatises the fight back against such a prohibition by identifying as one the interests of the US, Third World and international capital.

Privateers opens with a failed hijack when a freighter (a 'big fat ovum') opens to disgorge Soviet troops. This first scene establishes a number of associations between the Soviets and treachery, brutality and the subhuman. Here Bova recycles the trope of Communists-as-parasites used by Heinlein and other writers in the fifties. In fact the episode could come from *Starship Troopers*, but in reverse since all the Western astronauts, even the focaliser, are killed. This episode depersonalises the Soviets, preconditioning the reader to accept them as fair game in any conflict and paving the way for the novel's diagnosis of US weakness. America's political and military inertia is shared by the rest of the world who need Randolph to point out that winning the Cold War wasn't enough for the Kremlin: 'maybe they want to *rule* the whole world, turn the entire goddammed world into one big homogenised tightly controlled Soviet state' (Bova 1986a: 237). The evil genius directing this empire is one Malik who, like Darth Vader in *Star Wars*, has a showdown with Randolph in a space station before spaceships from the free countries arrive to defeat the Soviets in a final battle. No narrative could demonstrate more conclusively that SDI was not a cooperative venture since Randolph personifies all the qualities waiting to be restored to a feminised and supine America.

(IV)

No sooner had Reagan delivered his 1983 speech than comparisons began to multiply with the 1977 movie *Star Wars*. The words of the aging warrior, 'the Force will be with you always', were quoted by Reagan himself and General James A. Abrahamson ('We're not on the Dark Side ... We really do have the Force with us': Boffey 1988: 209). One placard in a 1985 demonstration at Cape Kennedy shrilled 'STOP DARTH REAGAN!' And the Star Wars label quickly became so institutionalised that it was used as the title of a Soviet military publication in 1985 which warned grimly that the USA was

'preparing the stage for a nuclear war'.[9] The film lent itself to a simplistic model of political conflict between an evil empire (the Soviet Union) and a rebellious freedom-loving planet-nation. The empire is presided over by an autocratic ruler whose cruelty is embodied in the masked Darth Vader who stalks the Death Star (an ultimate military space station) dressed in black. The combat is polarised between Good and Evil, and conducted with laser weapons which seemed to be actualised in the technology required for SDI. William J. Broad has shown that a number of the young physicists working on SDI weaponry at Teller's Livermore Laboratory were influenced by their reading of science fiction, one admitting an influence from Larry Niven's *Ringworld* and Niven and Pournelle's *The Mote in God's Eye*, while another confirmed the impact of Heinlein (Broad 1985b: 119–20, 131).

On the science fiction community the impact of SDI was more controversial. Those supporters already named tended to have a common background in military-related technology. Poul Anderson introduced the 1988 anthology *Space Wars* approving Graham's *High Frontier* and declaring that he 'would support a war on any scale necessary if that should prove the only alternative to letting in the Gulag' (Waugh and Greenberg 1988: x). Isaac Asimov, however, rejected it as a device to break the Soviet economy which would also break the US economy ('It's very much a John Wayne standoff') and Arthur C. Clarke testified to the US Senate that SDI plans were 'technological obscenities' (Broad 1985a: C3) and argued that laser satellites could be destroyed by launching buckets of nails into orbit. One of the most sustained attacks came from Frederik Pohl who had been unimpressed when Heinlein sent him a copy of *High Frontier*. He pronounced SDI a 'fuzzy-headed notion' which would be counterproductive: 'the Star Wars scenario is not merely not a way of keeping us from nuclear attack and very likely the nuclear winter as consequence. Rather, it is the surest way I can think of to make both these things happen'.[10] Thomas M. Disch subsequently salvaged a moral from the whole controversy in that for him it demonstrated the importance of science fiction as a forum for debating the US space programme (Disch 1986: 652).

Reagan's tendency to mix references to Star Wars with Armageddon and the Evil Empire provoked Walter M. Miller to assemble his 1985 anthology *Beyond Armageddon: Twenty One Sermons to the Dead* which was designed to challenge the military orthodoxies of SDI.[11] Unlike its supporters, Miller revises the sides in any Megawar to be 'militaristic Government' against the rest of humanity. His opposition is direct and moral:

Once Megawar is launched, nationality ceases to exist. The ultimate atrocity has been committed, and every political and military man who participated is thenceforward at war with the whole people of Earth, and all her various lifeforms. He is a world-killer. (Miller and Greenberg 1987: 11).

Like Lewis Mumford and Thomas Pynchon (whose 1973 novel *Gravity's Rainbow* probes the cultural origins of the Cold War), Miller grounds his criticism in a spiritual holism which he sees as being damaged by a secular scientific Logos or reason which 'cuts apart, divides, separates', partly by erecting a 'screen of symbols' (Miller and Greenberg 1987: 13). For Miller the ideological debates of the 1980s (Communist vs. Christian) were merely symptomatic of this Logos and he accordingly turns to Taoism as a system totally removed from Western culture.

From a totally different direction the second volume of Kim Stanley Robinson's Orange County trilogy *The Gold Coast* (1986) confronts what some felt was the hidden agenda behind SDI: the boosting of funding for the California-based defence industry. Robinson wrote the novel out of a fear that SDI marked the 'next generation weapons system in the cold war'. 'I was disgusted at this potential militarisation of space', he has stated, 'and the obvious boondoggle nature of the project, which was clearly a physical impossibility'.[12] In the novel the Laguna Space Research Company (LSR) is competing in the design of a method for tracking destroying missiles using lasers and space mirrors. Denis McPherson, chief engineer for LSR, has been sold on the SDI dream of a nuclear-free 'completely secure defense'. 'Have we reached that point in history', he wonders, 'where technology finally will make war obsolete, and nuclear weapons unnecessary?' (Robinson 1990: 62). The novel demonstrates that this is a premature question. What McPherson suppresses is an awareness of how rigged the testing and procurement procedures are. When LSR's tender is rejected because a USAF general interferes with the process, their response is to lodge an appeal which fails because the judge decides the *status quo* should stand 'in the interests of national security' (Robinson 1990: 287). Robinson blocks off hopes of an imminent change to Cold War strategy by redirecting the reader's attention to the recent history of Orange County where, since the Second World War, a military-industrial infrastructure has grown up. This complex drives national policy: 'And so the machine served the Korean War, and the Cold War, and the Vietnam War, and the Cold War ... and the Space War ... a war machine, ever growing' (Robinson 1990: 264).

As McPherson's hopes are dashed his jaundiced sense of the self-perpetuating system converges on the narrator's identification of the profit motive fuelling defence policy.

McPherson unconsciously repeats Reagan's dream of a final release from nuclear fear. And this must have informed the fiction of Ing, Bova, Pournelle and others which exaggerates the effectiveness of action divorced from the constraints of politics. The reinvigoration of national purpose through the image of the frontier was confusingly conflated with a specific defence proposal which risked transfer of the space programme to the military (Disch 1986: 656). The incompatibility between the metaphors of shield and frontier, the expansionism within the very notion of SDI, and the proximity between offence and defence denied the policy clarity. Historically Star Wars marked an unprecedented period of symbiosis between science fiction and the US administration which passed with the easing of Cold War tensions as the Communist regimes of the Soviet Bloc collapsed. Ben Bova describes a British security adviser's reaction to SDI in words which could stand as a coda for this whole volume: 'It sounds like science fiction to me ... But so much of today's world seems like science fiction that I suppose we must consider the idea quite carefully' (Bova 1986b: 268).

Notes

1. 'President's Speech on Military Spending and a New Defense', *New York Times* (24 March 1983) A20.
2. One instance of contact was the 1985 Futurist II conference held at an Ohio air force base where military researchers responded to speculations by Gregory Benford, Joe Haldeman, Larry Niven and Jerry Pournelle, among other writers.
3. *The Ransome of Black Stealth One* (1989) describes a Soviet attempt to steal the American spy plane. Ing's other main Cold War novels are two spy thrillers, *Blood of Eagles* (1987) and *Spooker* (1995). Other survivalist articles were collected in *The Chernobyl Syndrome* (1988). Ing invited Frederik Pohl to write a cover line for *Pulling Through*.
4. Reagan read Hackett in 1983 with enthusiasm: see Dugger 1984.
5. Letter from Jerry Pournelle, 10 February 1998.
6. Pournelle describes Marxist opponents in his 1979 *Janissaries* (see Gray 1994: 324) and during a period of disillusionment with the US government projected a near-future 'CoDominium' in his fiction where the two superpowers collaborate in repressive world rule. *Footfall* (1985) uses the alien contact theme to vindicate the resurgence of the American space programme ('the cold war began again, with all

its implications': Pournelle and Niven 1986: 122). Pournelle himself joined the Communist Party for a short time after his return from the Korean war (Platt 1987: 19).

7. Published with an endorsement by Reagan's science advisor.
8. Cf. Boyer 1998: 178–9 on the relation between SDI and a national tradition of self-reliance.
9. *'Star Wars' Delusions and Dangers*. Moscow: Military Publishing House, 1985: 31.
10. Pohl 1984: 26. Pournelle responded in *Science Fiction Chronicle*, 6.III (December 1984) where he rejected Pohl's claims and declared that he was 'talking nonsense' (16).
11. UK edition subtitled *Survivors of the Megawar*.
12. Letter from Kim Stanley Robinson, 6 April 1998.

Bibliography

(Original publication dates for fiction given in text)

Abrash, Merritt (1986), 'Through Logic to Apocalypse: Science-Fiction Scenarios of Nuclear Deterrence Breakdown'. *Science–Fiction Studies* 13. II: 129–38.

Agee, James (1972) *The Collected Short Prose*, ed. Robert Fitzgerald, London: Calder and Boyars.

Ahern, Jerry (1985), *The Survivalist*, No. 1: *Total War* [1981], London, New English Library.

Allen, Thomas B. (1994) *War Games*, London: Mandarin.

Amen, Carol (1981), 'The Last Testament', MS (August): 72–4, 81–2.

American Library Association (1953), *The Freedom to Read*, Chicago: American Library Association.

Anderson, Poul (1953), 'Security', *Space Science Fiction*, 1.III: 101–127.

——(1957), 'Marius', *Astounding Science Fiction*, 59.I (March): 129–40.

——(1961) *Strangers from Earth*, New York: Ballantine.

——(1963a) *Thermonuclear War*, Derby, CT: Monarch.

——(1963b) *Twilight World*, London: Gollancz.

——(1964) *Time and Stars*, London: Gollancz.

——(1965) *After Doomsday*, London: Panther.

—— (1972) *Un–Man and Other Novellas*, London: Dobson.

——(1974a), 'The Profession of Science Fiction: VI: Entertainment, Instruction or Both?', *Foundation*, 5 (January): 44–50.

——(1974b) *The War of Two Worlds*, London: Dobson.

——(1979), 'Concerning Future Histories'. *Bulletin of the Science Fiction Writers of America*, 14.III (Fall): 7–14.

——(1980) *There Will Be Time*, London: Robert Hale.

—— (1981) *Conquests*, St. Albans: Granada.

——(1984) *Orion Shall Arise*, London: Sphere.

——(1985) *Dialogues with Darkness*, New York: Tor.

Anisfield, Nancy ed. (1991) *The Nightmare Considered: Critical Essays on Nuclear War Literature*. Bowling Green: Popular Press.

Anvil, Christopher (1957), 'Torch', *Astounding Science Fiction*, 59.II (April): 41–50.

Ardrey, Robert (1967) *The Territorial Imperative*, London: Fontana.

Asimov, Isaac (1964) *Pebble in the Sky*, New York: Bantam.

——(1970) *Nightfall*, London: Rapp and Whiting.

——(1980) *In Memory Yet Green: The Autobiography of Isaac Asimov, 1920–1954*, New York: Avon.

——(1984a) *Asimov on Science Fiction*, London: Granada.

Asimov, Isaac, et al. (eds) (1984b) *Machines That Think*, London: Allen Lane.

Axelsson, Arne (1990) *Restrained Response: American Novels of the Cold War and Korea, 1945–1962*, Westport, CT: Greenwood Press.

Barrett, David and Mary Gentle (1988), 'Frederik Pohl', *Vector*, 142 (February/March): 10–15

Barth, John (1967) *Giles Goat-Boy: or, The Revised New Syllabus*, London: Secker and Warburg.

Barthelme, Donald (1989) *Sixty Stories*, London: Secker and Warburg.

Bartter, Martha A (1986), 'Nuclear Holocaust as Urban Renewal', *Science-Fiction Studies*, 13.II: 148–58.

——(1988) *The Way to Ground Zero: The Atomic Bomb in American Science Fiction*, New York: Greenwood Press.

Benchley, Nathaniel (1966) *'The Russians Are Coming, the Russians Are Coming'* [*The Off Islanders*], Harmondsworth: Penguin.

Bercovitch, Sacvan (1978) *The American Jeremiad*, Madison: University of Wisconsin Press.

Berger, Albert I (1976), 'The Triumph of Prophecy: Science Fiction and Nuclear Power in the Post-Hiroshima Period', *Science-Fiction Studies* 3.II: 143–50.

——(1978), 'Science-Fiction Critiques of the American Space Program, 1945–1958', *Science-Fiction Studies*, 5.I: 99–109.

——(1979), 'Nuclear Energy: Science Fiction's Metaphor of Power', *Science-Fiction Studies*, 6.II: 121–7.

——(1981), 'Love, Death, and the Atom Bomb: Sexuality and Community in Science Fiction, 1935–55', *Science-Fiction Studies*, 8.III: 280–95.

——(1984), 'The *Astounding* Investigation: The Manhattan Project's Confrontation with Science Fiction', *Analog*, (September): 125–37.

——(1993) *The Magic That Works: John W. Campbell and the American Response to Technology*, San Bernadino: Borgo Press.

Berriault, Gina (1961) *The Descent*, London: Arthur Barker.

Bethe, Hans, et al. (1950), 'The Facts about the Hydrogen Bomb', *Bulletin of the Atomic Scientists*, 6.IV (April 1950): 106–9, 126–7.

Bischoff, David (1983) *War Games*, Harmondsworth: Penguin.

Biskind, Peter (1983) *Seeing Is Believing: How Hollywood Taught Us to Stop Worrying and Love the Fifties*, New York: Pantheon.

Blish, James (1961) *So Close to Home*, New York: Ballantine.

——(1963) *A Case of Conscience*, Harmondsworth: Penguin.

——(1965) *Best Science Fiction Stories*, London: Faber.

——(1968) *They Shall Have Stars*, London: Faber.

——(1970) [as William Atheling, Jr], *More Issues at Hand*, Chicago: Advent.

——(1981) *Black Easter, and The Day after Judgement*, London: Arrow.

——(1985) *Cities in Flight*, London: Arrow.

Boffey, Philip M., et al. (1988) *Claiming the Heavens: The 'New York Times' Complete Guide to the Star Wars Debate*, New York: Times Books.

Bova, Ben (1982), 'Soviet Space Offensive', *Omni*, 4.X: 63–5, 108.

——(1986a) *Privateers*, London: Methuen.

——(1986b) *Star Peace: Assured Survival*, New York: Tor.

Boyer, Paul (1994) *By the Bomb's Early Light: American Thought and Culture at the Dawn of the Atomic Age*, Chapel Hill: University of North Carolina Press.

——(1998) *Fallout*, Columbus: Ohio State University Press.

Brackett, Leigh (1955) *The Long Tomorrow*, Garden City, NY: Doubleday.

Bradbury, Ray (1963), 'Bright Phoenix', *Magazine of Fantasy and Science Fiction*, 24.V (May): 96–102.

——(1967), 'At What Temperature Do Books Burn?', *The Writer*, 80 (July): 18–20.

——(1972), 'On a Book Burning', *Algol* 19 (November) 13–14.

——(1975), 'How Not to Burn a Book; or, 1984 Will Not Arrive', *Soundings*, 7.I (September): 5–32.

——(1983) *The Martian Chronicles* [*The Silver Locusts*], St. Albans: Granada.

——(1993) *Fahrenheit 451*, London: Flamingo.

Bradley, David (1949) *No Place to Hide*, London: Hodder and Stoughton.

Brady, Charles J. (1976), 'The Computer as a Symbol of God: Ellison's Macabre Exodus', *Journal of General Education*, 28: 55–62.

Brands, H. W (1993) *The Devil We Knew: Americans and the Cold War*, New York and Oxford: Oxford University Press.

Brennan, John P (1984), 'The Mechanical Chicken: Psyche and Society in *The Space Merchants*', *Extrapolation*, 25.II: 101–114.

Bretnor, Reginald (ed.) (1953) *Modern Science Fiction: Its Meaning and Future*, New York: Coward-McCann.

Brians, Paul (1987a) *Nuclear Holocausts: Atomic War in Fiction, 1895–1984*, Kent: Kent State University Press.

——(1987b), 'Red Holocaust: The Atomic Conquest of the West', *Extrapolation*, 28.IV: 319–29.

Brin David (1982), 'The Postman', *Isaac Asimov's Science Fiction Magazine*, 6.XI (November): 120–168.

——(1986) *The Postman*, New York: Bantam.

Broad, William J. (1985a), 'Science Fiction Authors Choose Sides in "Star Wars"', *New York Times*, (26 February): C1, C3.

——(1985b) *Star Warriors*, New York: Simon and Schuster.

Broderick, Mick (1992), 'Witnessing the Unthinkable: A Meditation on Film and Nuclear Sublime', *Antithesis*, 6.I: 67–75.

Brustein, Robert (1964), 'Out of This World', *New York Review of Books*, 1.XII (6 February): 3–4.

Bryfonski, Dedria (ed.) (1984) *Contemporary Authors Autobiography Series*, vol. 1, Detroit; Gale Research.

Budrys, Algis (1964) *Who?*, Harmondsworth: Penguin.

——(1986), 'Books', *Magazine of Fantasy and Science Fiction*, 70.III (March): 45–9.

Bukatman, Scott (1993) *Terminal Identity: The Virtual Subject in Postmodern Science Fiction*, Durham, NC: Duke University Press.

Bunch, David (1971) *Moderan*, New York: Avon.

Burden, Brian J. (1982), 'Philip K. Dick and the Metaphysics of American Politics', *Foundation*, 26 (October): 41–6.

Burnham, James (1947) *The Struggle for the World*, London: Jonathan Cape.

Burton, John (1964), 'The Nature of Agression as Revealed in the Atomic Age', in J. D. Cartley and F. J. Ebling (eds) *The Natural History of Aggression*, London and New York: Academic Press: 145–53.

Caidin, Martin (1956) *The Long Night*, New York: Dodd Mead.

Campbell, John W., Jr (1947) *The Atomic Story*, New York: Henry Holt.

——(1950), 'The Real Pushbutton Warefare', *Astounding Science Fiction*, 44.V (January): 4–5.

——(ed.) (1952) *The 'Astounding Science Fiction' Anthology*, New York: Simon and Schuster.

Caputi, Jane (1991), 'The Metaphors of Radiation', *Women's Studies International Forum* 14.V: 423–42.

Card, Orson Scott (1990) *Maps in a Mirror*, London: Random Century.

Chapman, Robert S. (1975), 'Science Fiction in the 1950s: Bill Graham, McCarthy and the Bomb', *Foundation*, 7–8 (March): 38–53.

Charnas, Suzy McKee (1998), 'The Profession of Science Fiction', 52: 'A Literature of *Unusual* Ideas', *Foundation*, 72 (Spring): 5–19.

Chernus, Ira (1986) *Dr. Strangegod: On the Symbolic Meaning of Nuclear Weapons*, Columbia: University of South Carolina Press.

Chilton, Paul (ed.) (1985) *Language and the Nuclear Arms Debate: Nukespeak Today*, London and Dover, NH: Frances Pinter.

Clareson, Thomas D. (ed.) (1971) SF: *The Other Side of Realism*, Bowling Green: Popular Press.

——(1977) *Many Futures, Many Worlds: Theme and Form in Science Fiction*, Kent: Kent State University Press.

——(1987) *Frederik Pohl*, Mercer Island: Starmont House.

Clareson, Thomas D. and Thomas L. Wymer (eds) (1984) *Voices for the Future*, vol. 3, Bowling Green: Popular Press.

Clark, W. H. (1961), 'Chemical and Thermonuclear Explosives', *Bulletin of the Atomic Scientists*, 17.IX (November): 356–60.

Clarkson, Helen [i.e. Helen McCoy] (1959) *The Last Day*, New York: Dodd Mead.

Clute, John, and Peter Nicholls (eds) (1993) *The Encyclopedia of Science Fiction*, London: Orbit.

Cohn, Carol (1987), 'Sex and Death in the Rational World of the Defence Intellectuals', *Signs*, 12.IV: 687–718.

Collier's (1951), 'Preview of the War We Do Not Want' (27 October).

Conklin, Groff (ed) (1948) *A Treasury of Science Fiction*, New York: Crown Publishers.

——(ed) (1954) *6 Great Short Novels of Science Fiction*, New York: Dell, 1954.

——(1962) *Great Science Fiction by Scientists*, New York: Collier.

Coppel, Alfred (1949), 'Secret Weapon', *Astounding Science Fiction*, 43.V (July): 93–104.

——(1953), 'Homecoming', *Vortex*, 1.I: 37–59.

——(1971) *Dark December*, London: Hodder Fawcett.

Crossen, K. F. [as Richard Foster] (1954) *Year of Consent*, New York: Dell.

——(1960) *The Rest Must Die*, London: Frederick Muller.

——(ed.) (1968) *Adventures in Tomorrow*, New York: Belmont.

Cummins, Elizabeth (1992), 'Short Fiction by Judith Merril', *Extrapolation*, 33.III: 202–14.

Davenport, Basil (ed.) (1964) *The Science Fiction Novel: Imagination and Social Criticism*, Chicago: Advent.

Davis, David Brion (ed.) (1971) *The Fear of Conspiracy*, Ithaca; Cornell University Press.

Davis, Elmer (1955) *Two Minutes till Midnight*, Indianapolis: Bobbs-Merrill.

De Camp, L. Sprague (1988), 'Robert A. Heinlein: In Memoriam', *Locus*, 21.VIII (July): 38–40.

Deer, James W. (1957), 'The Unavoidable Shelter Race', *Bulletin of the Atomic Scientists*, 13.II (February): 66–7.

DeLillo, Don (1983), 'Human Moments in World War III', *Esquire*, (July): 118, 120–6.

Derleth, August (ed.) (1948) *Strange Ports of Call*, New York: Pellegrini and Cudahy.

Derrida, Jacques (1984), 'No Apocalypse, Not Now (Full Speed Ahead, Seven Missiles, Seven Missives)', *Diacritics*, 14.II: 20–31.

Dewey, Joseph (1990) *In a Dark Time: The Apocalyptic Temper in the American Novel of the Nuclear Age*, West Lafayette: Purdue University Press.

Dick, Philip K (1970) *The World Jones Made*, London: Panther.

——(1974) *Flow My Tears, the Policeman Said*, London: Gollancz.

——(1975) *Clans of the Alphane Moon*, St. Albans: Granada.

——(1978) *The Penultimate Truth*, St. Albans: Triad/Panther.

——(1979) *Eye in the Sky*, London: Arrow.

——(1981) *Vulcan's Hammer*, London: Arrow.

——(1984) *Lies, Inc*, London: Gollancz.

——(1987) *Dr. Bloodmoney Or, How We Got along after the Bomb*, London: Arrow.

——(1988a) *Radio Free Albemuth*, London: Grafton.

——(1988b) *Time out of Joint*, Harmondsworth: Penguin.

Disch, Thomas M. (1977) *Camp Concentration*, St. Albans: Granada.

——(1978) *Under Compulsion*, St. Albans: Granada.

——(1986), 'The Road to Heaven: Science Fiction and the Militarization of Space', *The Nation*, (10 May): 650, 652–6.

——(1998) *The Dreams Our Stuff Is Made Of*, New York: Free Press.

Dowling, David (1987) *Fictions of Nuclear Disaster*, London: Macmillan.

——(1988), 'Russell Hoban's *Riddley Walker*: Doing the Connections', *Critique*, 20: 179–87.

Dubois, Theodora (1952) *Solution T–25*, London: Kelmsley Newspapers.

Dugger, Ronnie (1984), 'The President's Favorite Book', *The Nation* (27 October): 412–16.

Engelhardt, Tom (1995) *The End of Victory Culture: Cold War America and the Disillusioning of a Generation*, New York: Basic Books.

Engh, M. J. (1989) *A Wind from Bukhara*, London: Grafton.

Etchison, Dennis (ed.) (1993) *The Selected Letters of Philip K. Dick, 1972– 1973*. Lancaster, PA: Underwood-Miller.

Feenberg, Andrew (1977), 'An End to History: Science Fiction of the Nuclear Age', *Johns Hopkins Magazine* (March): 13–22.

Fergusson, Frances (1984), 'The Nuclear Sublime', *Diacritics*, 14.II: 4–10.

Fitzgibbon, Constantine (1975) *The Golden Age*, London: Hart-Davis MacGibbon.

——(1976) *Secret Intelligence in the Twentieth Century*, London: Hart-Davis MacGibbon.

——(1989) *When the Kissing Had to Stop*, London: Bellow.

Ford, Daniel (1986) *The Button: The Nuclear Trigger – Does It Work?* London: Unwin.

Francavilla, Joseph (1985), 'Disching It Out: An Interview with Thomas M. Disch', *Science-Fiction Studies*, 12.III: 241–51.

Frank, Pat (1960), 'Hiroshima: Point of No Return', *Saturday Review*, 43 (24 December): 25, 40.

——(1976) *Alas, Babylon*, New York: Bantam.

Franklin, H. Bruce (1980) *Robert A. Heinlein: America as Science Fiction*, New York: Oxford University Press.

——(1984), 'Viewpoint: Don't Worry, It's Only Science Fiction', *Isaac Asimov's Science Fiction Magazine*, 8.III (December): 27–39.

——(1988) *War Stars: The Superweapon and the American Imagination*, New York: Oxford University Press.

——(1998), 'The Vietnam War as American Science Fiction and Fantasy', *Critical Studies*, 11: 165–86.

Frazier, Robert (1954), 'Universe in Books', *Fantastic Universe Science Fiction*, 2.II (September): 127–8.

Freud, Sigmund (1975) *Civilization and Its Discontents*, transl. Joan Riviere, ed. James Strachey, London: Hogarth Press.

Friborg, A. C. (1954), 'Careless Love', *Magazine of Fantasy and Science Fiction*, 7.I (July): 43–59.

Fromm, Eric (1956) *The Sane Society*, London: Routledge and Kegan Paul.

——(1962) *May Man Prevail?* London: George Allen and Unwin.

Galison, Peter (1994), 'The Ontology of the Enemy: Norbert Wiener and the Cybernetic Vision', *Critical Inquiry*, 21: 228–66.

Galouye, Daniel (1963) *Dark Universe*, London: Science Fiction Book Club.

Geduld, Carolyn (1972) *Bernard Wolfe*, New York: Twayne.

Gelmis, Joseph (1971) *The Film Director as Superstar*, London: Secker and Warburg.

George, Peter (1979) *Dr. Strangelove Or, How I Learned to Stop Worrying and Love the Bomb*, Boston: Gregg Press.

Gibbons, Reginald, and Terrence Des Pres (1987), 'An Interview with Thomas McGrath', *TriQuarterly*, 70 (Fall): 38–102.

Goebel, Ulrich, and Otto Nelson (eds) (1988) *War and Peace: Perspectives in the Nuclear Age*, Lubbock: Texas Tech University Press.

Gold, H. L. (1952), 'Gloom and Doom', *Galaxy Science Fiction*, 3.IV (January): 2–3.

Goldman, Eric F. (1965) *The Crucial Decade – and after: America, 1945–1960*, New York: Alfred A. Knopf.

Goldwater, Barry (1960) *The Conscience of a Conservative*, New York: Hillman.

Graham, General Daniel (1983) *High Frontier: A Strategy for National Survival*, New York: Tor.

Gray, Chris Hables (1994), '"There Will Be War!": Future War Fantasies and Militaristic Science Fiction in the 1980s', *Science-Fiction Studies*, 21.III: 315–36.

Griffin, Russell M. (1973), 'Medievalism in *A Canticle for Leibowitz*', *Extrapolation*, 14.II: 112–25.

Gunn, James (1975) *Alternate Worlds: The Illustrated History of Science Fiction*, Englewood Cliffs: Prentice-Hall.

Haldeman, Joe (1978) *The Forever War*, London: Futura.

——, ed (1987) *Study War No More*. London: Futura.

Harrison, Harry (1960) *Bill, the Galactic Hero*, Harmondsworth: Penguin.

Hastings, Max (1987) *The Korean War*, London: Michael Joseph.

Heinlein, Robert A. (1951a) *The Day after Tomorrow*, New York: Signet.

——(1951b), 'The Puppet Masters', *Galaxy*, 2.VI (September)–3.II (November).

——(1964) *Farnham's Freehold*, London: Dobson.

——(1967a) *Revolt in 2100*, London: New English Library.

——(1967b) *Starship Troopers*, London: New English Library.

——(1974) *Beyond This Horizon*, St. Albans: Panther.

——(1975) *The Worlds of Robert A. Heinlein*, London: New English Library.

——(1977) *Assignment in Eternity*, London: New English Library.

——(1979a) *Destination Moon*, ed. David G. Hartwell, Boston: Gregg Press.

——(1979b) *The Door into Summer*, ed. David G. Hartwell, Boston: Gregg Press.

——(1979c) *The Puppet Masters*, Boston: Gregg Press.

——(1982) *Expanded Universe*, New York: Ace.

——(1989) *Grumbles from the Grave*, ed. Virginia Heinlein, London: Orbit.

——(1992) *Requiem*, ed. Yoji Kondo, New York: Tor.

Heller, David, and Jeane Heller (1962) *The Cold War*, Derby, CT: Monarch Books.

Hemingway, Ernest (1980) *By-Line*, Harmondsworth: Penguin.

Hersey, John (1986) *Hiroshima*, Harmondsworth: Penguin.

Hinds, L. B., and T. O. Windt, Jr (1991) *The Cold War as Rhetoric: The Beginnings, 1945–1950*, New York: Praeger.

Hine, Al. (1954), 'Hiroshima, Connect', *Saturday Review*, 37 (16 January): 15–16.

Hoban, Russell (1980) *Riddley Walker*, London: Jonathan Cape.

——(1984), 'A Personal View of *Threads*', *The Listener* (27 September): 3–4.

Hoberman, J. (1993), 'When Dr. No Met Dr. Strangelove', *Sight and Sound*, 3.XII (December): 16–21.

——(1994), 'Paranoia and the Pods', *Sight and Sound*, 4.V (May): 28–31.

Hofstadter, Richard (1966) *The Paranoid Style in American Politics and Other Essays*, London: Jonathan Cape.

Holt, Terrence (1990–1), 'The Bomb and the Baby Boom', *TriQuarterly*, 80: 206–20.

Huxley, Aldous (1947) *Science, Liberty and Peace*, London: Chatto and Windus.

——(1949) *Ape and Essence*, London: Chatto and Windus.

——(1994) *Brave New World Revisited*, London: Harper Collins.

Ing, Dean (1979), 'Vehicles for Future Wars', *Destinies*, 1.IV (August–September): 237–77.

——(1981) *Systemic Shock*, New York: Ace.

——(1987) *Pulling Through*, New York: Ace.

Jameson, Fredric (1982), 'Progress Versus Utopia; or, Can We Imagine the Future?' *Science-Fiction Studies*, 9.II: 147–58.

Johnson, Denis (1985) *Fiskadoro*, London: Chatto and Windus.

Johnson, Glen M. (1979), '"We'd Fight ... We Had To": The Body Snatchers as Novel and Film', *Journal of Popular Culture*, 13.I: 5–14.

Jones, D. F. (1968) *Colossus*, London: Pan.

Kagan, Norman (1972) *The Cinema of Stanley Kubrick*, New York: Holt, Rinehart and Winston.

Kahn, Herman (1961) *On Thermonuclear War*, 2nd ed., Princeton: Princeton University Press.

——(1962) *Thinking about the Unthinkable*, London: Weidenfeld and Nicolson.

Kane, Francis X. (1964), 'Security's Too Important to Be Left to Computers', *Fortune* (April): 146–7, 231–4, 236.

Karp, David (1967) *One*, London: Gollancz.

Keefer, T. F. (1977) *Philip Wylie*, Boston: Twayne.

Kermode, Frank (1959), 'The Way the World Ends', *Spectator*, 203 (2 October): 449.

Kincaid, Paul (1985), 'The Mouse, the Lion, and Riddley Walker', *Vector*, 124/5 (April–May): 5–9.

Klein, Richard (1990), 'The Future of Nuclear Criticism', *Yale French Studies*, 77: 76–100.

Knight, Damon (1954), 'Readin' and Writhin'', *Science Fiction Quarterly*, 3.I (May): 28, 62, 96.

——(1960), 'Level 7', *Magazine of Fantasy and Science Fiction*, 18.VII (July): 76–8.

——(1963) *Far Out*. London: Corgi.

Koestler, Arthur (1945) *The Yogi and the Commissar*, London: Jonathan Cape.

——(1949) *Insight and Outlook*, New York: Macmillan.

——(1955) *The Trail of the Dinosaur*, London: Collins.

——(1970) *Darkness at Noon*, London: Cape.

Kornbluth, C. M. (1953) *Takeoff*, New York: Pennant.

——(1981) *Not This August*, revised edn., New York: Tor.

——(1997) *His Share of Glory: The Complete Short Science Fiction*, ed. Timothy P. Szczesnil, Framingham: NESFA Press.

Korzybski, Alfred (1949) *Science and Sanity: An Introduction to Non-Aristotelean Systems and General Semantics*, 3rd edn., Lakeville, CT: International Non-Aristotelean Library.

Kubrick, Stanley (1963), 'How I learned to Stop Worrying and Love the Cinema', *Films and Filming* (June): 12–13.

Kuttner, Henry (1962) *Mutant*, London: Weidenfeld and Nicolson.

La Valley, Al (ed.) (1989) *Invasion of the Body Snatchers*, New Brunswick and London: Rutgers University Press.

Lakoff, George, and Mark Johnson (1980) *Metaphors We Live By*, Chicago and London: University of Chicago Press.

Lange, Oliver (1972) *Vandenberg*, New York: Bantam.

Lanouette, William (1992) *Genius in the Shadows: A Biography of Leo Szilard*, Chicago: University of Chicago Press.

Laurence, William L. (1961) *Men and Atoms*, London: Scientific Book Club.

Lear, John (1950), 'Hiroshima USA: Can Anything Be Done About It?' *Collier's* (5 August): 16, 64–9.

LeGracy, Arthur (1978), '*The Invasion of the Body Snatchers*: A Metaphor for the Fifties', *Literature Film Quarterly*, 6,III: 285–92.

LeGuin, Ursula (1984) *The Compass Rose*, London: Panther.

——(1989) *The Language of the Night*, revised edn., London: Women's Press.

Leiber, Fritz (1968) *The Secret Songs*, London: Rupert Hart–Davis.

——(1974) *The Best of Fritz Leiber*, London: Sphere.

Leinster, Murray [Will F. Jenkins] (1946) *The Murder of the USA*, New York: Crown.

——(1958), 'Short History of World War Three', *Astounding Science Fiction*, 60.V (January): 69–83.

——(1968) *Operation Terror*, London: Tandem.

Lewin, Leonard C. (1968) *Report from Iron Mountain on the Possibility and Desirability of Peace*, Harmondsworth: Penguin.

Life (1945), 'The 36-Hour War', (19 November): 27–35.

Ljoka, Dan (1977) *Shelter*, New York: Manor.

Macdermott, K. A. (1982), 'Ideology and Narrative: The Cold War and Robert Heinlein', *Extrapolation*, 23.III: 254–69.

McDonald, John (1996) *Strategy in Poker, Business and War*, New York and London: Norton.

McGrath, Thomas (1982), 'Statement to the House Committee on Un–American Activities', *North Dakota Quarterly*, 50.IV (Fall): 8–9.

——(1987) *The Gates of Ivory, the Gates of Horn*, Chicago: Another Chicago Press.

Macklin, F. Anthony (1965), 'Sex and Dr. Strangelove', *Film Comment*, 3: 55–7.

McMurray, Clifford (1978), 'An Interview with Joe Haldeman', *Thrust*, 11 (Fall): 18–21.

Magill, Frank N. (ed.) (1979) *Survey of Science Fiction Literature*, 5 vols, Englewood Cliffs: Salem Press.

Malamud, Bernard (1982) *God's Grace*, London: Chatto and Windus.

Maland, Charles (1979), 'Dr. Strangelove (1964): Nightmare Comedy and the Ideology of Liberal Consensus', *American Quarterly* (Winter): 697–717.

Mallardi, Bill, and Bill Bowers (eds) (1969) *The Double: Bill Symposium*, Akron: D:B Press.

Mannix, Patrick (1992) *The Rhetoric of Antinuclear Fiction: Persuasive Strategies in Novels and Films*, Lewisburg: Bucknell University Press.

Marcuse, Herbert (1972) *One Dimensional Man*, London: Sphere.

Masters, Dexter, and Katherine Way (eds) (1947) *One World or None*, London: Latimer House.

Matheson, Richard (1950), 'Born of Man and Woman', *Magazine of Fantasy and Science Fiction*, 1.III (Summer): 108–10.

May, Elaine Tyler (1988) *Homeward Bound: American Families in the Cold War Era*, New York: Basic Books.

May, Ernest R. (ed.) (1993) *American Cold War Strategy: Interpreting NSC 68*, New York: St. Martin's Press.

Medhurst, Martin J., et al. (1990) *Cold War Rhetoric: Strategy, Metaphor, and Ideology*, Westport: Greenwood Press.

Merril, Judith (1960) *Out of Bounds*, New York: Pyramid.

——(1966) *Shadow on the Hearth*, London: Roberts and Vintner.

Messmer, Michael W. (1988a), 'Nuclear Culture, Nuclear Criticism', *Minnesota Review*, 30–1: 161–80.

——(1988b), '"Thinking It through Completely": The Interpretation of Nuclear Culture', *Centennial Review*, 32: 397–413.

Meyers, Jeffrey (1975) *George Orwell: The Critical Heritage*, London: Routledge and Kegan Paul.

Mielke, Robert (1984), 'Imagining Nuclear Weaponry: An Ethical Taxonomy of Nuclear Representation', *Northwest Review*, 22.I–II: 164–80.

Miller, P. Schuyler (1960), 'The Reference Library', *Astounding Science Fiction*, 65.I (March): 155–9.

Miller, Walter M., Jr (1953), 'Check and Checkmate', *If: Worlds of Science Fiction* 1.VI (January): 4–24.

——(1955), 'A Canticle for Leibowitz', *Magazine of Fantasy and Science Fiction*, 8.IV (April): 93–111.

——(1957), 'The Last Canticle', *Magazine of Fantasy and Science Fiction*, 12.II (February): 3–50.

——(1973) *The View from the Stars*, St. Albans: Granada.

——(1984) *A Canticle for Leibowitz*, London: Black Swan.

Miller, Walter M., Jr, and Martin H. Greenberg (eds) (1987) *Beyond Armageddon: Survivors of the Megawar*, London: Robinson.

Mills, C. Wright (1959) *The Causes of World War Three*, London: Secker and Warburg.

Moore, C. L. (1957) *Doomsday Morning*, Garden City, NY: Doubleday.

Moore, Ward (1954), 'Lot's Daughter', *Magazine of Fantasy and Science Fiction*, 7.IV (October): 3–27.

Morrissey, Thomas J. (1986), 'Zelazny: Mythmaker of Nuclear War', *Science-Fiction Studies*, 13.II: 182–91.

Morrow, James (1989) *This is the Way the World Ends*, New York: Ace.

Mullen, R. D., et al. (eds) (1992) *On Philip K. Dick: 40 Articles from 'Science-Fiction Studies'*, Terre Haute: SF-TH.

Mumford, Lewis (1946) *Programme for Survival*, London: Secker and Warburg.

——(1952) *The Conduct of Life*, London: Secker and Warburg.

——(1964), '"Strangelove" Reactions', *New York Times* (1 March): 8.

——(1973a) *In the Name of Sanity*, Westport: Greenwood Press.

——(1973b) *Interpretations and Forecasts: 1922–1972*, London: Secker and Warburg.

Myers, Edward (1984), 'An Interview with Russell Hoban', *The Literary Review*, 28.I: 5–16.

Nadel, Alan (1995) *Containment Culture: American Narratives, Postmodernism, and the Atomic Age*, Durham, NC: Duke University Press.

Naipaul, V. S. (1959), 'New Novels', *New Statesman*, 58 (17 September): 516

Norris, Christopher (1995), 'Versions of Apocalypse: Kant, Derrida, Foucault', in Malcolm Bull (ed.), *Apocalypse Theory and the Ends of the World*, Oxford: Blackwell: 227–49.

O'Brien, Robert C. (1984) *Z for Zachariah*, London: Gollancz.

O'Brien, Tim (1985) *The Nuclear Age*, New York: Knopf.

O'Donnell, Patrick (1992), 'Engendering Paranoia in Contemporary Narrative', *Boundary 2*, 19.I: 181–204.

Olsen, Alexandra H. (1997), 'Re-Vision: A Comparison of *A Canticle for Leibowitz* and the Novellas Originally Published', *Extrapolation*, 38.II: 135–49.

Oppenheimer, J. Robert (1951), 'Encouragement of Science', *Bulletin of the Atomic Scientists*, 7.I (January): 6–8.

Orwell, George (1970) *The Collected Essays, Journalism and Letters of George Orwell*, Vol. 4: *In Front of Your Nose*, Harmondsworth: Penguin.

——(1989) *Nineteen Eighty-Four*, Harmondsworth: Penguin.

Ostow, Mortimer (1963), 'War and the Unconscious', *Bulletin of the Atomic Scientists*, 19.I (January): 25–8.

Ower, John B. (1974), 'Manacle-Forged Minds: Two Images of the Computer in Science-Fiction', *Diogenes*, 85 (Spring): 47–61.

Pangborn, Edgar (1968) *The Judgement of Eve*, London: Rapp and Whiting.

——(1969) *Davy*, Harmondsworth: Penguin.

——(1976) *The Company of Glory*, London: Wyndham.

Panshin, Alexei (1968) *Heinlein in Dimension*, Chicago: Advent.

Parkin–Speer, Diane (1985), 'Leigh Brackett's *The Long Tomorrow*: A Quest for the Future America', *Extrapolation*, 26.III: 190–200.

Paulding, Gouverneur (1960), 'Searing Tale Envisions the End of the Life We Know', *New York Herald Tribune Book Review* (6 March).

Peary, Danny (1982) *Cult Movies: A Hundred Ways to Find the Reel Thing*, London: Vermilion.

Percy, Walker (1971), 'Walker Percy on Walter M. Miller Jr.'s *A Canticle for Leibowitz*', in David Madden (ed.), *Rediscoveries*, New York: Crown Publishers, 1971: 262–9.

Peterson, Val (1954), 'They Said It Would Never Happen ...', *New York Times Book Review* (17 January): 4–5.

Platt, Charles (1987) *Dream Makers: Science Fiction and Fantasy Writers at Work*, revised edn., London: Xanadu.

Playboy (1963), 'The Playboy Panel: 1984 and Beyond', 13.VII (July): 25–37; 13.VIII (August): 31–5, 108, 112–18.

Pohl, Frederik (1962), 'What's in It for Us?' *Galaxy Science Fiction*, 20.III (February): 5–6.

——(ed.) (1965) *The Eighth Galaxy Reader*, Garden City, NY: Doubleday.

——(1968), 'On Inventing Futures', *Galaxy Science Fiction*, 26.V (June): 6–8, 10.

——(1971) *Digits and Dastards*, London: Corgi.

——(1973) *The Frederik Pohl Omnibus*, St. Albans: Granada.

——(1978) *Man Plus*, St. Albans: Granada.

——(1979) *The Way the Future Was: A Memoir*, London: Gollancz.

——(1980) *Jem: The Making of Utopia*, St. Albans: Granada.

——(1984), 'Wars over Star Wars', *Science Fiction Chronicle*, 6.I (October): 24, 26.

——(1987) *Chernobyl: A Novel*, New York: Bantam.

——(1997), 'The Politics of Prophecy', in Donald M. Hassler and Clyde Wilcox (eds), *Political Science Fiction*, Columbia: University of South Carolina Press: 7–17.

Pohl, Frederik, and C. M. Kornbuth (1952), 'Gravy Planet', *Galaxy Science Fiction*, 4.III (June)–4.V (August).

——(1965) *The Space Merchants*, Harmondsworth: Penguin.

——(1967) *The Wonder Effect*, London: Gollancz.

Porter, Jeffrey (1990), '"Three Quarks for Muster Mark": Quantum Wordplay and Nuclear Discourse in Russell Hoban's *Riddley Walker*', *Contemporary Literature*, 31.IV: 448–69.

Porush, David (1985) *The Soft Machine: Cybernetic Fiction*, New York and London: Methuen.

Pournelle, Jerry (ed.) (1979) *The Endless Frontier*, New York: Ace.

——(1980) *A Step Further Out*, London: W. H. Allen.

Pournelle, Jerry, and John F. Carr (eds) (1984) *There Will Be War*, vol. III: *Blood and Iron*, New York: Tor.

——(1986) *There Will Be War*, vol. V: *Warrior*, New York: Tor.

——(1987) *There Will Be War*, vol. VI: *Guns of Darkness*, New York: Tor.

——(1989) *There Will Be War*, vol. VIII: *Armageddon!* New York: Tor.

Pournelle, Jerry, and Dean Ing (1984) *Mutual Assured Survival*, New York: Baen.

Pournelle, Jerry, and Larry Niven (1986) *Footfall*, London: Sphere.

Pournelle, Jerry and Stefan T. Possony (1970) *The Strategy of Technology: Winning the Decisive War*, Cambridge, MA: University Press of Cambridge.

Priestley, J. B. (1959), 'Best Anti-Bomb Story Yet', *Reynolds News* (20 September): 4.

Punter, David (1985) *The Hidden Script: Writing and the Unconscious*, London: Routledge.

Pynchon, Thomas (1979) *The Crying of Lot 49*, London: Picador.

Rabkin, Eric S., et al. (eds) (1983) *The End of the World*, Carbondale: Southern Illinois University Press.

Ranelagh, John (1986) *The Agency: The Rise and Decline of the CIA*, London: Weidenfeld and Nicolson.

Reaves, R. B. (1984), 'Orwell's "Second Thoughts on James Burnham" and *1984*', *College Literature*, 11.I: 13–21.

Reynolds, Mack (1983) *The Cosmic Eye*, London: Ace/Stoneshire.

Richards, Guy (1957) *Brother Bear*, London: Michael Joseph.

Rickman, Gregg (1988) *Philip K. Dick: In His Own Words*, revised edn., Long Beach: Fragments West.

——(1989) *To the High Castle. Philip K. Dick: A Life 1928–1962*, Long Beach: Fragments West.

Riesman, David (1964) *Abundance for What? And Other Essays*, London: Chatto and Windus.

Robinson, Kim Stanley (1984) *The Novels of Philip K. Dick*, Ann Arbor: UMI Research Press.

——(1986) *The Wild Shore*, London: Macdonald.

——(1990) *The Gold Coast*, London: Futura.

Rogin, Michael (1984), 'Kiss Me Deadly: Communism, Motherhood and Cold War Movies', *Representations*, 6 (Spring): 1–36.

Rosenthal, Peggy (1991), 'The Nuclear Mushroom Cloud as Cultural Image', *American Literary History*, 3: 63–92.

Roshwald, Mordecai (1960), 'Training the Nuclear Warrior', *The Nation* (2 April): 287–9.

——(1965), 'Order and Over-Organisation in America', *British Journal of Sociology*, 6: 243–51.

——(1966) *A Small Armageddon*, London: New English Library.

——(1967), 'The Cybernetics of Blunder', *The Nation* (13 March): 335–6.

——(1989) *Level 7*, New York: Lawrence Hill.

Rothbard, Murray N. (1986), 'George Orwell and the Cold War: A Reconsideration', in Robert Mulvihill (ed.) *Reflections on America, 1984: An Orwell Symposium*, Athens and London: University of Georgia Press: 5–14.

Ruthven, Ken (1993) *Nuclear Criticism*, Carlton: Melbourne University Press.

Sagan, Carl, and Richard Turco (1991) *A Path Where No Man Thought: Nuclear Winter and the End of the Arms Race*, London: Century.

Sambrot, William (1966) *Island of Fear*, London: Mayflower Dell.

Sammon, Paul M. (1997) *The Making of 'Starship Troopers'*, London: Little Brown.

Samuelson, David N. (1977), '*Limbo*: The Great American Dystopia', *Extrapolation*, 19.I: 76–87.

Sayre, Nora (1982) *Running Time: Films of the Cold War*, New York: Dial Press.

Schaub, Thomas Hill (1991) *American Fiction in the Cold War*, Madison: University of Wisconsin Press.

Scheick, William J. (1988), 'Continuative and Ethical Predictions: The Post-Nuclear Holocaust Novel of the 1980s', *North Dakota Quarterly*, 56: 61–82.

——(1990), 'Nuclear Criticism: An Introduction', *Papers on Language and Literature*, 26.I (Winter): 3–12.

Schell, Jonathan (1982) *The Fate of the Earth*, London: Jonathan Cape.

Schelling, Thomas C. (1960), 'Meteors, Mischief, and War', *Bulletin of the Atomic Scientists*, 16.VII (September): 292–6, 300.

Schweitzer, Darrell (1977), 'An Interview with Joe Haldeman', *Science Fiction Review*, 20 (February): 26–30.

Schwenger, Peter (1986), 'Writing the Unthinkable', *Critical Inquiry*, 13: 33–48.

——(1990a), 'Nuclear Critics and the Monstrous New', *Dalhousie Review*, 70: 56–67.

——(1990b), 'Postnuclear Postcard', *Papers on Language and Literature*, 26.I: 164–81.

——(1992) *Letter Bomb: Nuclear Holocaust and the Exploding Word*, Baltimore: Johns Hopkins University Press.

See, Carolyn (1996) *Golden Days*, Berkeley: University of California Press.

Seed, David (1994a), 'The Flight from the Good Life: *Fahrenheit 451* in the Context of Postwar American Dystopias', *Journal of American Studies*, 28.II (1994): 225–40.

——(1994b), 'Military Machines and Nuclear Accident: Burdick and Wheeler's *Fail-Safe*', *War, Literature and the Arts*, 6.I: 21–40.

——(1997a), 'Brainwashing and Cold War Demonology', *Prospects*, 22: 535–73.

——(1997b), 'One of Postwar SF's Formative Figures', *Interzone*, 126 (December): 13–15, 26.

Shafer, Robert (1955) *The Conquered Place*, London: Putnam.

Shaheen, Jack G. (ed.) (1978) *Nuclear War Films*, Carbondale: Southern Illinois University Press

Sheckley, Robert (1987) *Journey beyond Tomorrow*, London: Gollancz.

Shippey, Tom (1979), 'The Cold War in Science Fiction 1940–1960', in Patrick Parrinder (ed.), *Science Fiction: A Critical Guide*, London: Longman: 90–109.

——(ed.) (1991) *Fictional Space: Essays on Contemporary Science Fiction*, Oxford: Basil Blackwell.

——(1994), 'The Critique of America in Contemporary Science Fiction', *Foundation*, 61: 36–49.

Shiras, Wilmar H. (1959) *Children of the Atom*, London: T. V. Boardman.

Shute, Nevil (1957) *On the Beach*, London: Heinemann.

Siebers, Tobin (1993) *Cold War Criticism and the Politics of Skepticism*, New York: Oxford University Press.

Silverberg, Robert (ed.) (1970) *Science Fiction Hall of Fame*, vol. 1, Garden City, NY: Doubleday.

——(ed.) (1977) *Mutants*, London: Corgi.

Siodmak, Curt (1969) *Hauser's Memory*, London: Herbert Jenkins.

Slusser, George (1977a) *The Classic Years of Robert A. Heinlein*, San Bernardino: Borgo Press.

——(1977b) *Robert A. Heinlein: Stranger in His Own Land*, San Bernardino: Borgo Press.

Smetak, Jacqueline R. (1990), '"So Long, Mom": The Politics of Nuclear Holocaust Fiction', *Papers on Language and Literature*, 26.I: 41–59.

Smith, Curtis C. (ed.) (1986) *Twentieth-Century Science Fiction Writers*, 2nd edn., Chicago and London: St James Press.

Smith, George H. (1961) *Doomsday Wing*, Derby, CT: Monarch.

Smith, Harrison (1953), 'Rival to Orwell', *Saturday Review*, 36 (17 October): 28–9.

Smith, Philip E. (1978), 'The Evolution of Politics and the Politics of Evolution: Social Darwinism in Heinlein's Fiction', in Joseph D. Olander and M. H. Greenberg (eds), *Robert A. Heinlein*, Edinburgh: Paul Harris: 137–71.

Sohl, Jerry (1955) *Point Ultimate*, New York: Rinehart.

Solberg, Carl (1973) *Riding High: America in the Cold War*, New York: Mason and Lipscomb.

Solomon, J. Fisher (1988) *Discourse and Reference in the Nuclear Age*, Norman and London: University of Oklahoma Press.

——(1990), 'Probable Circumstances, Potential Worlds: History, Futurity and "Nuclear Referent"', *Papers on Language and Literature*, 26.I: 60–72.

Sontag, Susan (1987) *Against Interpretation*, London: André Deutsch.

Spencer, Susan (1991), 'The Post–Apocalyptic Library: Oral and Literate Culture in *Fahrenheit 451* and *A Canticle for Leibowitz*', *Extrapolation*, 32.IV: 331–42.

Spinrad, Norman (1974) *The Iron Dream*, St. Albans: Panther.

Stentz, Zack (1997), 'Au Contrarian', *Metro* (6–12 February). From website http://www-leland.stanford.edu/~blandon/brin.html.

Stolley, Richard B. (1964), 'How It Feels to Hold the Nuclear Trigger', *Life* (6 November): 34–41.

Stone, Albert E. (1994) *Literary Aftershocks: American Writers, Readers and the Bomb*, New York: Twayne.

Strieber, Whitley, and James W. Kunetka (1984) *Warday and the Journey Onward*, London: Hodder and Stoughton.

Sturgeon, Theodore (1955a) *Caviar*, New York: Ballantine.

——(1955b) *A Way Home*, New York: Pyramid.

Sullivan, Richard E. (1960), 'The End of the "Long Run"', *Centennial Review*, 4: 391–408.

Sutin, Lawrence (ed.) (1995) *The Shifting Realities of Philip K. Dick: Selected Literary and Philosophical Writings*, New York: Pantheon.

Suvin, Dako (1979) *Metamorphoses of Science Fiction*, New Haven: Yale University Press.

Swirski, Peter (1991), 'Dystopia or Dischtopia? The Science-Fiction Paradigms of Thomas M. Disch', *Science-Fiction Studies*, 18.II: 161–178.

Symington, W. Stuart (1950), 'The Importance of Civil Defence Planning', *Bulletin of the Atomic Scientists*, 6.VIII–IX (August–September): 231–3.

Szilard, Leo (1947), 'The Physicist Invades Politics', *Saturday Review* (3 May): 7–8, 31–4.

——(1950), 'The Diary of Dr. Davis', *Bulletin of the Atomic Scientists*, 6.II: 51–7.

——(1992) *The Voice of the Dolphins and Other Stories*, Stanford: Stanford University Press.

Teller, Edward, with Allen Brown (1962) *The Legacy of Hiroshima*, London: Macmillan.

Tenn, William (1956) *Off All Possible Worlds*, London: Michael Joseph.

——(1964) *Time in Advance*, London: Gollancz.

——(1968) *The Wooden Star*, New York: Ballantine.

Tevis, Walter (1986) *The Man Who Fell to Earth*, New York: Dell.

Thompson, E. P. (1985) *The Heavy Dancers*, London: Merlin Press.

Tucker, Wilson (1955) *Wild Talent*, London: Michael Joseph.

——(1980) *The Long Loud Silence*, London: Hodder and Stoughton.

Van Vogt, A. E. (1977) *Tyranopolis*, London: Sphere.

Von Hoffman, Nicholas (1982), 'The Brahms Lullaby', *Harpers*, 264 (February 1982): 50–9.

Vonnegut, Kurt (1975) *Wampeters Foma and Granfalloons*, London: Jonathan Cape.

——(1977) *Player Piano*, St. Albans: Granada.

——(1979) *Welcome to the Monkey House*, St. Albans: Triad/Panther.

Wagar, W. Warren (1982) *Terminal Visions: The Literature of Last Things*, Bloomington: Indiana University Press.

Walker, Paul (1976), 'Leigh Brackett: An Interview', *Luna Monthly*, 61 (January): 1–8.

Walsh, Chad (1962) *From Utopia to Nightmare*, London: Geoffrey Bles.

Warren, Bill (1982) *Keep Watching the Skies! American Science Fiction Movies of the Fifties*, Jefferson and London: McFarland.

Watt, Donald (1980), '*Fahrenheit 451* as Symbolic Dystopia', in M. H. Greenberg and Joseph D. Olander (eds), *Ray Bradbury*, Edinburgh: Paul Harris: 195–213.

Waugh, Charles, and Martin H. Greenberg (eds) (1988) *Space Wars*, New York: Tor.

Weart, Spencer R. (1988) *Nuclear Fear: A History of Images*, Cambridge, MA: Harvard University Press.

Weiss, Alan (1997), 'Not Only a Mother: An Interview with Judith Merril', *Sol Rising*, 18 (April): 1, 6–9; 19 (August): 6–9.

Welch, Robert (1963) *The Politicians*, Belmont, MA: Robert Welch.

Wells, Earl (1993), 'Robert A. Heinlein: EPIC Crusader', *New York Review of Science Fiction*, 56 (April): 1, 3–7.

Wells, H. G. (1988) *The World Set Free*, London: Hogarth Press.

Wheeler, Harvey (1968), 'The Strategic Calculators', in Nigel Calder (ed.), *Unless Peace Comes: A Scientific Forecast of New Weapons*, London: Allen Lane: 91–107.

White, E. B. (1950), 'The Morning of the Day They Did It', *The New Yorker* (25 February): 27–33.

White, Hayden (1978) *Tropics of Discourse: Essays in Cultural Criticism*, Baltimore and London: Johns Hopkins University Press.

——(1987) *The Content of the Form: Narrative Discourse and Historical Representation*, Baltimore and London: Johns Hopkins University Press.

Whitfield, Stephen J. (1996) *The Culture of the Cold War*, 2nd edn., Baltimore: Johns Hopkins University Press.

Wiener, Norbert (1950) *The Human Use of Human Beings*, Boston: Houghton Mifflon.

——(1961) *Cybernetics: or, Control and Communication in the Animal and the Machine*, Cambridge, MA: M.I.T.

Williams, Nick Boddie (1956) *The Atomic Curtain*, New York: Ace.

——(1961) *The Day They H–Bombed Los Angeles*, New York: Ace.

Wingrove, David (1978), 'An Interview with Frederik Pohl', *Vector*, 90 (November–December): 5–20.

Winkler, Allan M. (1984), 'A 40-Year History of Civil Defense', *Bulletin of the Atomic Scientists*, 41 (June–July): 16–22.

Wolfe, Bernard (1951), 'Self Portrait', *Galaxy Science Fiction*, 3.II (November): 58–63.

——(1952) *Limbo*, New York: Random House.

——(1959) *The Great Prince Died*, London: Jonathan Cape.

Wolfe, Gary K. (1979) *The Known and the Unknown: The Iconography of Science Fiction*, Kent: Kent State University Press.

Wollheim, Donald (ed.) (1956) *The End of the World*, New York: Ace.

Wouk, Herman (1968) *The 'Lomokome' Papers*, New York: Pocket Books.

Wylie, Philip (1942) *Generation of Vipers*, New York: Rinehart.

——(1945), 'Deliverance or Doom', *Collier's* (29 April): 18–19, 79–80.

——(1948), 'Safe and Sane', *The Atlantic* (January): 90–3.

——(1949) *Opus 21*, New York: Rinehart.

——(1951a), 'A Better Way to Beat the Bomb', *The Atlantic* (February):38–42.

——(1951b), 'Impure Science', *Bulletin of the Atomic Scientists*, 7.VII–VIII (August): 196–200.

——(1952), 'After the Hydrogen Bombs', *New York Herald Tribune Book Review*, (14 December): 11.

——(1954a), 'Panic, Psychology and the Bomb', *Bulletin of the Atomic Scientists*, 10.II (February): 37–40, 63.

——(1954b) *Tomorrow!* New York: Rinehart.

——(1956) *The Answer*, London: Frederick Muller.

——(1957) *The Innocent Ambassadors*, New York: Rinehart.

——(1960), 'Why I Believe There Will Be No All–Out War', *The Rotarian*, 97 (September): 22–5.

——(1963) *Triumph*, Garden City: Doubleday.

——(1965) *The Smuggled Atom Bomb*, New York: Lancer.

——(1968), 'McNamara's Missile Defense: A Multibillion-Dollar Fiasco?' *Popular Science*, 192 (January): 59–62, 182.

——(1972) *The Disappearance*, London: Gollancz.

Wylie, Philip, and Edwin Balmer (1970) *After Worlds Collide*, New York: Paperback Library.

Zins, Daniel L. (1986), 'Rescuing Science Fiction from Technocracy: *Cat's Cradle* and the Play of Apocalypse', *Science-Fiction Studies*, 13.II: 170–81.

——(1990), 'Exploding the Canon: Nuclear Criticism in the English Department', *Papers on Language and Literature*, 26.I: 13–40.

Index